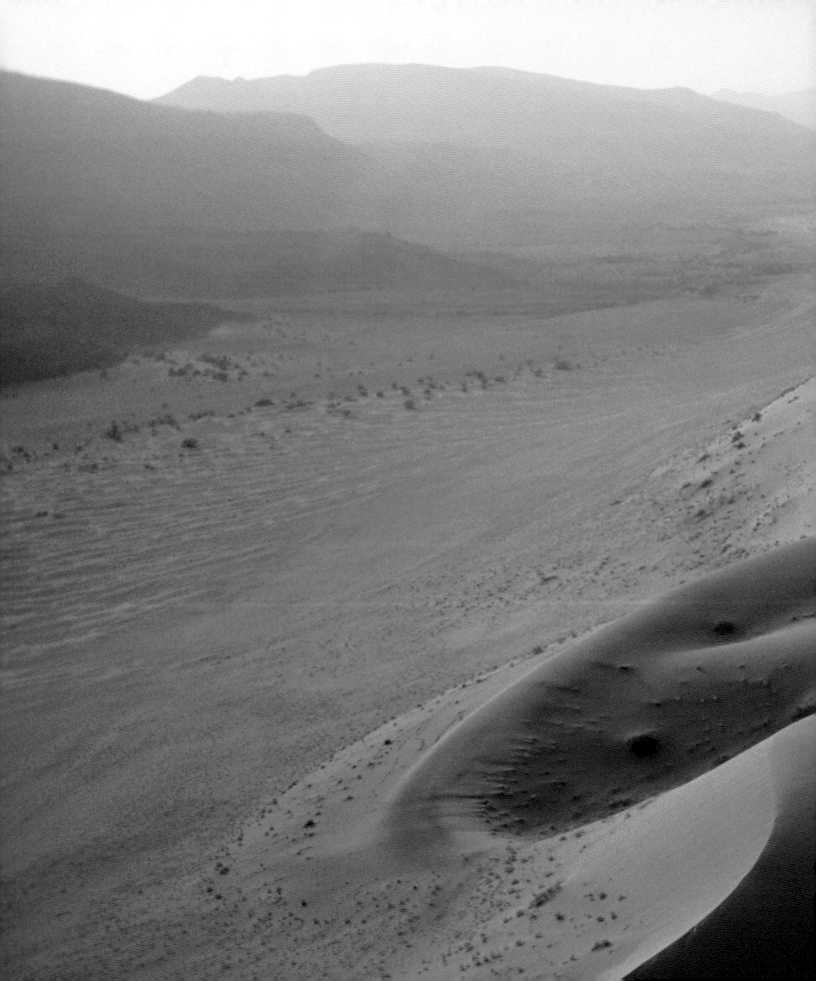

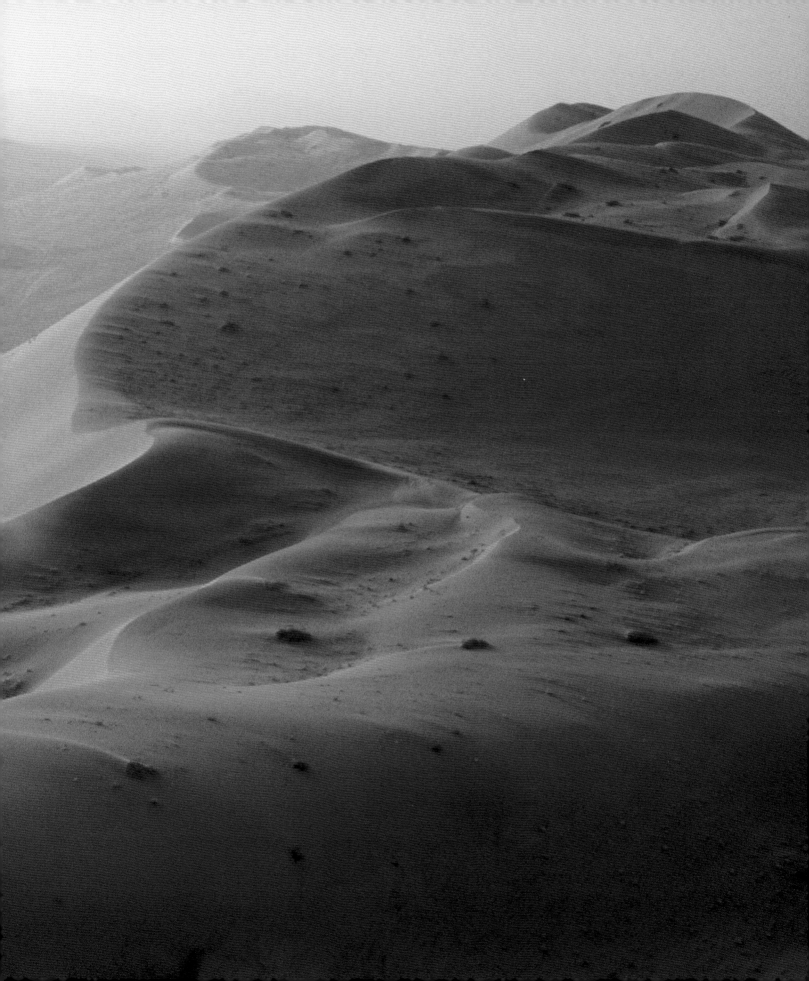

# CARAVAN

## YEMEN AND THE ANCIENT

# KINGDOMS

## INCENSE TRADE

EDITED BY ANN C. GUNTER     ARTHUR M. SACKLER GALLERY     SMITHSONIAN INSTITUTION     WASHINGTON, D.C.

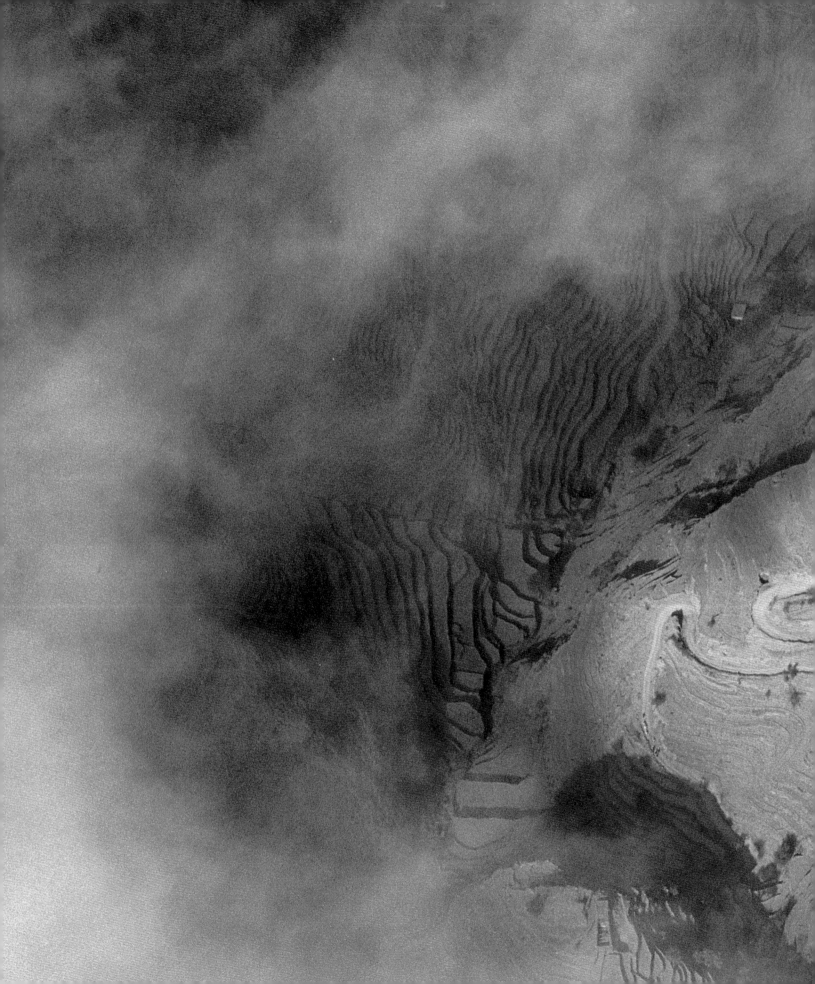

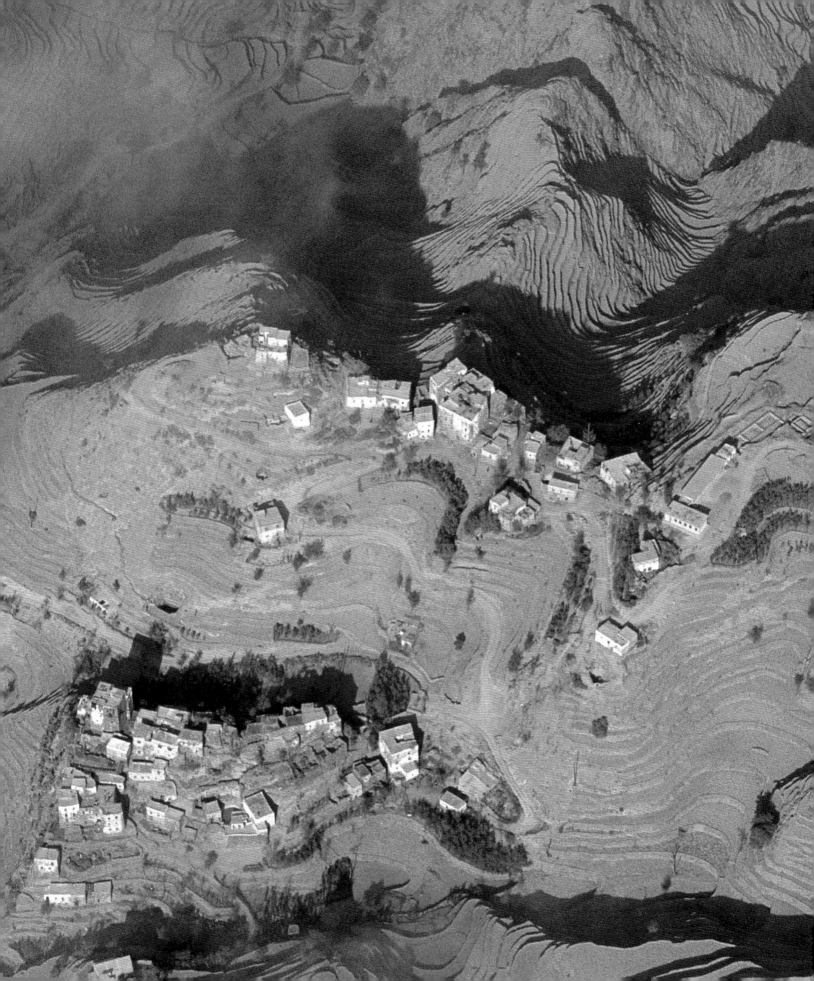

# CONTENTS

## 1 History, Chronology, and Archaeology

FOREWORD

Originating in the "Land of Incense," the exhibition *Caravan Kingdoms: Yemen and the Ancient Incense Trade*, symbolizes the deep cultural ties between antiquity and the present. The exhibition is the result of continued joint efforts by the Arthur M. Sackler Gallery, Smithsonian Institution, and the General Organization of Antiquities and Museums, Ministry of Culture and Tourism of the Republic of Yemen, to embody the principle "Communication between Cultures."

This book will transport you to the realm of the civilizations that evolved in the land of Yemen, in the southwestern corner of the Arabian Peninsula, the region known in antiquity as "Arabia Felix." American experts were among the first to investigate the archaeological and historical treasures that lie deep beneath the soil of this good land. They continue to participate with us in seeking additional treasures, undertaking numerous research projects through the American Institute of Yemeni Studies, which was established in 1978. Those projects have been the most creditable investigations to employ modern technology in exploring history's secrets. The commendable efforts made by Dr. Julian Raby, director of the Freer Gallery of Art and Arthur M. Sackler Gallery, will live on in the minds of many generations to come. He and his staff undertook the task of organizing the exhibition to emphasize the fundamental role of ancient Yemeni culture, with its knowledge and experience, in nourishing other ancient cultures, particularly those that developed in the Mediterranean world and South Asia.

The hosting of this exhibition by the Freer and Sackler galleries, the national museum of Asian art for the United States, has significant implications. Washington is the capital of the New World that seeks eagerly to learn more about ancient civilizations. In addition, Washington is a focal tourist destination for thousands of foreign visitors and the most appropriate place to present and promote Yemeni civilization. The exhibition continues the good and solid relations and enhances cultural exchange between the two friendly nations of Yemen and the United States, and it documents the cooperation and understanding the two countries enjoy.

We extend our most profound thanks to all cultural organizations that have participated in this exhibition and to Mr. Abdulwahab al-Hajjiri, our ambassador in Washington, D.C. We hope that the exhibition is a first step along the path of future cooperation between the Smithsonian Institution and our country's Ministry of Culture and Tourism.

HIS EXCELLENCY KHALED ABDULLA AL-ROWAISHAN
MINISTER OF CULTURE AND TOURISM IN THE REPUBLIC OF YEMEN

من ارض البخور والاطياب يقام هذا المعرض في متحف (آرثر ام ساكلر) التابع لمؤسسة (سميثسونيان) في عاصمة العالم الجديد (واشنطن) ليمثل عمق التواصل الحضاري بين الاصالة والمعاصرة، بين التاريخ والحداثة. (قوافل الممالك: اليمن وتجارة البخور التاريخية) هو عنوان هذا المعرض الذي جاء نتيجة جهود تنسيق متواصلة بين متحف (ساكلر) والهيئة اليمنية العامة للآثار والمتاحف ووزارة الثقافة والسياحة في اليمن ليجسد قاعدة التواصل بين الحضارات.

يحلق الإصدار الذي بين أيدينا بجناحي البهجة والروعة، ليجوب في أفق الحضارات الإنسانية التي نشأت على ارض اليمن، البلد الذي يستكين وادعا في الزاوية الجنوبية الغربية من شبه الجزيرة العربية والذي عرف قديما بالعربية السعيدة (ARABIA FELIX) لقد كان خبراء الآثار الأمريكيين من أوائل الباحثين عن الكنوز الأثرية والتاريخية المدفونة في أعماق هذه الأرض الطيبة، ولا يزالون يسهمون معنا في البحث عن المزيد منها وإجراء العديد من الدراسات العلمية عبر المعهد الأمريكي للدراسات اليمنية الذي أنشئ في عام 1978 م، وكانت هذه الدراسات العلمية اصدق توظيف للثقافة الحديثة في الكشف عن أسرار التاريخ، وستظل الجهود الطيبة للسيد/جوليان رابي مدير متحف (ساكلر) و متحف (فرير)، راسخة في عقول الأجيال القادمة حيث قام هو و معاونوه بتنظيم المعرض لإبراز الدور الأساسي للحضارة اليمنية القديمة في رفد الحضارات القديمة بمعارفها وخبراتها خاصة الحضارات التي نشأت في حوض البحر الأبيض المتوسط وجنوب آسيا.

أن استضافة معرض (ارثر ام ساكلر) التابع للمتحف القومي للفنون الآسيوية في الولايات المتحدة الأمريكية لهذا المعرض في مدينة (واشنطن) له دلالات بالغة فواشنطن هي عاصمة العالم الجديد الذي يتوق إلى التعرف على الحضارات القديمة، إضافة إلى أن هذه المدينة تعد واجهة سياحيا لمئات الآلاف من الزوار الأجانب، وهي انسب مكان للتعريف بحضارة اليمن والترويج له سياحيا ويعتبر هذا المعرض امتدادا للعلاقات الطيبة والمتينة وتعزيزا للتبادل الثقافي بين الشعبين الصديقين اليمني والأمريكي، وتوثيقا لعلاقات التعاون والتفاهم بين اليمن والولايات المتحدة الأمريكية.

نشكر كل المؤسسات الثقافية التي أسهمت في إقامة هذا المعرض كما نشكر سعادة الأخ/عبد الوهاب الحجري سفير بلادنا في واشنطن ونأمل أن يكون هذا المعرض خطوة على طريق التعاون المستقبلي بين المعهد ووزارة الثقافة والسياحة في بلدنا اليمن.

خالد عبدالله الرويشان
وزير الثقافة والسياحة بالجمهورية اليمنية

It gives me great pleasure to write a foreword to this publication that accompanies the exhibition *Caravan Kingdoms: Yemen and the Ancient Incense Trade* at the Arthur M. Sackler Gallery, Smithsonian Institution, Washington, D.C.

We in Yemen, and perhaps other societies, have much to learn from the civilizations that flourished in the southern Arabian peninsula in antiquity—the civilizations that form the subject of this exhibition and its publication. Those civilizations created and sustained impressive technologies of water management, built roads and ships for travel overland and by sea, and developed sophisticated forms of written and symbolic communication that made it possible for them to record and transmit accumulated knowledge and experience to their contemporaries and heirs. Archaeological fieldwork and scholarly research into Yemen's past increases our understanding of the natural and human resources of this land that nourished these ancient civilizations for over a thousand years. Such a perspective can contribute to our own efforts today in developing and maintaining the most effective use of those resources.

Among other programs, the Social Fund for Development supports a range of projects in the arena of cultural heritage, designed to help preserve Yemen's historical heritage and features and to maintain and rehabilitate sites and monuments of cultural value at national, regional, and international levels. In conjunction with the exhibition, this publication offers the first presentation of Yemen's remarkable yet little-known ancient civilizations to audiences throughout the United States and beyond its North American borders. We trust that our sponsorship of this publication will help create new awareness of the achievements of Yemen's ancient civilizations, and therefore also of the value and importance of preserving Yemen's unique and endangered cultural heritage.

ABDULKARIM ISMAIL AL-ARHABI
MANAGING DIRECTOR, SOCIAL FUND FOR DEVELOPMENT

بسعادة بالغة أتشرف بتقديم هذا الكتيب الخاص بالمعرض الذي نأمل أن يحوز رضاكم بعنوان: (ممـالك القوافل: اليمـن وتجـارة البخـور القديمـة) المقام في معرض (ساكلر) التابع لمعهد (سميثسونيان) في مدينة (واشنطن) العاصمة.

هنالك الكثير الذي يجب أن نتعلمه نحن في اليمن وربما في مجتمعات أخرى في العالم من الحضارات القديمة التي ازدهرت في جنوب شبه الجزيرة العربية. تلك الحضارات هي موضوع هذا الكتيب وهذا المعرض، وهي التي أوجدت تقنيات بارعة في إدارة المياه وبناء الطرقات والسفن لتعبر البحار وقامت بتطوير رموز للكتابة والتعبير لتوصيل وتبادل المعلومات مع المجتمعات التي عاصرتها والتي تلتها. إن الأبحاث في علوم الآثار في تاريخ اليمن تزيد من فهمنا عن شعوب تلك المنطقة ومصادر ثرواتها الطبيعية والبشرية على مدى أكثر من ألف عام. وهذه النظرة تعزز جهودنا طبعاً لتهدينا إلى أفضل الطرق لاستغلال تلك المصادر أفضل استغلال في يومنا هذا.

و ضمن عدد من البرامج، فإن الصندوق الاجتماعي للتنمية يدعم عددا من المشاريع الحضارية المصممة للحفاظ على حضارة اليمن وطابعها المميز على المستوى المحلي والأقليمي والدولي. بالمشاركة مع المعرض، فإن هذا الكتيب يعطي لمحة أولى عن الحضارة اليمنية المرموقة والتي لا يعرفها حق المعرفة كثير من الناس عبر الولايات المتحدة وحتى خارجها في أمريكا الشمالية. نحن على ثقة أن تبني مثل هذا المنشور سيفتح أعين الكثيرين على منجزات الحضارات اليمنية القديمة و كذلك قيمة وأهمية الحفاظ على الإرث الحضاري اليمني الفريد من نوعه و المهدد بالضياع.

عبد الكريم الأرحبي
المدير التنفيذي للصندوق الاجتماعي للتنمية

For more than a thousand years, from around 800 BCE to 600 CE, the kingdoms of Qataban, Saba (biblical Sheba), and Himyar, in present-day Yemen, grew fabulously and famously wealthy. They derived their wealth from control over the caravan routes of the southern Arabian Peninsula and, in particular, from the international trade in frankincense and myrrh. Excavations at the capitals of these ancient kingdoms have yielded spectacular examples of ashlar architecture, distinctive stone funerary sculpture, coins, elaborate inscriptions on stone, bronze, and wood, and sophisticated metalwork. Admired for its fragrant and abundant foliage and luxuriant pastures, Yemen was central to the ancient "global economy" that extended from the Mediterranean Sea to the Indian Ocean. It is no wonder that it was known to the Greeks and Romans as "Arabia the Blessed." The exhibition *Caravan Kingdoms: Yemen and the Ancient Incense Trade* and its accompanying publication explore this rich and little-known period of cultural achievement and internationalism in the southern Arabian Peninsula.

The exhibition is organized in conjunction with the Ministry of Culture and Tourism of the Republic of Yemen and the General Organization of Antiquities and Museums (GOAM). His Excellency Khaled Abdulla al-Rowaishan, Minister of Culture and Tourism, generously encouraged our interest in this special opportunity to draw upon the collections of multiple museums in Yemen. Dr. Abdulla Bawazir, chairman of GOAM, kindly granted permission to borrow these rare objects, and Muhannad al-Saiani as GOAM's curator ably oversaw their transportation and installation. In addition, we owe deepest appreciation to Dr. Abd al-karim al-Iryani, senior adviser to the president of the Republic of Yemen, who encouraged and assisted us at every stage of exhibition planning and development. His Excellency Abdulwahab al-Hajjiri, the Republic of Yemen's ambassador to the United States, warmly endorsed and facilitated this undertaking, and Mohammad Albasha and Ghafoura Alwadi assisted in communicating with officials both in Yemen and here in the United States. Jamila Raja expeditiously arranged for meetings with individuals and institutions during my visit to Yemen in August 2004 and helped to follow up with exhibition plans. In Sanaa, His Excellency Thomas Krajeski, United States ambassador to Yemen, together with Nabil Khouri, Deputy Chief of Mission, and John Balian, Public Affairs Officer, lent their support and encouragement. Here in the United States, we owe special thanks to Barbara Bodine and Edmund Hull, former U.S. ambassadors to Yemen, Abdulhakem Alsadeh, honorary consul of the Republic of Yemen in Detroit, Michigan, and Amal Abul-Hajj-Hull, for enthusiasm and practical advice on promotion and sponsorship for the exhibition. Initially organized as a traveling exhibition by the Institut du Monde Arabe in 1997, the exhibition subsequently journeyed

to numerous museums across Europe, and many individuals at these institutions have generously contributed advice and expertise. For crucial information and materials for the publication we are especially indebted to Brahim Alaoui, Sabina Antonini, Éric Delpont, Iris Gerlach, Holger Hitgen, Christian Robin, Alessandro de Maigret, St John Simpson, and Burkhard Vogt.

The scientific investigation of Yemen's ancient kingdoms by American archaeologists began with the pioneering fieldwork conducted by Wendell Phillips for the American Foundation for the Study of Man in the early 1950s. Thanks to the generosity and friendship of Merilyn Phillips Hodgson, president of the foundation, nearly three hundred objects from those excavations have been on long-term loan to the Sackler Gallery since 1992. This exhibition provides the opportunity to display the most significant works from the foundation's collections in conjunction with archaeological finds housed in Yemen. Through an exceptional set of circumstances, we have also been able to include in the exhibition the spectacular bronze horse in the collection of Dumbarton Oaks, Washington, D.C. Thanks to Edward L. Keenan, director, and Gudrun Buehl and Stephen Zwirn, curators in the Byzantine Department, we are able to display this masterpiece in connection with major works of the same period and cultural sphere.

We are pleased that the Arthur M. Sackler Gallery, Smithsonian Institution, is able to host the exclusive presentation of this exhibition in North America. By bringing to greater public awareness the extraordinary contributions of Yemen's ancient civilizations to diverse realms of art, religion, and technology, this exhibition helps to fulfill the museum's key mission as a center for the study of art and culture whose purview spans the entire continent of Asia, from remote antiquity to the present day. It follows on the immensely successful symposium, "Windows on the Cultural Heritage of Yemen," held at the Freer Gallery of Art in September 2003. This three-day symposium, organized by Brigitte Boulad-Kiesler and Maria deJ. Ellis under the sponsorship of the Embassy of Yemen in the U.S., the American Institute of Yemeni Studies, the Foundation for the Protection of Antiquities and Cultural Heritage in Yemen, and the U.S. Embassy and the Royal Netherlands Embassy in Yemen, vividly introduced to a large and receptive audience Yemen's remarkable achievements in art, architecture, music, and other fields.

*Caravan Kingdoms: Yemen and the Ancient Incense Trade* is generously supported by Mrs. Richard Helms, Hunt Oil Company, Occidental Petroleum Corporation, Mr. Hossein Afshar, The Universal Companies (Yemen), and the Friends of the Freer and Sackler Galleries.

The catalogue accompanying the exhibition is made possible by the Social Fund for Development, Republic of Yemen.

JULIAN RABY
DIRECTOR, FREER GALLERY OF ART
& ARTHUR M. SACKLER GALLERY

ARABIA

MAIN

AL-JAWF

JABAL-RUWAIQ

• BARAQISH

RAMLAT AS-SABATAYN

HADRAMAWT

• RAYBUN

• SHIBAM AL-GHIRAS

• MARIB

• SHABWA

• SIRWAH

SABA

• SANAA

• YALA

• TAMNA

• HAJAR IBN HUMAYD

QATABAN

RED SEA

AWSAN

• ZAFAR

HIMYAR

DHU-RAYDAN

JABAL AL-LAWDH

• MOUZA

• ADEN

GULF OF ADEN

BAB
AL-MANDAB

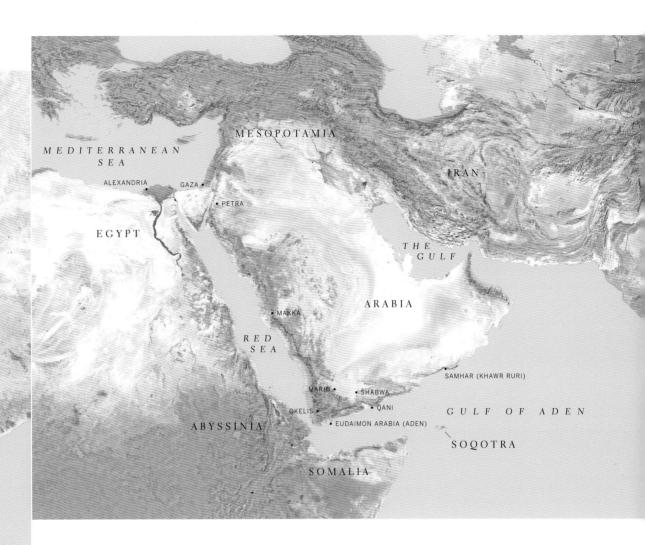

MEDITERRANEAN
SEA

MESOPOTAMIA

IRAN

ALEXANDRIA •        GAZA •
                         • PETRA

EGYPT

THE
GULF

ARABIA

• MAKKA

RED
SEA

SAMHAR (KHAWR RURI) •

MARIB •     • SHABWA
                    • QANI
OKELIS •
      • EUDAIMON ARABIA (ADEN)

GULF OF ADEN

SOQOTRA

ABYSSINIA

SOMALIA

INDIAN
OCEAN

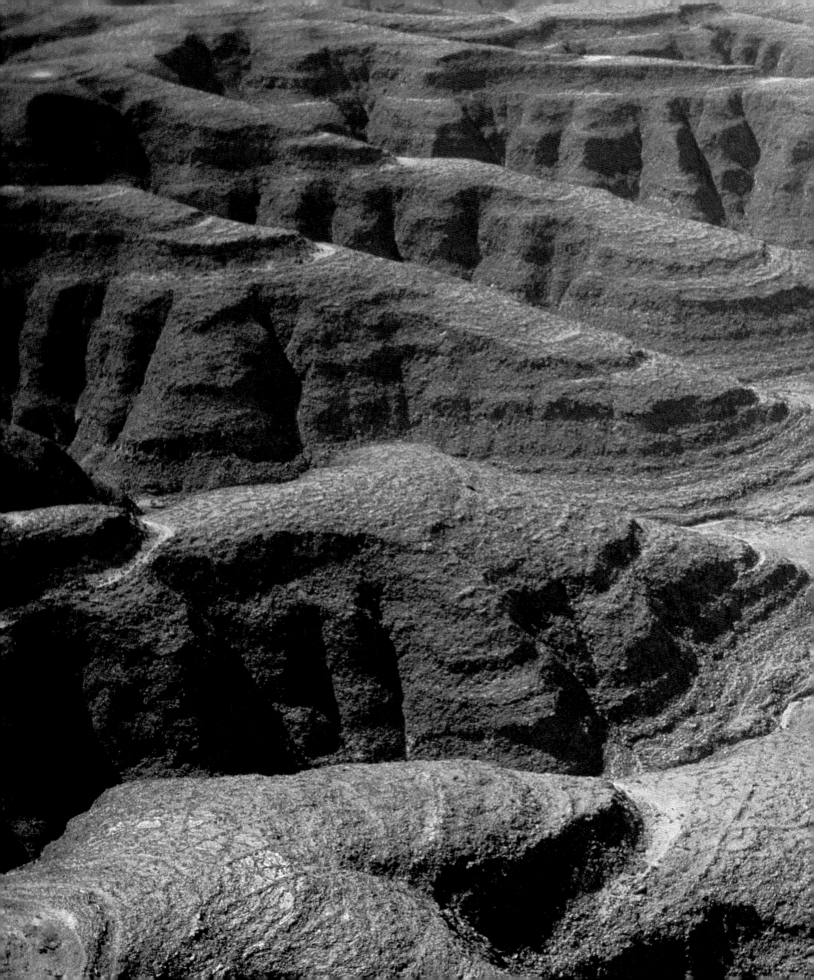

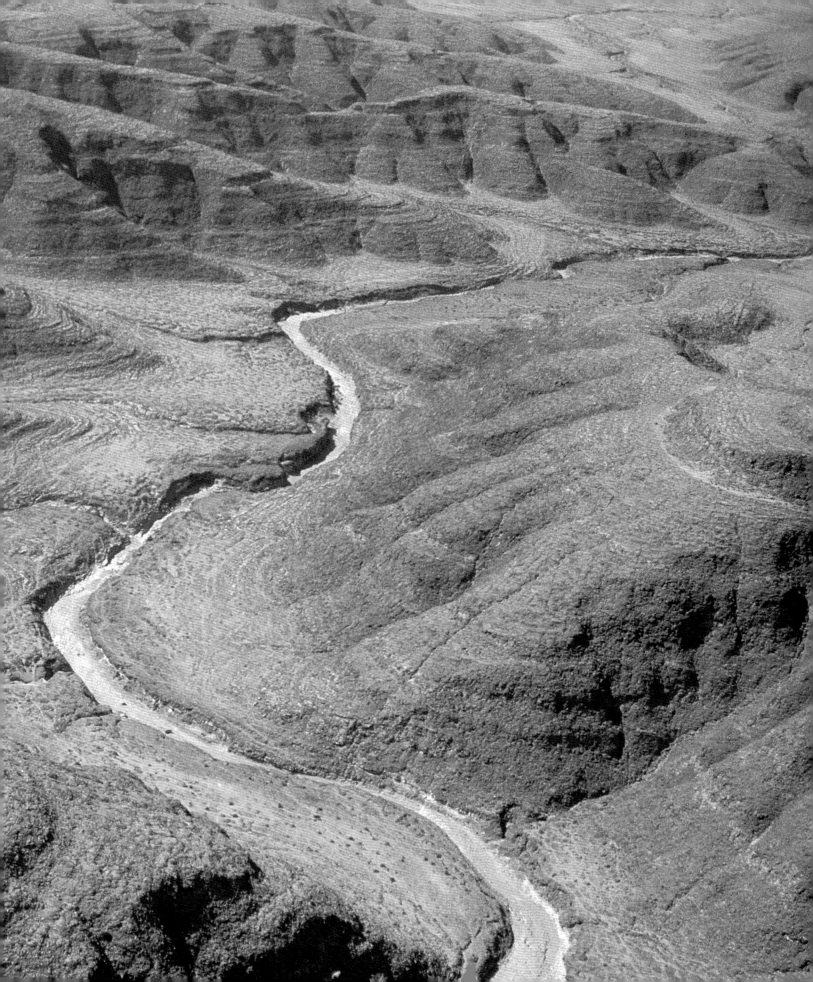

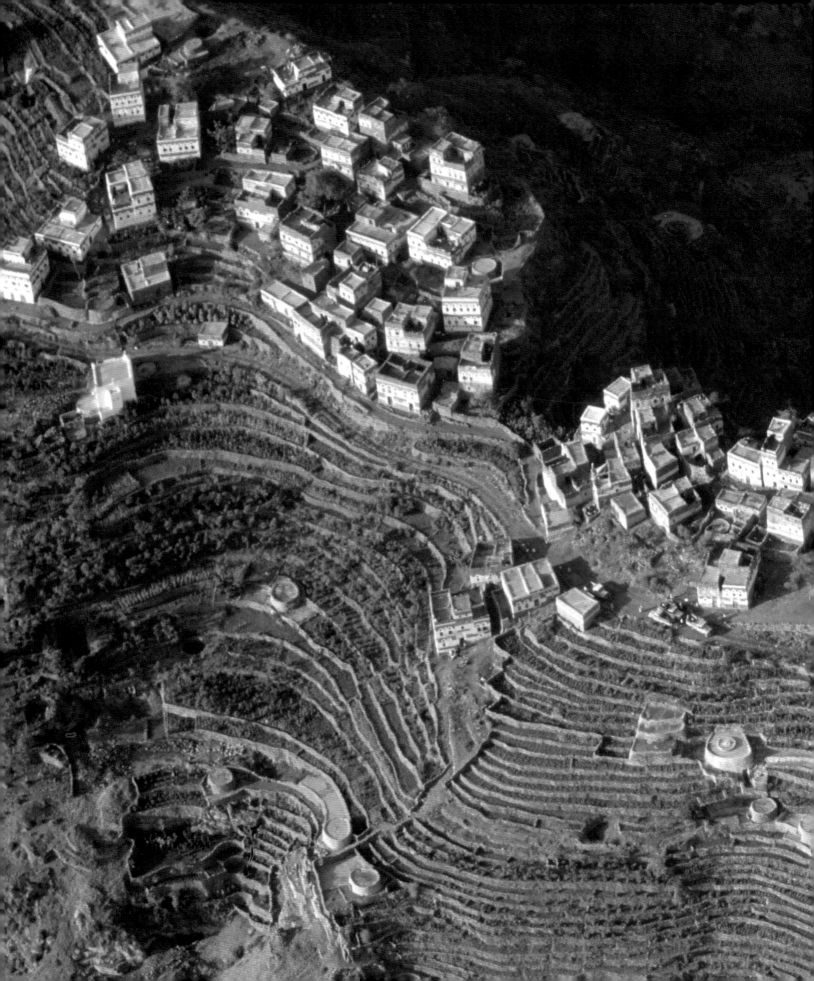

# 1 History, Chronology, and Archaeology

ALESSANDRO DE MAIGRET

# The Dawn of History
# in Yemen's Interior

The recent discovery of the Yemeni Bronze Age (third–second millennia BCE) has revealed that the material culture of this period differs profoundly from that of the South Arabian period that followed (first millennium BCE–first millennium CE), as a look at the ceramic production of the two periods alone suffices to establish. But precisely when did the Bronze Age come to an end? When did the South Arabian period begin? This question has been the subject of a long debate among specialists, and the existence of a "South Arabian protohistory" depends largely on how one answers it.

We know that history properly speaking begins in southern Arabia with the appearance of monumental inscriptions. The proponents of the "short chronology" (led by the French scholar Jacqueline Pirenne), who think they see the influence of classical Greece in the style of the earliest inscriptions, situate this development around the year 500 BCE. By contrast, those who advocate a "long chronology" (following the Austrian scholar Hermann von Wissmann) identify the rulers named in the inscriptions with those mentioned in the Assyrian annals, locating it some two centuries earlier around 700 BCE. This second hypothesis seems the most correct, and the proof was provided in 1951 by the American excavations at Hajar ibn Humayd, in the Wadi Bayhan, where the oldest levels of the tell—which date to the tenth century BCE—yielded South Arabian material (FIGS. 1–3). This evidence is still too isolated, however, to convince the advocates of the short chronology. Given the problems of the political situation in Yemen, archaeologists and historians have had to wait three decades before this theory could be confirmed or refuted through new excavations.

In 1985, the publication of the results of a sounding by American archaeologists provided the first confirmation of the long chronology by establishing the

FIG 1 BOWL WITH ZOOMORPHIC SPOUT. HAJAR IBN HUMAYD, STRATUM N, LATE 8TH–LATE 6TH CENTURY BCE. CERAMIC; H 11.3–11.7 D (RIM) 18–18.5 CM. THE AMERICAN FOUNDATION FOR THE STUDY OF MAN, H 2128

presence of South Arabian material culture in the oldest levels. The pottery and other artifacts unearthed in the seven levels of Hajar at-Tamra—a small site in the Wadi al-Jubah, south of Marib—were dated between the tenth and fourth centuries BCE and could easily be linked to those of Hajar ibn Humayd (tenth to seventh century BCE). In particular, the deepest levels (V–IIc), which correspond to levels R–N of Hajar ibn Humayd, appear to belong to the period preceding the monumental inscriptions.

The publication in 1989 of the results of excavations at Yala/al-Durayb definitively confirmed this hypothesis. The Italian Archaeological Mission had discovered this important city in 1985 in a still-unexplored area southwest of Marib (eastern Khawlan), and with it an entire series of associated monuments—workshops, hydraulic installations, fortifications, sanctuaries, villas—which made it possible to reconstruct, for the first time and in exhaustive detail, the life of a Sabaean community of the archaic period. The significance of these finds was increased by the discovery in a neighboring wadi of an impressive group of royal inscriptions, which could be shown to be contemporaneous with the Yala complex. Surface survey of the area indicated that this large fortified city, identified with ancient Hafar, was abandoned at a rather early date, around 600 BCE, and not reoccupied, permitting the archaeologists to explore exclusively the ancient levels.

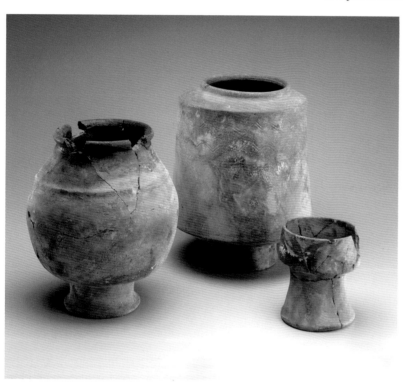

FIG 2 VESSELS. HAJAR IBN HUMAYD, STRATA R, M, AND N, END 2ND MILLENNI-UM BCE/LATE 8TH–LATE 6TH CENTURY BCE. CERAMIC; H 29.5  D MAX 31; H 36.7 D 18; H 17  D 14.4 CM. THE AMERICAN FOUNDATION FOR THE STUDY OF MAN, H 2885, H 2188, H 2130

Excavations carried out in 1987 in the interior of the fortified enclosure, in the city's western sector, proved decisive, yielding for the first time precise chronological evidence in deep stratification. Archaeologists uncovered the complete plan of a stone building comprising six rooms ("House A"), which opened onto a street and in which the presence of a staircase, also made of stone, indicated a second story. Clear traces of burning and collapse indicate that this building was violently destroyed, an event most probably connected with the city's abandonment. In addition to interesting domestic architecture, the investigations also produced a complete household inventory of ceramics and objects, which could be dated to the eighth to seventh centuries BCE through radiocarbon analysis of wood charcoal samples. But the most interesting evidence of all came from exploration of the underlying stratification. The removal of paving stones in the building (level A) showed that it had been preceded by two other building phases (levels B and C), which could be dated through radiocarbon analysis between the twelfth and ninth centuries BCE.

On typological grounds, the ceramics recovered from "House A" at Yala could be linked to those from levels N to K at Hajar ibn Humayd. This confirmed, on the one hand, the correctness of the stratigraphic scheme of the site excavated by the Americans and, on the other, the true age of the deepest levels of Yala. Except for a cult tablet made of baked clay, whose unique figural deco-

ration places it in the earliest phase of the history of South Arabian art, the other objects excavated offered no special artistic merit (grinding stones, pestles, fragments of bronze and iron, fragments of alabaster vessels, shells, animal bones). Nevertheless, a comparative analysis of various classes of artifacts in their architectural context proved of exceptional interest, providing the first clear impression of daily life in a South Arabian community of the archaic period. But the most important (and least anticipated) discovery consisted of brief inscriptions in South Arabian script, incised on the walls of several ceramic vessels (FIG. 4). These comprise the oldest examples of writing thus far discovered in South Arabia; found both in levels A and B, they push back the inception of this writing system before the tenth or ninth century BCE. They consist, essentially, of personal names—probably the owners of the vessels—which are known not only in Sabaean onomastics but also (and sometimes only) in that of northern Arabia. The ethnic identity of the ancient inhabitants of Yala has thus become a controversial issue, at the same time complicating the problem of the origins of Yemen's population in the protohistoric period.

It must be noted, however, that the excavations at Yala have demonstrated a marked cultural continuity throughout the stratified sequence. This could suggest that there was no decisive change in the ethnic character of the inhabitants prior to the city's destruction around 600 BCE. A stone boustrophedon inscription discovered on the surface of the site yielded, among other names, that of the ancient city, Hafar. Written in Sabaean dialect, it seems to confirm the character of the local ethnic population in the seventh century BCE. The rock inscriptions already mentioned, found not far away in the Shib al-Aql and also written in Sabaean dialect, invoke the ritual of the famous sacred hunt by Yathiamar Bayan, son of Sumhualay, and Karibil Watar, son of Dhamarali, both of whom held the title of *mukarrib* (federator) of Saba. Further supporting the Sabaean character of the archaic period, at least in this western region of the Ramlat as-Sabatayn desert, is the fact that all of the oldest inscriptions thus far recovered in this area are Sabaean. Their degree of sophistication, on both stylistic and formal levels, would seem to presuppose a rather lengthy period of development.

In the region east of the desert, the course of development appears to have been rather different. Here, too, the excavations conducted by the Russian Archaeological Mission beginning in 1983 in the region of ancient Raybun in the Wadi Doan (a branch of the right bank of the Wadi Hadramawt) exposed levels dating to the end of the second and the beginning of the first millennium BCE. The pottery of these early levels differed markedly from the South Arabian tradition; its closest parallels occur in the pottery of southern Palestine and northwest Arabia from the thirteenth to twelfth centuries BCE (FIG. 5). Consequently, the Russian archaeologists proposed a northwestern source for these first inhabitants of the Hadramawt; taking into account their knowledge of South Arabian writing, they speak of an "ancient Hadrami culture."

FIG 3 VESSELS. HAJAR IBN HUMAYD, STRATUM N, STRATUM M–N, LATE 8TH–LATE 6TH CENTURY BCE. CERAMIC; H 7.1-7.4 D MAX 9; H 12 D MAX 9; H 9.2 D MAX 12.1; H 7.1-7.3 D MAX 8.8-9 CM; THE AMERICAN FOUNDATION FOR THE STUDY OF MAN, H 2070, H 2069, H 2064, H 2066

Toward the end of the eighth century BCE, the pottery changed and became similar to that of Yala and other western sites. The appearance of lapidary inscriptions with linguistic characteristics of Sabaean type, including dedications to divinities such as Almaqah, the supreme god of the Sabaeans, leaves no doubt about the identity of some of the newcomers. Their arrival in this region correlates with the powerful hegemony that the kingdom of Saba seems to have exercised during this period in southern Arabia and on the high plateaus of Ethiopia (Tigray). The Russian archaeologists baptized this new culture, created from the ancient Hadrami substrate and Sabaean contributions, the "classical Hadrami culture."

The fieldwork of the French mission at Shabwa carried out from 1976 to 1981 also seems to confirm the existence of a "non-Sabaean" protohistory in the Hadramawt dating roughly between 1200 and 700 BCE. The excavation report, published in 1992, established that the pottery that came to light in the lowest levels (I to III) resembled that of Late Bronze Age Palestine (level I of Shabwa seems to go back to the fifteenth century BCE).

There was thus no single, homogeneous culture at the dawn of history in southern Arabia. On the one hand, we have a distinctively South Arabian culture that we could call "proto-Sabaean," which extended along the edge of Yemen's western desert and, as the recent British excavations in the Wadi Siham demonstrate, on the high plateaus of northern Yemen. On the other hand, a culture of the Palestinian tradition, which we could designate "proto-Hadrami," developed in the eastern regions. On one issue there can be no doubt, given the current state of our knowledge: the area that would later become the kingdom of Saba was certainly the cradle of South Arabian (Sabaean) culture. It seems logical to place the inception of this culture around 1200 BCE, when the Yemeni Bronze Age came to an end, in light of the stratigraphic evidence from Yala as well as the general diffusion, beginning around this date, of the Iron Age pottery known as "Aramaean."

FIG 4 INSCRIBED SHERDS. YALA/AL-DURAYB, 12TH–9TH CENTURY BCE. CERAMIC; H 9.5 D 5.4; H 12 D 10.5 TH 1.7 CM. SANAA, NATIONAL MUSEUM, YM 6112, YM 6117

FIG 5 DECORATED SHERDS. RAYBUN, 13TH/12TH–LATE 8TH–EARLY 7TH CENTURY BCE. CERAMIC; H 25 (MAX) L 12 CM (MAX). SAYUN MUSEUM, SM 2531, 2570

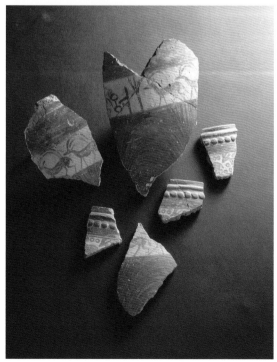

CHRISTIAN ROBIN

# Saba and the Sabaeans

The name of Saba enjoys remarkable fame. In countries of Judeo-Christian or Muslim culture, there is an immediate association with an exotic and mysterious queen, evoked both in the Bible and the Quran. Saba is not a mythical location, as a kingdom with this name really did exist in ancient Yemen. Here is an opportunity to put forward what is known about this mysterious kingdom and to consider the reasons for its fame.

## THE REDISCOVERY OF HISTORICAL SABA

Thousands of texts inscribed in stone or on wood or cast in bronze and discovered at archaeological sites throughout Yemen indicate that ancient South Arabia was divided into a number of kingdoms. Saba was the most important of these. European scholars derived the terms "Sabaean" and "Sabaeans" from the name Saba to describe the language and the inhabitants of the kingdom.[1]

At the heart of the Sabaean territory was the Wadi Dhana, a watercourse that flows from the Yemeni highlands towards the desert interior, where it vanishes into the sands of the Ramlat as-Sabatayn. Marib was the capital of this kingdom and was situated at the precise point where the wadi emerges from the mountains, a location that was particularly favorable for developing oasis agriculture. Each spring and summer, torrential rains over the mountains filled the wadis with runoff. The torrent slowed after emerging from the mountains and could, with a certain amount of organization, be directed into irrigation channels. The soil was easily prepared for the cultivation of crops, as it was relatively flat and lacked natural vegetation because of the dry climate. The territory of Saba initially comprised the region of Marib, but during the reign of its most famous ruler, Karibil Watar, son of Dhamarali, or Karibil the Great (circa 700–680 BCE), the territory was expanded to include a large part of southwest Arabia

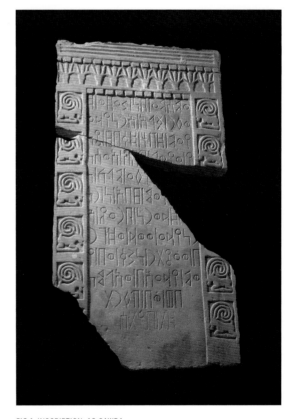

FIG 1 INSCRIPTION. AS-SAWDA (ANCIENT NASHAN), TEMPLE OF THE GOD ARANYADA. ALABASTER; TOTAL H 128 W 63 TH 8 CM. SANAA, NATIONAL MUSEUM YM 11126, 11192. THE TEXT DESCRIBES A WAR IN WHICH THE SABAEAN *MUKARRIB* KARIBIL THE GREAT DESTROYED THE KINGDOM OF AWSAN IN CIRCA 700 BCE.

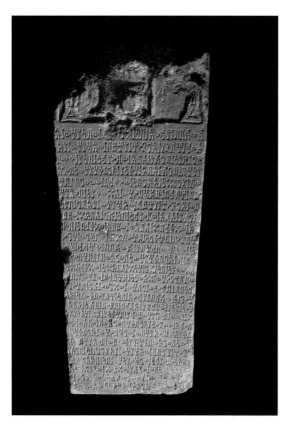

**FIG 2** INSCRIBED STELA. MARIB, MID-3RD CENTURY CE. LIMESTONE; H 62 W 23 CM. BAYHAN MUSEUM, BAM 1. THE TEXT'S AUTHOR DEDICATED VALUABLE OBJECTS TO THE GOD ALMAQAH FOLLOWING A BATTLE BETWEEN SABA AND HIMYAR, BOTH OF WHICH CLAIMED VICTORY.

(FIG. 1). Later, the territory was restricted to the regions of Marib and Sanaa, the secondary capital founded in the first century CE.

The kingdom of Saba existed from the beginning of South Arabian civilization. The oldest stone inscriptions, which date to the eighth century BCE, already refer to it in the form of royal titles such as the "*mukarrib* of Saba"; hence this period is also known as the "*mukarrib* period." The title *mukarrib*, or federator, was more prestigious than that of "king" and seems to have been reserved for sovereigns who exercised a certain hegemony over other tribes or kingdoms. The term continued to be used until the beginning of the first century CE. These first texts are very short and commemorate the dedication of religious offerings or the building of walls or other constructions, whereas earlier inscriptions are limited to single words incised or painted on pottery that were apparently used to identify the contents, the owners, or the destinations and reveal at best very little about tribal affiliations or dialect.

Thus, what is known about the history of the kingdom of Saba is based on the archaeological remains and thousands of inscriptions that date from between the eighth century BCE and 275 CE, the latter being the approximate date when Saba was annexed by its neighboring kingdom of Himyar (FIG. 2). There are two sorts of inscriptions. The first type are primarily carefully executed texts, indelibly inscribed in stone or cast in bronze, which were designed to be on public display. The overwhelming majority of these texts commemorate the performance of rituals (to remind the deities about the merits of the donor) and the realization of works (to establish property rights); several outline particular laws, rules, or bans. The second type comprises texts in cursive script, incised on wooden sticks or palm branches and primarily used to record correspondence and personal contracts. The use of language, the particular gods that are invoked, the tribes and locations that are mentioned, the rituals, and the calendar of events identify a Sabaean text. However, the language itself is not sufficient to establish whether a South Arabian inscription is Sabaean, as the kingdom of Himyar also used this language between 110 BCE and 570 CE.

These local sources are complemented by a few references to Saba in the Bible and in Assyrian documents and more substantial texts about Arabia by certain classical authors. Used together, these allow a reconstruction of the outline of the history of Saba that can be divided into two broad periods.[2] The first period—the "mukarribate"—lasted from the eighth to the first centuries BCE and was dominated by a caravan economy with links to the markets of the Near East, mostly at Khindanu on the Middle Euphrates (ninth to eighth centuries BCE), later at Gaza during the Persian period, and then finally at Petra during the Hellenistic period. Saba was a theocratic monarchy held together by the common cult of the god Almaqah, who was offered special tribute during a pilgrimage in July. The Sabaeans also venerated four other deities: the gods Athtar and Hawbas and the goddesses dhat-Himyam and dhat-Badanum. Important resources were derived from aromatics gathered in the deserts of southern Arabia, such as frankincense, which was largely grown in the Hadramawt, and myrrh, as well as valuable commodities from India and Africa, such as ivory, tortoiseshell, and precious woods, for which Saba acted as the intermediary in the overland trade.

The chronology of this period is still under discussion. Many South Arabian inscriptions cannot be closely dated as they mention people whose identities are obscure or they fail to cite any externally datable events. In addition, although many sovereigns are known, their relative and absolute chronology still remains elusive. This is largely because it is difficult to distinguish a *mukarrib*, or king, by his homonyms. Until around the end of the first century CE, all the Sabaean rulers bore titles consisting of a name followed by an epithet, each chosen from six and four possible alternatives. The names included Dhamarali, Karibil, Sumhualay, Yadail, Yakrubmalik, and Yathiamar, and the epithets included Bayan, Dharih, Watar, and Yanuf. Furthermore, the archaeological chronology is also uncertain, as the dates mostly rest on stylistic analysis of the inscriptions—a study known as paleography—and the results are usually only approximate.

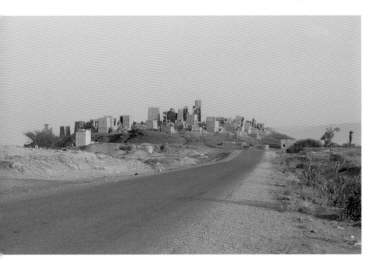 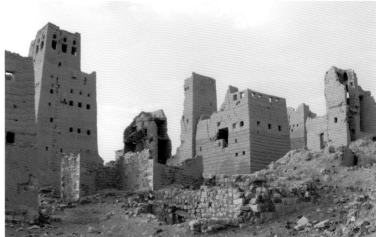

FIG 3 VIEWS OF MARIB, CAPITAL OF SABA

The first Sabaean period came to a brutal end when Rome, which had conquered Syria in 63 BCE and then Cleopatra's Egypt in 30 BCE, diverted the lucrative overland trade network from the kingdom of Saba. Rome even attempted to conquer southern Arabia by sending an expedition from the north in the form of two legions plus auxiliary troops, including a thousand Nabataean camel riders and five hundred Jewish archers, under the command of the Egyptian prefect Aelius Gallus. Marib was besieged in circa 26–25 BCE, but owing to sickness and heat exhaustion the Roman army retreated after only a week.[3] Then from the south the Romans took control of the naval intermediaries between Egypt and India, redirecting the overland aromatics trade to maritime routes, despite the unfavorable winds. The port chosen for the collection of the South Arabian commodities was Qani in the Hadramawt, far from the Sabaean territory.[4] These events severely weakened the kingdom of Saba, and its vulnerability provoked a major dynastic change, with the accession of Himyar to the Sabaean throne.

The second Sabaean period, from the first to the third centuries CE, was marked by a shift in the balance of power, during which the highland tribes usurped the inhabitants of the oasis on the desert margin. The Himyarite kings exercised power for a century from Raydan, the citadel of the city of Zafar, and

took the title "king of Saba" and dhu-Raydan with the word "Saba" used first in order to underline the legitimacy of their claim to the Sabaean throne. Saba liberated itself between circa 100 and 275 CE, the period during which Himyar and Saba had sovereigns that each carried the title "king of Saba and dhu-Raydan," and after 275 was subsequently reincorporated under Himyarite control. The chronology is relatively certain and precise for this second period. Some inscriptions are dated according to eras for which the approximate dates are known. The general order of the kings of this period has been established with the aid of numerous texts that highlight the major events of each reign, and the homonyms become rare with the appearance of new names. Thus, often the margin of error is less than a decade compared to the first period, when the error is often in the order of a century.

THE ARCHAEOLOGICAL SEARCH FOR SABA

The kingdom of Saba was discovered in the middle of the nineteenth century during the expedition of the French pharmacist Thomas Joseph Arnaud. Having served the Egyptian regiment in Arabia, and then the imam in Sanaa, Arnaud was persuaded by the French consul at Jeddah to return to Yemen in order to study the South Arabian inscriptions. Arnaud arrived at Sanaa on 9 July, 1843, and through his connections was able to join a caravan that was traveling to the east on 12 July. He returned to Sanaa on 25 July, having visited the ancient monuments of Marib, notably the dam, the great temple of Almaqah, and the ruins at Sirwah. Arnaud managed to copy a total of fifty-six inscriptions.[5]

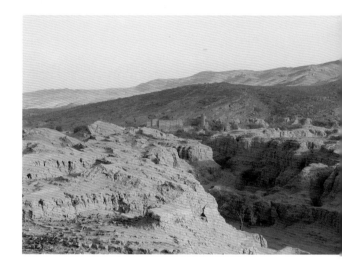

Thereafter, the archaeological exploration of Saba was renewed by an expedition led by Joseph Halévy (1827–1917) and organized under the auspices of the Académie des Inscriptions et Belles-Lettres of Paris. Halévy undertook a long and dangerous voyage through eastern Yemen, which took him to the Jawf, Najran, and Marib. He discovered numerous archaeological sites and copied 686 inscriptions, the publication and study of which marked the true beginning of South Arabian studies. Halévy was accompanied on his voyage by Hayyim Habshush, a Jewish resident of Sanaa, who was never mentioned by name in the reports. Hayyim Habshush later made himself known by producing his own version of the expedition, in which he claimed credit for the mission's success.[6]

A third explorer, the Austrian Eduard Glaser (1855–1908), also played an important role in the advance of Sabaean studies. Glaser made four missions to Yemen from 1882 to 1894, during the Ottoman occupation of the country. This explorer and scholar produced extraordinary results in a number of fields, especially in epigraphy, archaeology, ethnography, cartography, and astrology.[7] Glaser visited the regions north of Sanaa and traveled to Marib disguised as a Muslim doctor of religious science, under the name of faqih Husayn, son of Abd Allah al-Biraqi from Prague.

The first archaeological excavation in Yemen took place in 1927–28, when the explorer Carl Rathjens and geographer Hermann von Wissmann uncovered the small temple at al-Huqqa, twenty-three kilometers north-northwest of

Sanaa.[8] The second archaeological excavation was conducted in 1937–38 by the British archaeologist Gertrude Caton-Thompson at the Sayin temple at Huraydah, in association with geologist Elinor Gardner and the famous explorer Freya Stark (1893–1993).[9] No excavations were conducted at Marib itself until the winter of 1951–52, when the American Foundation for the Study of Man (AFSM), led by its director and founder, Wendell Phillips, excavated the peristyle hall of the Mahram Bilqis; however, this mission was unfortunately curtailed because of insecurity in the region.[10]

It was not until the 1970s, with the end of the civil war in North Yemen (1962–68), that Sabaean archaeology began again in earnest. The research was initially in the form of surveys that were undertaken by Soviet (1969–71), French (1971–), and German archaeologists (1971–). The Americans and Italians exca-

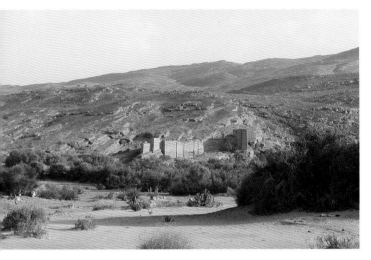

FIG 4 VIEWS OF THE GREAT DAM AT MARIB

vated the first archaeological soundings; large-scale excavations that took place at Marib and Sirwah were commenced in the 1980s by the German Archaeological Institute in Sanaa (DAI).[11]

## THE EVIDENCE FOR SABA

The archaeological remains at Marib, which is first called Maryab in the inscriptions and was only known as Marib from the end of the second century CE, Sirwah, and in the Jawf are very important in the understanding of the Sabaean kingdom. Marib was by far the largest ancient city in southern Arabia—indeed, possibly the only real city—with a stone enclosure wall that contained an area of some 110 to 120 hectares (FIG. 3).[12] Outside the perimeter of the city were two gardens, an irrigation system including the enormous Marib dam, sluices, and canals, and two temples dedicated to the Sabaean national deity Almaqah. Many other structures are mentioned in the inscriptions, such as the royal palace of Saba and a sixth-century church, but these have not yet been discovered.

The most famous monument at Marib is undoubtedly the Great Dam on the Wadi Dhana, seven kilometers upstream from the city (FIG. 4). This construction made it possible to irrigate up to ten thousand hectares. In its final stage,

which dated to the fifth to sixth century CE, this dam consisted of a thick mud-brick retaining wall measuring 650 meters long and 15 meters high, with two stone sluices anchored in the bedrock on the north and south banks. The inscriptions, dating between the mid-fourth century CE and 558 CE, mention a series of four repairs to the dam, which was finally destroyed between 558 and the death of Muhammad in 632 CE, according to the Quran (34: 15–16). Marib had played a central role in the history of southern Arabia for as long as the Sabaean kingdom remained independent, which was until around 275 CE. The city then came under Himyarite control and rapidly declined. The pagan temples were abandoned in the third quarter of the fourth century, when the Himyarite dynasty converted to Judaism.

The most spectacular monument at the walled city of Sirwah, thirty-five kilometers west of Marib, is a temple dedicated to "Almaqah master of the Ibex." The temple enclosure wall is semioval in plan and is almost entirely intact. Long inscriptions describing the achievements of Karibil the Great (or Karibil Watar, son of Dhamarali) were discovered inside the temple, which has now been excavated by the German Archaeological Institute. Some eight kilometers northeast of Sirwah are the calcite-alabaster mines of al-Makhdara, where huge quantities of rock have been quarried from the mountain.

In the Jawf—a vast tectonic fault to the west-northwest of Marib—a number of towns were Sabaean throughout all or most of their history. These are characterized by their remarkable enclosure walls and extramural temples. The enclosed areas are relatively modest and measure some fifteen hectares at the most. A sanctuary site consisting of several religious complexes lies in the foothills and slopes of Jabal al-Lawdh and marks the northern limit of the Sabaean territory during the late period.

The highlands around Sanaa were Sabaean from their origin, but the regions have very few remains because, as they have always been occupied, the ancient structures have been destroyed through reuse of building materials. The principal Sabaean monument in Sanaa was the Ghumdan palace, the earliest reference to which dates to the beginning of the third century CE. The number of floors, the richness of its decoration, and the clepsydra (water clock) were celebrated by poets.[13]

> Foremost among the palaces of Yemen and having the most remarkable history and the most widespread reputation is Ghumdan....
> Ghumdan was twenty stories high, one on top of the other....
> At each of the palace's four corners stood a copper statue of a lion.
> These were hollow so that whenever the wind blew through them
> a voice similar to the actual roaring of lions would be heard.
>
> —AL-HAMDANI 8.5, 15, 22-5

Ghumdan, probably situated north of the Grand Mosque, was destroyed under the caliph Uthman (644–56 CE).

## THE SABAEAN MODEL
Saba occupied a special place in South Arabian civilization. Sabaean remains

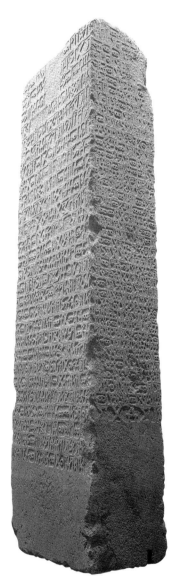

FIG 5 STELA OF ABRAHA. MARIB, 549 CE. LIMESTONE; H 250 W 66 TH 40 CM. MARIB MUSEUM, BAR 2. THE INSCRIPTION DESCRIBES ABRAHA'S REPAIRS TO THE GREAT DAM AT MARIB AND THE FOREIGN EMBASSIES HE RECEIVED AT HIS COURT, INCLUDING THE BYZANTINES AND SASANIANS.

are without doubt more numerous and of a better quality relative to those of other kingdoms, but this is not the only reason for the kingdom's fame. A number of factors underline the important role that Saba played. The first clue is that the most ancient South Arabian inscriptions come from Marib or sites in the surrounding area. The second indication rests in the fact that the Sabaean onomastics were used throughout southern Arabia. Sabaean was the only language used in southern Arabian nomenclature, particularly in the case of personal names including a possessive pronoun or a factitive verb, which are grammatical forms that are presented differently in Sabaean compared to Minaean, Qatabanian, or Hadrami, the other main South Arabian languages. A third clue is found in the language of the most ancient inscriptions from Qataban and the Hadramawt, which use verbal and pronominal forms borrowed from Sabaean inscriptions, indicating that Sabaean served as the basis for the formulation of these documents.

Saba not only acted as the model for writing, nomenclature, and language, but the kingdom also strongly influenced the architecture of the entire region. The same architectural forms are found throughout South Arabia: palaces, city enclosure walls, and private houses of a certain date present only very minor variations in appearance and structure, and polygonal columns, square capitals with denticular and incised decoration, and marginally drafted and pecked limestone masonry were popular everywhere. The iconographic and decorative repertoire also provides a good example of Sabaean influence: the same motifs of the ibex, crescent moon and star, and dentils were widely used.

There is no doubt that the ancient South Arabians, as well as the first Abyssinian kingdoms, considered Saba to be the birthplace of South Arabian civilization. The name of Saba was a source of legitimacy and prestige. There is a perfect example from Himyarite history of the esteem in which Saba was held. When Himyar first separated from Qataban in circa 110 BCE, the tribe rejected Qatabanian and adopted the Sabaean language (which was different from Himyarite). Still more astonishing was the fact that the kings of Himyar placed Saba at the beginning of their royal titles, before dhu-Raydan, the dynastic palace of the Himyarites. The last Himyarite kings, who ruled in the fifth and sixth centuries CE, did their utmost to preserve the city of Marib, the capital of Saba, from decline and abandonment by maintaining the Great Dam and the irrigation network, despite terrific difficulty, revolt, and disease, as recorded on the stela of Abraha (FIG. 5).[14] Neighboring Arab tribes from the desert also held Saba in the same regard.

Having discussed the evidence for a Sabaean origin of South Arabian civilization, it is important to consider how cultural unification came about in ancient southern Arabia. Initially there was a tension between the diverse political, social, cultural, and linguistic systems on the one hand and an imitation of the Sabaean model on the other, whereas the earliest South Arabian inscriptions demonstrate that there were a number of South Arabian states of greatly varying size, with their own institutions, divine panthea, calendars, and individual languages. Nevertheless, unity could be seen through some shared traits, such as the use of the same script, iconography, and architectural styles as well as the

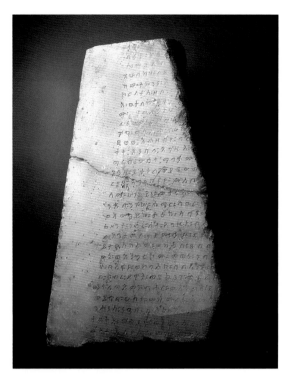

FIG 6 STELA WITH ETHIOPIAN INSCRIPTION. MARIB, 530 CE. ALABASTER; H 70 W 41 TH 10 CM. SANAA, NATIONAL MUSEUM YM 1049. WRITTEN IN OLD ETHIOPIAN LANGUAGE AND SCRIPT, THIS FRAGMENT REFERS TO THE ABYSSINIAN INVASION OF YEMEN IN 525 OR 529/30, WHICH DEPOSED THE REIGNING KING.

same typology and phraseology for similar inscriptions.

Between the eighth century BCE and the beginning of the common era, the South Arabian kingdoms were inclined to affirm their own particular idiosyncrasies. Qataban, for example, developed an original type of elegantly styled calcite-alabaster statuary. With the emergence of Himyar (circa 110 BCE), followed by the disappearance of the kingdoms of Main (around the end of the first century BCE) and Qataban (circa 175 CE), this tendency was radically reversed and South Arabia began to unify. The principal reason for this change was the rise to power of Himyar, which annexed vast territories and unified the whole of South Arabia in circa 290 CE. Political unity was accompanied by the use of a single calendar and administrative language, henceforth Sabaean. As it was extremely difficult to cultivate a common faith on the remains of paganism, the Himyarite dynasty chose a new religion. The kings as individuals adopted Judaism and chose a more toned-down version of monotheism for the state religion in the years following 384 CE. Greater contacts with the outer world resulted in the rapid increase in Hellenistic-Roman influence in art and architecture, which also acted to unify the region culturally.

At the same time, the individual became as important as the clan or tribe, a fact witnessed by the increasingly personal contents of the dedicatory inscriptions. In the political domain the nature of power was radically modified. The South Arabian kingdoms in the ancient period based their collective identity on their allegiance to a great deity and in the practice of communal rituals. After the ascendance of Himyar, the cement that bound the political entities was no longer the sharing of a small number of religious practices but the allegiance to a prince. The perception of time was even modified, and a new linear system was slowly imposed, beginning with the appearance of three eras with the years counted from a chosen point in time.

By the fifth century CE Yemen had every sign of a true nation with a strong central power, a unified language (Sabaean) and writing system (South Arabian), a common artistic expression, and a dominant religion (Judaism, largely practiced by the ruling classes) after some fourteen hundred years of historical development. The political unification and cultural homogeneity under the Himyarites was without doubt not as deep-rooted as the ruling classes would have wished, as was generally the case in the empires of late antiquity. Failure began to loom large on the horizon. An ecological crisis devastated the irrigation agriculture on the plain. In order to involve Himyar in its war against the Persians, Byzantium encouraged proselytizing Christians, who managed to divide the country and provoke a victorious military intervention from Abyssinia in circa 525–30 CE (FIG. 6). These wars and the great epidemic of the years 547–48 CE decimated the Himyarite population. The Himyarites, having liberated themselves from the Abyssinians only to fall under the control of the Sasanian empire in circa 570 CE, found their kingdom divided into small principalities. The collapse of the Himyar regime had significant consequences: without it, the foundation, by Muhammad, of the first Islamic state at al-Madina in 622 CE would not have been possible.

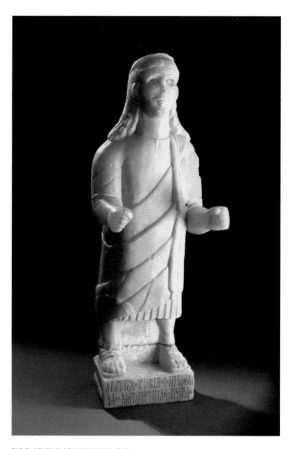

FIG 7 STATUE OF YASUDUQIL FAR SHARAHAT, KING OF AWSAN. WADI MARKHA, 1ST CENTURY CE. ALABASTER; H 70 W 28 TH 19 CM. ADEN, NATIONAL MUSEUM, NAM 609

## THE ORIGINS OF SABA

As previously discussed, Saba seems to have been the birthplace of the South Arabian civilization, but this is not to say that the Sabaean architectural style, writing, and iconographic repertoire were developed in cultural isolation. Saba was partly indebted to its Egyptian and Near Eastern neighbors for its inspiration. There is no doubt, for instance, that South Arabian writing was derived from the consonant-based writing of the Near East, of which proto-Sinaitic and Ugaritic are two different examples. The carving and working of stone was doubtless influenced by techniques developed in Egypt.

The methods of cultural and technological transfer that operated from the Near East toward the southern Arabian Peninsula are not well known. Long-distance commercial exchange probably developed from a very early date. The first products that were exchanged were metals, precious stones, and all sorts of rare commodities, including aromatic gums and resins, which the Egyptians (from the third millennium BCE) and then the Near Easterners and Greeks (from the first centuries of the first millennium BCE) used in cultic and funerary rituals, perfumes, and pharmaceuticals. The commerce was initially a "down-the-line" system, without the producers or consumers ever meeting, but very quickly the lure of profit would have brought certain enterprising individuals into direct contact. The use of the camel as a beast of burden, from the beginning of the first millennium BCE, would have permitted the regular transport of aromatic products from southern Arabia to the Near East. Perhaps the earliest mention of the Sabaeans and long-distance camel caravan trade in historical texts may be dated to the middle of the eighth century BCE. This Assyrian text describes the seizure of a caravan by the governor of Sukhu and Mari near the city of Khindanu on the Middle Euphrates. The caravan was accompanied by a hundred people from Tayma (located in northwest Arabia) and Saba and consisted of two hundred camels carrying myrrh, wool, iron, alabaster, and blue- or purple-dyed cloth. The caravan was apprehended for the nonpayment of tolls as they traveled homeward. The text lists some of the commodities that may have been traded in exchange for southern Arabian products.[15]

This document, as well as other Assyrian texts from the same period and the references to Saba in the Bible, shows that an important trade network developed under Sabaean control. This trade certainly put Sabaean merchants in contact with the people of the Near East, and they doubtless became the means by which cultural and technological influences spread from the north to the south. The first use of the camel as a beast of burden and the appearance of writing and monumental stone buildings in southern Arabia are loosely synchronized, but that is not to say that Saba suddenly appeared in the eighth century BCE. The

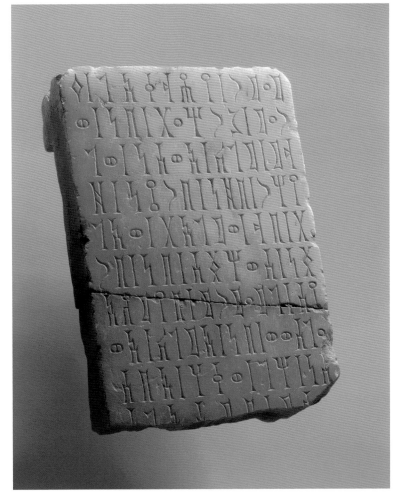

FIG 8 FUNERARY STELA OF YASUDUQIL FAR SHARAHAT, KING OF AWSAN. WADI MARKHA, 1ST CENTURY CE. ALABASTER, H 41 W 21 TH 6.5 CM. ADEN, NATIONAL MUSEUM, NAM 601

kingdom had a long evolution; irrigation agriculture may have been practiced as early as the third millennium BCE in the oasis of Marib.

The prestige of Saba in South Arabia was no doubt linked to its central role in the beginning of South Arabian civilization. It was also the result of the political supremacy that Saba achieved towards the end of the eighth century BCE. The prime mover in the increase of Sabaean power was the previously mentioned *mukarrib* Karibil the Great. In eight military campaigns, Karibil the Great not only annihilated the rival kingdom of Awsan but also successfully conquered the whole of western Yemen and imposed his supremacy over the remaining independent kingdoms, notably Qataban and the Hadramawt (FIGS. 7–8). An offering made in his name in Mesopotamia permits the dating of his reign to the end of the eighth and the beginning of the seventh century BCE.[16]

FIG 9 SIRWAH, ALMAQAH TEMPLE, LIMESTONE INSCRIPTION OF THE SABAEAN RULER KARIBIL WATAR (CIRCA 685 BCE)

The exploits of Karibil the Great are known thanks to a detailed account of his reign engraved on two superimposed seven-meter-long limestone blocks (FIG. 9). The inscriptions were carved towards the end of his life and were placed in the center of the sanctuary at Sirwah.[17] After Karibil, Saba maintained its hegemony for more than a century, until the emergence of the Qatabanian power.

## THE PARADOX OF THE FAME OF SABA

Curiously, the fame of Saba was never based on the reasons discussed above but instead on fables and stories. Saba gradually became known through Greek and Roman authors, who referred to the southern half of the Arabian Peninsula as "happy Arabia." These authors circulated extravagant tales about the prosperity and luxurious lifestyle of the South Arabians. The poet Horace echoed this idyllic image: "With desire today for the fortunate treasures of the Arabs, you prepare a harsh campaign against the kings of the Sabaean land, still ignorant of defeat."[18]

The fame of Saba was mostly derived from the Bible. According to the First Book of Kings (10:1–13), an anonymous queen of Saba arrived in Jerusalem to visit King Solomon, who is traditionally dated to the tenth century BCE.[19] Having heard about the fame of Solomon, the queen wanted to confirm for herself whether the king was as wise and his kingdom as flourishing as was rumored. The biblical author reported that the queen arrived with a great camel caravan laden with quantities of aromatics, 120 talents of gold, and precious stones, and left enlightened. This story was intended to give the reign of King Solomon the aura of a golden age, a propaganda tool that was used with considerable success. The story lent itself particularly well to anecdotal expansion and permitted the Abyssinians to establish a link with the kingdom of Israel.

The story of the queen of Saba is also recounted in the Quran. Curiously enough, this rendition depends entirely on the biblical story and Jewish ampli-

fications and does not contain any additional information drawn from local Arab sources. The Arab Islamic traditions that relate to pre-Islamic Arabia confirm that from the beginning of Islam, the memory of Saba was almost completely erased. It only took a few decades for the people of southern Arabia to forget what the title "king of Saba" signified, a title that had been used by the Abyssinian kings of Yemen as late as the year 560.

**ENDNOTES**

1 BEESTON 1995; BRIEND 1996.

2 THERE HAS BEEN CONSIDERABLE DISCUSSION IN EARLIER LITERATURE OVER THE ABSOLUTE CHRONOLOGY OF SOUTHERN ARABIA, SPECIFICALLY OVER THE MERITS OF THE SO-CALLED "LONG" (ACCEPTED BY MOST SCHOLARS TODAY) AND "SHORT" CHRONOLOGIES (THE LATTER CHAMPIONED BY THE LATE J. PIRENNE); SEE ROBIN AND VOGT EDS. 1997, 228–29, 240; SCHIPPMANN 2001, 35–48.

3 STRABO, GEOGRAPHY, XVI, 4, 24. THIS EVENT IS ATTRIBUTED TO 25/24 BCE BY SOME OTHER MODERN AUTHORS; SEE YOUNG 2001, 100–103, FOR A CRITICAL VIEW OF THE MOTIVES BEHIND THE EXPEDITION.

4 PERIPLUS (CASSON 1989, 27–28); SEDOV 1997; YOUNG 2001.

5 ARNAUD 1845; PIRENNE 1958, 275–90.

6 GOITEIN ED. 1941; HALÉVY 1872, 1873, 1877.

7 GLASER 1913; DOSTAL 1990, 1993.

8 RATHJENS AND VON WISSMANN 1932.

9 CATON-THOMPSON 1944.

10 PHILLIPS 1955.

11 THE HISTORY OF RESEARCH AND FIELDWORK IN THIS REGION IS ALSO SUMMARIZED BY DE MAIGRET (2002) AND SCHIPPMANN (2001), AND MANY OF THE LATEST RESULTS ARE DISCUSSED IN ESSAYS PUBLISHED IN THE CATALOGUES EDITED BY ROBIN AND VOGT (1997) AND SEIPEL (1998).

12 MÜLLER 1991; SEE ALSO SIMPSON ED. 2002, CHAPTERS 5 AND 9, FOR COMPARATIVE CITY SIZES. ALTHOUGH BEESTON (1970) ARGUED THAT THERE WERE NO TRUE CITIES IN SOUTHERN ARABIA, THE PRESENCE OF MAJOR MONUMENTAL BUILDINGS AND THEIR RELATIVE SIZE COMPARED TO RURAL SETTLEMENTS SUGGEST OTHERWISE.

13 AL-HAMDANI 1938; SEE PIOTROVSKY 1988.

14 BEAUCAMP, BRIQUEL-CHATONNET, AND ROBIN 1999-2000.

15 SUKHU; SEE LIVERANI 1992.

16 GALTER 1993.

17 RES 3945–6.

18 CUVIGNY 1997 (SHORTENED VERSION; FOR A LENGTHIER VERSION, SEE SEIPEL ED. 1998); CALVET AND ROBIN ET AL. 1997, 42–47.

19 BRIEND 1996; SEE ALSO SIMPSON ED. 2002, CHAPTER 2.

ALESSANDRA AVANZINI

# The Hegemony of Qataban

The earliest reference to the kingdom of Qataban occurs in the great Sabaean inscription of Karibil Watar, datable to the beginning of the seventh century BCE. After describing the battle against one of his principal enemies, the kingdom of Awsan, Karibil reports that he dismembered the conquered territory to give to the kings of Hadramawt and Qataban, his allies. The kingdom of Qataban, like that of Hadramawt, is identified by the names of its principal deities, then by that of its king and his tribe. Other Qatabanian inscriptions contemporaneous with Karibil Watar's inscription now in the Bayhan Museum mention the king Warawil, although without his royal titulary (FIG. 1). Qataban is almost unknown to the Arab authors of the Islamic period, although it is true that the kingdom had disappeared more than four hundred years before the advent of Islam. Among the genealogies of the Yemeni historian al-Hamdani (893–971) there is only a single reference, with the vocalization Qutban, which seems to reflect the original form since it has a corresponding form in the work of the Roman author Pliny (the Gebbanitae, "Qatabanians"). The vocalization "Qataban" is based on one of the forms of the name in Greek (*Kattabaneis*). There is no trace of Qataban in the Arabic sources; the vocalization "Qataban" for the name of the tribe and the kingdom is purely conventional.

The direct documentary sources are exclusively epigraphic, and they constitute a relatively rich corpus with respect to geography, typology, and chronology. The inscriptions, which range in date from the seventh century BCE to the third century CE, are classified according to the traditional categories of ancient South Arabian epigraphy: dedications, building inscriptions, prescriptives, and the like. Some of those in the last-named group are of considerable interest, despite the difficulties they present for interpretation. For example, the decree establishing the regulations governing Tamna's market—including

FIG 1 INSCRIBED STATUE BASE MENTIONING THE FIRST KING OF QATABAN. TAMNA OR HAJAR IBN HUMAYD, CIRCA 700 BCE. LIMESTONE; H 24 L 25 CM. BAYHAN MUSEUM, BAM 36. THIS IS THE OLDEST PRESERVED INSCRIPTION FROM THE KINGDOM OF QATABAN.

references to taxes and the division of space into shops reserved for Qatabanians or foreigners—is virtually unique in the world. Other interesting inscriptions were also found on the city's gate. While reserving interpretation, the main theme of these inscriptions was apparently the king's need to reclaim certain privileges that had been clearly lost or vigorously challenged. The king sought to limit the tribes' legislative independence or strengthen his alliance with groups of priests. This latter group of inscriptions also furnishes some information on religious and political authority. Certain priestly responsibilities could, for example, be carried out by men or women of a tribe that exercised autonomous economic control over a region with respect to the central authority. The inscriptions from Tamna's necropolis—Hayd ibn Aqil, the principal pre-Islamic cemetery known from southern Arabia—are equally of great interest for onomastics and philology.

In fact, the majority of Qatabanian inscriptions come from the region of the Wadi Bayhan and the Wadi Harib. Archaeological investigations have yielded good results from the Wadi Bayhan, where the principal sites, although sacked, were not reoccupied after the fall of the kingdom of Qataban and thus were more readily accessible than in other regions of Yemen. An American expedition directed by Wendell Phillips conducted field-work in the Wadi Bayhan in the early 1950s, excavating at Hajar Khulan (the Tamna of the inscriptions) and at Hajar ibn Humayd (dhu-Ghayl), which furnished a complete stratigraphic sequence. In 1969, Gus van Beek published a report on the excavation as well as a detailed study of the pottery. The initial occupation of Hajar ibn

FIG 2 INSCRIPTION MENTIONING CONSTRUCTION OF A PALACE BY A QATABANIAN *MUKARRIB*. TAMNA, 3RD–2ND CENTURY BCE. GRANITE; H 50  W 106  TH 29 CM. BAYHAN MUSEUM, BAM 673

Humayd goes back to the eleventh century BCE, while the latest covers the period between the second and seventh centuries CE. The Americans also carried out an important study of the irrigation canals and hydraulic installations along the wadi. Wadi Bayhan and Wadi Harib were linked by an ancient road cut through the mountain; inscriptions carved on rocks in the vicinity of the mountain pass describe its construction.

The kingdom of Qataban, as well as its capital, was known by classical authors. Linked to the trade in incense, it was described in the texts with all the standard epithets expressing wealth. Thus, for example, in the Wadi Bayhan, where there are no sedimentary rocks, the alabaster and marble that were so abundantly used in building had to be imported. Indirect evidence also gives an idea of the kingdom's geographic extent. Citing Eratosthenes, Strabo mentions that the Qatabanian territory extended to the Red Sea straits, which direct sources confirm. The Roman author Pliny also frequently mentions the kingdom of Qataban, reporting the names of numerous cities of which the capital of the Gebbanites was Tamna. He also provides interesting information on commercial routes and merchandise exchanged. Pliny affirms, for example, that the rulers of Tamna maintained a monopoly on cinnamon and also imposed a tax on the myrrh harvested in Arabia and eastern Africa.

It is not easy to determine Qataban's exact boundaries. Qatabanian rule could be assumed in areas where inscriptions in the language have been attested, in keeping with a South Arabian cultural tradition of imposing the conquerors' language and religion on the defeated population. It is even more difficult to determine whether the presence of the cult of Qataban's chief god, Amm, alone suffices to prove Qatabanian authority. The heart of the kingdom seems to have occupied a rather limited area—namely, the wadis Bayhan and Harib—even if, at certain periods in its history, Qataban dominated a vast territory.

The titulary of certain Qatabanian rulers, known as the "long titulary," attests to the expansion of power to the south. It enumerates a series of places over which Qataban's sway extended: Awsan, Dathinat (*Dtnt*), Yafa (*Dhsm*), and Tuban (*Tbnw*). In this case, certainly, the presence of Qatabanian inscriptions—in the region of Rada, Wadi Bana, Hasi Bayt al-Ward, al-Misal to Banu Bakr—compared with classical sources, shows that it represented a real extension of the Qatabanian sphere of influence.

Lack of documentation makes it difficult to reconstruct the various phases of Qataban's history. Following an alliance between Saba and Hadramawt to limit the expansion of Awsan, the kingdom of Qataban disappeared for a lengthy period from the epigraphic record. The period of alliance with Saba clearly came to an end at the beginning of the sixth century BCE. Sabaean sources mention various wars with Qataban, which seem to have continued throughout the sixth century, since a Sabaean inscription from the Mahram Bilqis, dated to the end of the century, mentions a final struggle that lasted five years. A Qatabanian inscription from the same period records a war waged over domination of the region north of the Wadi Bana. This latter inscription, engraved on a cliff face of the Jabal al-Lawdh, a neighbor of Zafar, could demonstrate Qatabanian expansion toward the southwest of Yemen.

At a certain point in their history the Qatabanian rulers took the title of *mukarrib* (federator). The first to do so was Hawfiamm Yuhanim, son of Sumhuwatar (inscriptions of the sixth century BCE). This initiated a long period of greatness for the kingdom of Qataban, which continued until the first century (FIG. 2). Its territory seems to have extended as far as the Bab al-Mandab, or Red Sea straits; its cities, surrounded by walls, were graced by temples and palaces; its output of inscriptions and works of art prospered. Qataban's decline became evident from the beginning of the first century BCE. Yet, although reduced in size, Qataban nonetheless retained its autonomy. In the year 165 CE it participated in a great war in which Saba and Hadramawt were also involved. Shortly thereafter, the Wadi Bayhan came under the latter's control, as two Sabaean inscriptions from the end of the second or beginning of the third century CE establish. The first mentions the alliance signed by Alhan Nahfan, king of Saba, and Yadail, king of Hadramawt, in dhat-Ghayl (Hajar ibn Humayd), in the middle of Qatabanian territory. The second, dated in the reign of the son of Alhan, Shar Awtar, reports that during the war between Saba and the Hadramawt, before the breakup of the alliance, the ruler of Hadramawt was taken prisoner during a battle at dhu-Ghayl. Texts found in situ also prove Hadramawt's annexation of the Wadi Bayhan. From Hajar ibn

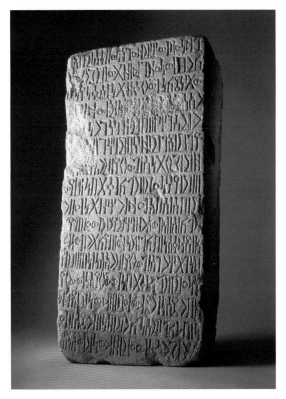

FIG 3 INSCRIBED STELA MENTIONING THE LAST KING OF QATABAN. AL-HINU, LATE 2ND CENTURY CE. LIMESTONE; H 50 W 24 TH 14 CM. ADEN, NATIONAL MUSEUM, NAM 511

Humayd came Hadramitic inscriptions, one of which stated that the king of Hadramawt had rebuilt part of the city wall. The kingdom of Qataban thus seems to have come to an end in the last quarter of the second century CE (FIG. 3). The American excavations at Tamna suggested on archaeological grounds that the kingdom's capital had already been abandoned at an earlier period, in the first century CE. If this hypothesis is confirmed, we could postulate that Tamna was abandoned in the first century, followed by the transfer of the capital to dhu-Ghayl. This latter city, mentioned in the latest royal Qatabanian inscriptions, would have remained the capital for about a century before the entire region was annexed by the kingdom of Hadramawt (FIG. 4).

It is not easy to characterize Qataban from the political-social point of view. A principal tribe became the eponym of the kingdom and, in obedience to a king and the cult of a god, the link that united all its subjects. As in Main, decisions were made by the king with the assistance of a council composed of tribal elders. Judging by indirect evidence, we might be able to infer that the laity exercised comparatively greater power in the kingdom of Qataban. In the inscription establishing the regulations governing Tamna's market, for example, no deity is invoked.

The principal god of the confederation was Amm. Anbay and Hawkam, the latter probably the female counterpart of Anbay, were connected with kingship. In his titulary the king declared himself to be "first-born of Anbay and Hawkam." A deity common to all South Arabian cultures, Athtar was likewise present in Qataban; the goddess Athirat is attested in the Wadi Harib. The reference to this deity, not found in any other South Arabian texts, creates an interesting link with Astarte, a divinity well known in the Syro-Mesopotamian world in the second millennium BCE.

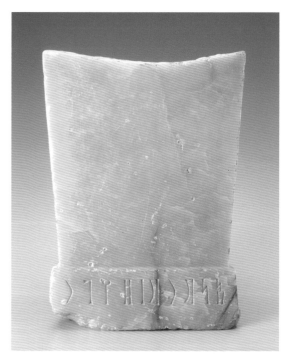

FIG 4  FUNERARY STELA. TAMNA, CEMETERY, 1ST HALF OF 1ST CENTURY CE. ALABASTER; H 32.7  W 23.2  TH 5.5 CM. THE AMERICAN FOUNDATION FOR THE STUDY OF MAN, TC 1736

FRANÇOIS BRON

# Languages and Writing

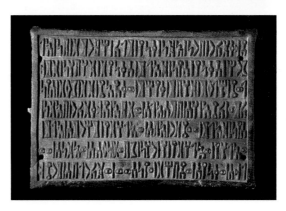

"South Arabian Epigraphic" is the conventional term used to designate the language of the inscriptions carved in stone, wood, or metal that constitutes the only surviving examples of writing of the pre-Islamic civilization of Yemen. The earliest examples go back to the first half of the first millennium BCE, whereas the most recent predate the Islamic conquest by a few decades. The name by which the inhabitants of Yemen referred to their language is unknown, as is the name by which they referred to themselves, other than the name of the tribe to which they belonged. All that is known is that the term "Arab" to them meant the desert nomads, or bedouin. "South Arabian" also denotes a series of languages spoken today in a region astride the frontier between Yemen and Oman and on the island of Soqotra. These will not be discussed here, and recent research seems to demonstrate that they are not closely related to the languages of antiquity, although they, too, are Semitic.

CHRONOLOGY

The chronology of South Arabian inscriptions has been a long-standing matter for scholarly debate.[1] It is only during the last few years that a consensus has been reached for dating the earliest inscriptions to around the eighth century BCE. Essentially, they are written in four dialects, originally attested in three wadis (streambeds) in the inland desert of Ramlat as-Sabatayn and in the Wadi Hadramawt. This desert was also called Sayhad by medieval Arab geographers, and this has led A. F. L. Beeston to propose the name "Sayhadic" for these dialects.[2] From northwest to southeast they are Minaean in the Wadi Jawf, Sabaean in the Marib region and on the Wadi Dhana, Qatabanian in the Wadi Bayhan and the Wadi Harib, and Hadramitic. The origin of these languages remains shrouded in mystery. They are normally classified, according to their

FIG 1 SABAEAN BUILDING INSCRIPTION, CIRCA 8TH–7TH CENTURY BCE, REUSED IN THE DAM AT MARIB.

FIG 2 INSCRIPTION WITH A DEDICATION TO THE GOD SAYIN. SHABWA, 1ST CENTURY CE. BRONZE; H 22.5 W 33.5 TH 1.5 CM. THE BRITISH MUSEUM, ANE E48479

geographical distribution, as a south Semitic group together with Arabic and the languages of Ethiopia, but they also present strong affinities with west Semitic languages of the Levant, notably Ugaritic and Aramaean. The earliest onomastic, in particular, offers disturbing similarities with Amorite onomastic of the second millennium BCE.[3]

The origins of Yemeni civilization still remain very obscure, owing to the relative lack of archaeological excavation of early-period sites. This leads us tentatively to argue as a simple working hypothesis that Sabaean was originally the only written language, arising from the supremacy of the kingdom of Saba, which, at the beginning of the seventh century BCE, succeeded in dominating the greater part of Yemen. The other languages would only later have achieved the status of written languages when the respective states of Main, Qataban, and Hadramawt freed themselves from Sabaean domination.

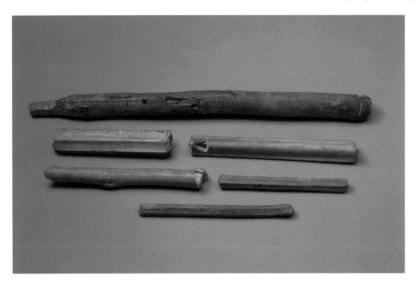

It is therefore very difficult to date the earliest Sabaean inscriptions with any precision on purely paleographic grounds. It is certain that they go back to at least the eighth century BCE, as the long historical inscriptions dated to the early seventh century have a monumental character and elaborate phraseology that can only have resulted from a lengthy period of evolution. From these latter texts it is known that the kingdom of Saba dominated a large part of Yemen at that period. Later, during the second half of the first millennium BCE, the kingdom lost its power, and Sabaean was only used in the Marib region and on the high plateau to the north of Sanaa.

Nevertheless, from the beginning of the Christian era, Sabaean expansion revived. Sabaean was adopted as the written language of the Himyar tribe that originated to the south of the high plateau and seized power in the kingdom of Saba towards the end of the third century, before unifying the whole of Yemen under its domination and finally embarking on a political campaign of conquests that engulfed the whole of the south of the Arabian Peninsula. This is attested by half a dozen rock inscriptions in Saudi Arabia, extending as far as the Riyadh region.[4] Furthermore, from the second century BCE, with the arrival of new nomad populations, Sabaean was increasingly influenced by Arabic, especially on a lexical level.

The chronology of the other dialects is less certain. The earliest Minaean texts seem to be contemporary with the first Sabaean inscriptions. Minaean derives its name from the Minaeans, the Greek name of the small kingdom of Main on the Jawf that consisted of three adjacent towns—Main, Baraqish, and Nashan—and owed its prosperity to caravan trade. Inscriptions found in the capital indicate the regions where Minaean merchants resided, that is, in the north of the Arabian Peninsula, Egypt, Gaza, and throughout the western part of the Fertile Crescent. However, recent discoveries indicate that this dialect was used at sites that were independent of Main and may even have antedated the foundation of the Minaean kingdom; this has led Christian

| ʾ | b | t | th | g | ḥ | kh | d | dh | r | z | s | sh | ś | ṣ |
|---|---|---|----|---|---|----|---|----|---|---|---|----|---|---|

| ḍ | ṭ | ẓ | ʿ | gh | f | q | k | l | m | n | h | w | y |
|---|---|---|---|----|---|---|---|---|---|---|---|---|---|

FIG 4 THE SOUTH ARABIAN ALPHA-BET AND CORRESPONDING LATIN CHARACTERS

Robin to propose the term Madhabian, from the Wadi Madhab that flows into the Jawf.[5] Numerous inscriptions, mostly rock-cut, have been discovered in al-Ula oasis in the north of the Hejaz, where the Minaeans had founded an important colony. They also left written evidence of their presence as far as Egypt and the island of Delos.[6] Its situation in the northern part of South Arabia meant that the Minaean kingdom was the first of the South Arabian states to be submerged by the advance of desert nomads, and it vanished towards the end of the first millennium BCE.

Qatabanian is the dialect of the kingdom of Qataban, which occupied the wadis Bayhan and Harib. Around the fourth to third centuries BCE it became a homogeneous entity and extended into the high plateaus as far as the Zafar region, which adopted its language. However, from the first century BCE this influence declined; the tribes of the region recovered their autonomy and adopted Sabaean. Finally, in the first century CE, the capital Tamna was destroyed, and the kingdom was reduced to the upper reaches of the Wadi Bayhan before being conquered by the Hadramawt toward the end of the second century.

As for the Hadramawt, the earliest texts from the region, which are extremely laconic, display a strong Sabaean influence that gradually diminished. From the middle of the first millennium BCE, the Hadramitic dialect established itself and reveals a striking series of peculiarities that distinguish it from other South Arabian dialects. From then on it is attested not only in the wadi but also in the capital Shabwa, located further west, and at various sites between the Hadramawt and the Indian Ocean. In the first century CE a colony was founded in Zafar, which lies in present-day Oman, where a series of texts has been found.[7] This dialect disappears when the Hadramawt was finally absorbed into the Himyarite kingdom at the beginning of the fourth century CE.

Although knowledge of these languages has greatly increased during the last thirty years, it is still very incomplete. This is essentially due to the documentation that survives. The inscriptions belong to a certain type of text that could be termed "official" and stereotyped (FIGS. 1–2). They are mostly records of the construction of houses, tombs, religious buildings, or irrigation works,

FIG 5 INSCRIPTION COMMEMORATING CONSTRUCTION. SIRWAH, 8TH CENTURY BCE. LIMESTONE; H 31.5 W 107 TH 23 CM. SANAA, NATIONAL MUSEUM, YM 16465

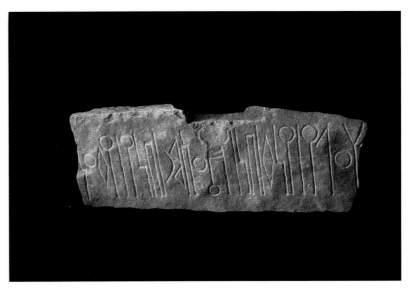

dedications in temples, and some legal texts, with only a few commemorative inscriptions recording hunting or military expeditions. These are always couched in the third person, and it is only recently that the first and second persons of the verb and pronoun became known. It is noteworthy that no mythological or literary texts survive, with the possible exception of a hymn to the sun goddess carved on a rock, which appears to be written in a peculiar and largely incomprehensible dialect.[8] Common words are fairly well understood, but the meanings of specialist terms relating to law or architecture, for instance, are largely elusive. However, this situation is beginning to change: a new type of document has appeared during the last thirty years of which the first examples have only very recently been published. These texts consist of little wooden sticks inscribed in tiny writing that is very different from the monumental script and has had to be deciphered (FIG. 3). This method was used for documents relating to daily life, accounts, contracts, and letters, although only a score of these documents has so far been published.[9]

The South Arabian dialects are characterized by a phonetic system consisting of twenty-nine phonemes, that is, one more than Arabic. Like biblical Hebrew and modern South Arabian dialects, they distinguish three sibilants. In other respects, however, the phonetic system seems to be identical to that of Arabic.

South Arabian writing, like other Semitic scripts, originally recorded only the consonants, thus considerably hampering an understanding of the language; vocalization, vowel length, and even the doubling of consonants remain unknown. Only *w* and *y* at the ends of words may sometimes indicate vowels. For this reason, knowledge of the language must rely, to a large extent, on comparison with other related Semitic languages. South Arabian morphology seems to have many affinities with that of Arabic, with which it shares many characteristics, such as the abundance of broken plurals of nouns. Because of the system of writing, the different verbal tenses cannot be precisely distinguished. Unlike Arabic, the causative is formed using the prefix *h-* in Sabaean and *š-* in Minaean, Qatabanian, and Hadramitic. This same difference in vocalization appears in the way the third-person pronouns are formed (Sabaean *hw*, Qatabanian *šww*, "he"). There is another difference with Arabic in that the definite article is appended to a word, *-n (-hn* in Hadramitic). Finally, it has recently been discovered that the first- and third-person forms of the verb in the accomplished tense have the ending *-k (fᶜlk* compared with *faᶜaltu* in Arabic), as is the case with modern South Arabian languages and Geez. Although the vocabulary is generally closely related to Arabic, it nevertheless has some peculiarities, with a sizable proportion of words more closely related to northwest Semitic. Finally, another part of the vocabulary can only be understood thanks to its survival in Arabic dialects in present-day Yemen.

## THE SOUTH ARABIAN ALPHABET

The inscriptions of ancient Yemen are written in a peculiar alphabet of twenty-nine signs, unlike Phoenician,

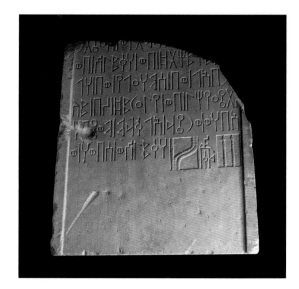

FIG 6 INSCRIPTION POSSIBLY COMMEMORATING THE BUILDING OF A PRIVATE SHRINE. MARIB, CIRCA 7TH CENTURY BCE. LIMESTONE; H 65.2 W 56 CM. SANAA, MILITARY MUSEUM, MIM 149

FIG 7 STELA WITH SABAEAN INSCRIPTION COMMEMORATING THE DIGGING OF A WELL. WADI AKHIRR, MID-1ST CENTURY CE. LIMESTONE; H 35 W 53 CM. BAYHAN MUSEUM, BAM 672

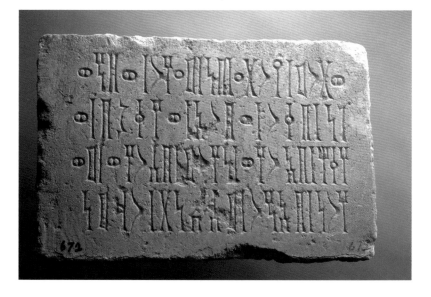

which has twenty-two signs (FIG. 4). The languages of the Arabian Peninsula, including present-day Arabic, have a richer use of phonemes than those of the Fertile Crescent. Whereas the different alphabets used throughout the modern world ultimately derive from the Phoenician alphabet, the South Arabian alphabet has survived up to the present in the Ethiopian syllabary. The first South Arabian inscription of any length was discovered by the British sailors Captain S. B. Haines and Lieutenant J. R. Wellsted on the coast of Oman in 1834.[10] This text, together with others recorded soon afterward, enabled the South Arabian alphabet to be deciphered in the 1840s by two German scholars, H. F. W. Gesenius and E. R. Rödiger.[11]

The origins of this alphabet remained obscure until very recently. A certain relationship with the Phoenician alphabet has long been recognized, as some signs are identical in the two alphabets (', *t*) or demonstrate a close resemblance (*g, l, n, q, š*). Nevertheless, the existence of different signs suggests two independent traditions with a common origin, each with its own order for the letters that survives to the present. Our own alphabet has preserved the essentials of the Phoenician alphabet, whereas the Ethiopian syllabary has preserved the South Arabian order. The basis for this hypothesis was the discovery in 1950–51, during American excavations of Hajar Kuhlan in the Wadi Bayhan, of a pavement made up of stone slabs, each of which bore a South Arabian letter to indicate the respective position of the slabs. Some of these signs were, however, difficult to read, leading to different interpretations of the evidence.[12] In the last quarter of a century, however, numerous other alphabets have been found: first some fragmentary Sabaean texts, then a Minaean rock-cut inscription at al-Ula consisting of twenty-six of the twenty-nine signs, and finally a Qatabanian inscription that has enabled the complete alphabet to be reconstructed.[13] This order is also that of other branches of the South Arabian script, for instance, in Lihyanite and, of course, in Ethiopian inscriptions written in South Arabian script.[14] A decisive step was taken by a Russian scholar, A. G. Lundin, who in 1987 proposed a new interpretation of a tablet inscribed in Ugaritic cuneiform, which had been found in 1933 during American excavations at Beth Shemesh in southern Palestine and which dated to the thirteenth century BCE: it was an alphabet arranged in the same order as South Arabian.[15] This discovery allowed two essential deductions to be made, namely, that the south Semitic alphabet was as old as the Phoenician and that its origin was also to be sought in the Fertile Crescent. Furthermore, in 1990 the French excavators at Ras Shamra/Ugarit also found a cuneiform alphabet of south Semitic type, so it is, henceforth, clear that the two traditions existed from the beginning.[16] It now remains to be explained what these two traditions represented and why one spread exclusively in the Arabian Peninsula.

The question of how long the South Arabian script was used in ancient Yemen needs to be addressed. As mentioned above, the present tendency is to date the earliest royal inscriptions to the beginning of the seventh century BCE. This must have been preceded by a formative period of unknown duration. At the other end of South Arabian history, the most recent inscription bears a date that corresponds to 554 CE. In total, therefore, South Arabian inscriptions cover

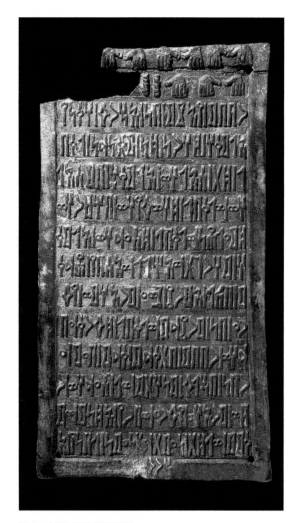

FIG 8 INSCRIPTION MENTIONING
A BATTLE BETWEEN THE SABAEANS
AND THE ARABS IN THE JAWF. AMRAN.
1ST CENTURY BCE. BRONZE; H 31.5
W 18.5  TH 2 CM. THE BRITISH
MUSEUM, ANE 1862-10-28,9

a period of some thirteen or fourteen centuries. There is certainly a clear evolution of the script during this period of time, but until recently it was thought that there had been no radical modification, unlike the situation with the Phoenician alphabet and its derivatives. This view still holds good with regard to the stone-cut, monumental script: during this long period, only three or four stages in its development can easily be identified, and the development from one stage to the next was so gradual as to be barely distinguishable, thus making it extremely difficult to use paleography for the precise dating of inscriptions.

In a first stage, which could be termed archaic, the proportions of the letters were not yet established, and certain forms are present that were later to disappear (FIG. 5). The general impression is clumsy and lacks harmony. With the royal inscriptions of the seventh century, the script reached perfection with a very marked geometric aspect: each letter is inscribed in a rectangle and has at least one, if not two, symmetrical axes. The general appearance is harmonious and severe, without any decorative embellishments. Until about the fourth century BCE the inscriptions are boustrophedon, that is, the lines of writing are read alternately from right to left and from left to right (FIG. 6).

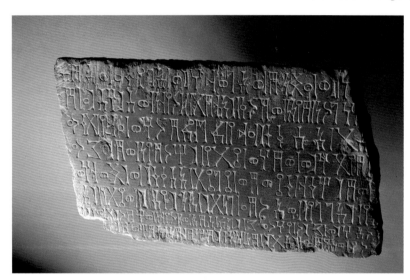

Over time this canon changed, with the script becoming at times squatter or more slender. Its geometric character gradually lessens, the angles become more rounded, and curving lines become more sinuous. The extremities of the uprights of the letters become wider at first; later they flare out. The appearance of the script can vary from one inscription to the next, and it becomes softer and less imposing (FIGS. 7–8). However, this development does not necessarily apply to regional scripts, and the evolution of Qatabanian is not exactly the same as that of Sabaean.

With the appearance of monotheism toward the beginning of the fourth century CE, these tendencies amplify and combine to form a script that can be termed baroque and loses its clarity (FIGS. 9–10). Most inscriptions are henceforth carved in relief. Alongside the monumental inscriptions, however, there are also graffiti, which are very basic and lack any aesthetic pretensions. They bear some resemblance to the scripts of the nomads of central and northern Arabia.[17]

Finally, as has been mentioned above, a third type of script has recently been identified that must have been widely used in antiquity for day-to-day transactions. This minute script, which derived from the monumental script, was inscribed on small sticks or palm leafstalks. Two examples appeared on the antiquities market around 1970 and were studied by the Palestinian scholar M. Ghul.[18] From the 1980s onward, these texts were sold in the Sanaa souk (marketplace) by the score, and now hundreds of them are known. They come from clandestine excavations, probably in the Jawf and more precisely from the site of Nashan; some examples have also been discovered during the Russian excavations at Raybun in the Hadramawt.[19] Thanks to this abundant documentation, it is now possible to trace the evolution of the script from forms that are

almost identical to those of the monumental script, which must go back to the seventh century BCE, to the most recent texts, some of which are dated to the end of the fourth century CE. The script becomes increasingly cursive and more and more difficult to decipher, with many of the letters becoming almost identical. The exploitation of this exceptional resource has only just begun, but it has revealed aspects of the pre-Islamic civilization of Yemen that had previously remained hidden. The Belgian scholar J. Ryckmans has undertaken a detailed analysis of the development of this script and has been able to establish a relative chronology for the documents, but their decipherment and translation are still awaited.[20]

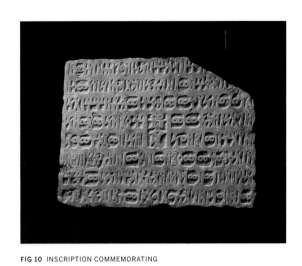

FIG 10 INSCRIPTION COMMEMORATING CONSTRUCTION OF A PALACE BY ABYSSINIAN AMBASSADORS. ZAFAR, 510 CE. LIMESTONE; H 46  W 63 CM. ZAFAR MUSEUM, ZM 579

ENDNOTES

1 SEE ALSO SCHIPPMANN 2001, 19–22.

2 FOR INSTANCE, BEESTON 1987; OTHER
  SCHOLARS HAVE DEFINED THESE DIALECTS
  AS DISTINCT LANGUAGES.

3 BRON 1991; 1994.

4 RYCKMANS 1953.

5 ROBIN 1992.

6 SEIPEL ED. 1998, 293, 295, NO. 164.

7 ALBRIGHT 1982.

8 ABDULLAH 1988.

9 RYCKMANS, MÜLLER, AND ABDULLAH 1994;
  FRANTSOUZOFF 1999.

10 WELLSTED 1838.

11 GESENIUS 1841; RÖDIGER 1841.

12 HONEYMAN 1952.

13 ROBIN AND BRON 1974; BEESTON 1979;
   IRVINE AND BEESTON 1988.

14 RYCKMANS 1985; SIMA 1999.

15 LUNDIN 1987.

16 BORDREUIL AND PARDEE 1995.

17 RYCKMANS 1984.

18 BEESTON 1989.

19 FRANTSOUZOFF 1999.

20 RYCKMANS 2001.

IRIS GERLACH

# Sirwah

NEW RESEARCH AT THE SABAEAN CITY AND OASIS

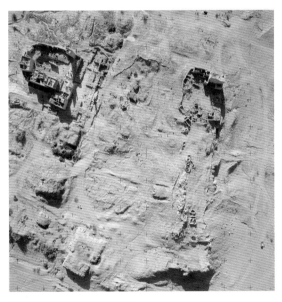

In 2001, the Sanaa Branch of the German Archaeological Institute launched an interdisciplinary project at the Sabaean city and oasis of Sirwah, located forty kilometers west of Marib.[1] During the first millennium BCE, Sirwah was the most important center of the Sabaean kingdom after the ancient metropolis of Marib. Unlike ancient Marib, however, the preservation of which was severely impaired by its changing history and especially by destruction over the past centuries, Sirwah still boasts impressive buildings of the Sabaean period. In the early 1990s, the German Archaeological Institute carried out at Sirwah a study of the architectural history of the sanctuary of the god Almaqah. The goal of the new project is much broader: to achieve a reconstruction as comprehensive as possible of the city's ancient culture and environment. For this reason, in addition to archaeological excavations in the city area, surveys are being carried out in the oasis and its immediate vicinity.

The city was founded at the outlet of a wadi on the most extended rise within the basin (FIG. 1). This favorable location protects it from the destructive power of the seasonal floods, on the one hand, and, on the other, with its excellent and unobstructed vista, also offers strategic advantages. Both factors in combination were probably decisive in founding the settlement on this site. With an extant intramural area of approximately three hectares and only scattered Islamic buildings on top of the ancient architecture, the city's various functional areas and its infrastructure can be identified with relative ease by well-targeted survey and excavation. Clearly visible from aerial photos taken from a hot air zeppelin is the city wall that, with its projections and recesses, corresponds to the typical South Arabian fortification walls (FIG. 2). In addition to areas of presumably secular dwellings, eight larger buildings have thus far been recognized, of which at least five can be identified as temples within the city. Outside the city wall, remains

FIG 1 THE SABAEAN CITY OF SIRWAH, SEEN FROM THE WEST

FIG 2 AERIAL VIEW, SITE OF THE SABAEAN CITY OF SIRWAH

visible on the surface can be interpreted as domestic quarters and workshops, and as the site of a cemetery.

## THE ALMAQAH TEMPLE

Approaching the ancient city of Sirwah from the direction of Marib, one first sees the irregularly oval outer wall of the Almaqah temple, which still stands over eight meters in height (FIG. 3). The inscriptions engraved on the outer side of this wall name its builder as the Sabaean ruler Yadail Darih, in the middle of the seventh century BCE. Construction of curvilinear rather than rectilinear walls around sanctuaries is an unusual architectural form in pre-Islamic South Arabia. A similar wall, also built by Yadail Darih, is found at the Awam temple in Marib.

The construction of the building shows a real mastery of stoneworking. The stones of the facade are carefully smoothed and fit together exactly. The irregular curve of the wall is arranged in separate limestone blocks in such a way that each individually formed stone—first roughly hewn and later smoothed as a constructed unit—only fits into a single position in the wall. A frieze with a toothed motif forms the upper edge of the oval wall on the exterior, and originally there was an ibex frieze on the interior.

Access to the interior of the Almaqah temple is via two propylaea with pillars and a paved courtyard in the western part of the sanctuary (FIG. 4a). Here, some 150 to 200 years ago, local inhabitants used ancient stone blocks to build a small village, well sheltered by the high outer wall but now abandoned. In order to uncover the site of the Sabaean city, the mostly badly demolished houses of this village were first recorded in drawings and photographs and then for the most part removed (FIG. 5). The Islamic tower erected over the temple's outer wall on the south, intended to serve as a vantage point, rises above an ancient side entrance. The floor of the inner temple area is paved with stone slabs. Installations for ritual banquets and other ritual activities are preserved here, including a banqueting area with stone benches and tables, and altars and pedestals for ablutions. Numerous animal bones and horns, chiefly of sheep, goat, ibex, and antelope, provide evidence of ritual sacrifice on this spot. A deposit of clay statuettes of bulls and sheep also suggests that during the rituals substitutes for the sacrificial animals were used (FIG. 6). In a late ancient bronze workshop to the northeast of the temple propylaea, in addition to broken crucibles, numerous fragments of bronze objects, including inscribed plates, fittings, statuettes, and larger statues, but also jewelry made of agate and gold, have been found (FIGS. 7a-b). The finds date from the different Sabaean cultural phases (approximately seventh century BCE to third century CE).

The center of the courtyard is dominated by the inscription stones of Karibil Watar, set on a plinth made of brick and once probably faced with alabaster slabs (SEE ROBIN, FIG. 9). The two superimposed stones, each 6.80 meters long and weighing approximately twenty-five metric tons in all, bear the longest Sabaean

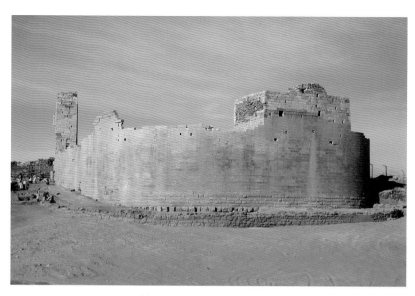

FIG 3 OUTER WALL OF THE ALMAQAH TEMPLE AT SIRWAH, APPROXIMATELY 8 M IN HEIGHT; MID-7TH CENTURY BCE

inscription known to date. It records both civic and military deeds of the Sabaean ruler Karibil Watar, one of the few rulers in ancient South Arabian history whose dates can be closely established. According to the Neo-Assyrian annals, he sent gifts to the Assyrian king Sennacherib (704–681 BCE) that were shortly thereafter laid in the foundations of the New Year festival building during its construction, an event that took place around 685 BCE. As a result of his military successes, Karibil Watar is rightly described as the first to unite large parts of the territory comprising present-day Yemen. His military campaigns led him in the north as far as Najran, in what is now Saudi Arabia; in the west as far as the Tihama; in the south into the Yemeni highlands and the coastal region of Lahj; and in the east as far as the center of Saba's greatest enemy, the kingdom of Awsan. The Sabaean ruler achieved his conquests through brutal campaigns, as manifested by the large numbers of dead, of prisoners, and animals that were carried off. As stated on the reverse of the inscribed blocks, however, Karibil Watar also devoted himself to the civilian population; he records the erection and redevelopment of the dam and irrigation systems in the oasis of Marib. Such deeds must have held particular significance for the Sabaeans, as they guaranteed the kingdom's economic foundation and the feeding of its population. This monument, which was also important for his successor, certainly played a significant role in the ritual activities carried out in the temple. Exactly how we should envisage those activities still remains largely unclear, however, although we do know that the ritual banquets held in the excavated banqueting area—which the textual sources also mention—were surely an important component. Evidence for similar installations has been found in other temples, for example, at Baraqish and in the Jawf.

Excavations north and west of the sanctuary revealed an older wall running parallel to the temple wall. This wall probably did not enclose an earlier temple, but rather served as a foundation for the vast outer wall. Numerous later features that have come to light, including the water drainage system and fragmentary inscriptions from different phases, document the long use of the sanctuary through the first centuries CE. In addition, a Sabaean-Nabataean bilingual inscription discovered in the interior of the temple documents Sirwah's involvement in international trade networks and contacts (FIG. 8). This, the first Nabataean inscription found in Yemen, concerns the dedication by a Nabataean to the main god of the Nabataeans, dhu-Shara, and mentions the third year of office of the Nabataean king Aretas IV. The inscription can therefore be dated to the seventh to sixth century BCE and provides the first evidence for the presence of Nabataean traders in the Sabaean kingdom.

## THE ADMINISTRATIVE BUILDING

On the basis of numerous pieces of evidence, one of the best-preserved monuments at Sirwah can be interpreted as an administrative building, possibly even a palace. The building, located in the north of the city and dating to the end of the second century BCE, is integrated into the fortification (FIG. 9). It consists of a huge podium originally 12.5 meters high and a forecourt on the south side, with substructures for a gallery along three sides. The remains of the podium visible today form only the base of a building, built in half-timbered technique, which presumably consisted of

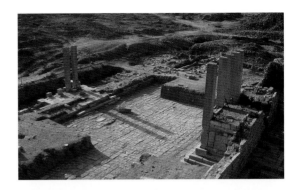

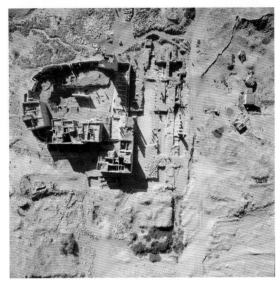

FIG 4A COURTYARD IN FRONT OF THE ALMAQAH TEMPLE OF SIRWAH

FIG 4B AERIAL VIEW OF THE ALMAQAH SANCTUARY

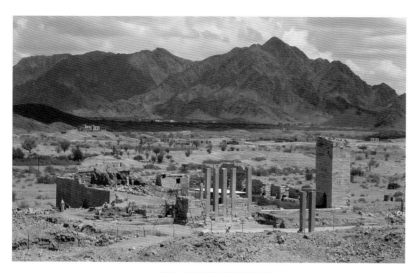

several stories. The plan of the building, with its forecourt, and the platform's construction, consisting of several refilled chambers, are reminiscent of the administrative and palace architecture of the Hadrami capital of Shabwa and the Qatabanian metropolis of Tamna. The podium's chamberlike substructures serve as an extension of the bearing surface that is particularly necessary in half-timbered buildings or in wooden constructions. Also based on a chamber system are the substructure buildings adjacent to the podium, surrounding the forecourt in a horseshoe shape. These chambers were filled with sand and earth and, like the podium, served as a basis for the architectural design of the forecourt surrounds. Remains of this architecture have unfortunately not been preserved. Comparison with the palace of Shabwa suggests the probable reconstruction of a gallery supported by pillars or columns, but as yet no surviving architectural elements confirm this assumption. The outer facade of the courtyard was covered with carefully worked limestone blocks that, with a few exceptions, have been the victim of stone-robbing. In the south the entrance to the courtyard was in the center; the western and eastern corners of the wall surrounding the courtyard were emphasized architecturally by projections.

The podium is integrated into the city's fortifications, leaving free a passageway on the east immediately next to the building. If this was a city gate, there would be a very close parallel to the palace at Shabwa not only in the architectural form of the administrative building but also in its location within the city area. The building also lies in the spandrel of the city wall and a gate immediately next to one of the main street axes of the city. Since only a few comparable buildings have been examined in South Arabia, however, it is still too early to speak of patterns. Unfortunately, the building was thoroughly plundered after its final surrender or destruction, from the precious facade stones to almost the whole of its inventory. With a few exceptions, the excavations uncovered no inscriptions, furnishings, or household items that could assist with identification and dating. An interpretation of the area has therefore been based on the architectural remains and the two inscriptions on the podium facade.

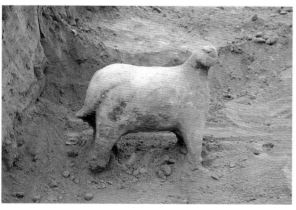
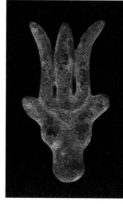
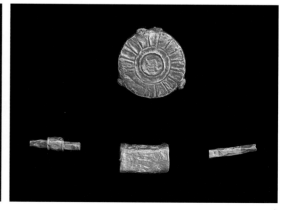

## THE CITY FORTIFICATIONS

The area of the city, covering about three hectares, is surrounded by an enormous city wall of which many sections still stand several meters in height (FIG. 10). The wall encloses an almost trapezoidal area. It consists of a system of frequent towers connected to each other by recesses and projections in the wall, a typical construction method in South Arabia. In many places the differing building materials, such as limestone, travertine, and lapilli breccia, are visible. The various materials and the numerous joints in the buildings and modifications demonstrate that the enclosure wall was built not at one time but was continually repaired and rebuilt. A remarkable fact about the construction of the fortification wall is that many of the monumental buildings still visible today, such as the great Almaqah temple, the administrative building, and the representative residential buildings, are integrated into the city wall. This feature continues old traditions of ancient South Arabian fortifications, while the regular towers and recesses comprise a later element.

In its latest phase, which is what is visible today, the wall encompasses a history of more than a thousand years. In the interior of the city immediately next to the wall are cultural layers preserved up to a height of several meters. All sections of the city wall, although constructed at various periods, are built directly on the rock to take advantage of its solid foundation. Only the different heights of the outlets for drains show that the fortifications had to adapt over time to continually changing circumstances and thus, for example, had to take into consideration the rising level of water flow in the city's interior.

## THE ENVIRONMENT OF SIRWAH

In addition to archaeological and architectural research in the city of Sirwah itself, several surveys were carried out in the oasis and its immediate vicinity to investigate the environment of the ancient site and to reconstruct living conditions during the Sabaean period. It was already known from reports of earlier travelers that in the oasis of Sirwah, as in the one in Marib, the water that flowed from the mountains during the rainy season could be raised to the level of the fields with the help of dams, locks, and canals. The elevation of the fields constantly rose through time as the artificial irrigation deposited silts on them, whereas scouring kept the wadi at a roughly constant elevation. The irrigation system compensated for the difference in level by retaining water in front of the dams; the water then flowed onto the fields via locks and canals. In turn, the fields were bordered by low berms so that overflow during periods of flooding could be retained at a depth of sixty centimeters as it slowly penetrated the soil. Even today, the system of field flooding is still used during the rainy season in addition to irrigation with pumps. Low berms around the fields, and stone walls that led the water from the wadi to the cultivated land, testify to the use of these Sabaean irrigation methods up to the present. Remains of ancient water management installations—earth walls secured with large stones and lock systems and

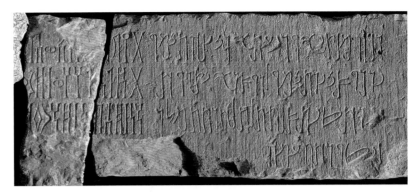

FIG 8 FRAGMENT OF A SABAEAN-NABATAEAN BILINGUAL INSCRIPTION FROM THE ALMAQAH TEMPLE, DEDICATED TO THE GOD DHU-SHARA; 7TH–6TH CENTURY BCE. TRANSLATION BY NORBERT NEBES

FIG 9 AERIAL VIEW OF PLATFORM OF THE ADMINISTRATIVE BUILDING AFTER EXPOSING THE TOP OF THE WALLS

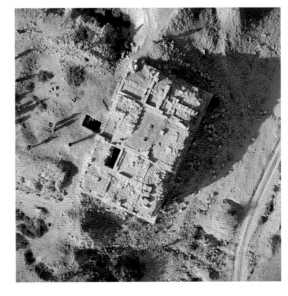

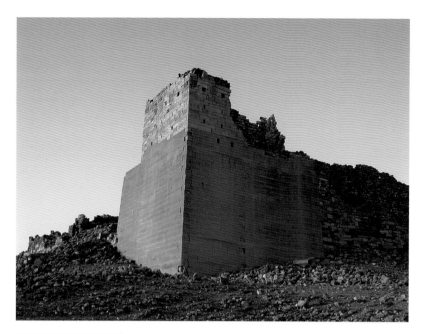

FIG 10 FORTIFICATION WALL OF
SIRWAH, SOUTHWEST TOWER

canals hewn into the rock—are still preserved in several places within the oasis.

Ancient settlement in the oasis of Sirwah was not confined to the main wadi. During the survey, traces of pre-Islamic settlements were also observed along the smaller wadis. Here, too, like the ancient city, the settlements have their foundations far above the wadi bed, protected from the force of seasonal deluges. In the surrounding mountains are hundreds of Sabaean rock inscriptions. Most consist of names, but longer texts were also carved in the stone, including one from two warriors giving thanks for their safe return home from a successful military campaign.

Among the most interesting features of landscape architecture in the region is a kilometer-long system of walls surrounding a mountain. The walls, which reach a height of just under two meters and a width of eighty centimeters, lead from the plain through the valley to the mountain top (FIGS. 11a–b), where they enclose areas of various sizes. The most plausible explanation for these structures is that they are animal enclosures; the animals could be driven from their grazing pastures in the wadi along these walls up into the mountains and kept in various pens. Smaller enclosures in the upper mountain regions, interpreted as feeding sites, support this theory. It is still unclear what kinds of animals were kept here and from what period the site dates. Wild animals such as ibex and antelope could easily leap over walls of this height. On the other hand, it would be surprising that such elaborate wall construction would have been built specially for keeping domestic animals. The arrangement of the walls with their various boundaries makes dubious an interpretation as border lines between tribes or clans. Documentation with aerial photos, intensive surface inspection, and small, focused sondages are planned to clarify the function of this landscape feature. It is hoped that the resulting information will also provide an indication of the date of the walls.

A further question posed by the project is Sirwah's position in the Sabaean trading network. An attempt was made to reconstruct the regional road system

FIGS 11A–B KILOMETER-LONG WALLS,
2 METERS IN HEIGHT, BUILT OF QUARRY STONES. THE WALLS, WHICH
EXTEND ALONG A MOUNTAIN RANGE,
MAY HAVE SERVED AS ENCLOSURES
FOR ANIMALS.

using aerial photos and satellite pictures, and to connect the path of the roads with the traces of paved caravan routes known in the region (SEE GROOM, FIG. 3). One of these roads leads from Sirwah via a calcite quarry to the main caravan route that runs to the north along the edge of the desert to Najran and on to Gaza or Mesopotamia. Trade in calcite from the stone quarries in al-Makhdara (FIGS. 12a–b), only fifteen kilometers northwest of Sirwah, via Sirwah to Marib or in a northerly direction to Baraqish and Main must have been an important economic resource. Calcite was a material indispensable for the embellishment of South Arabian buildings, in particular of temples and palaces, and calcite was also used, for example, for three-dimensional works of art.

In the district of al-Makhdara are a series of stone quarries that were originally often worked as open-pit mines. During further exploitation of the calcite deposits, larger underground cavities were subsequently formed. On their walls are South Arabian letters painted in black, perhaps marking the various sections or working units. Unfortunately, the cavities have been filled in to a height of several meters, and a complete examination of this mine would only be possible with great difficulty.

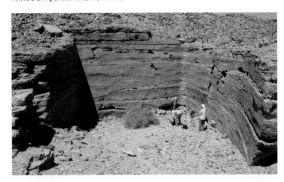

**FIGS 12A–B** CALCITE-ALABASTER QUARRY OF AL-MAKHDARA, APPROXIMATELY 15 KM NORTHWEST OF SIRWAH. CAVITIES WERE FORMED THROUGH QUARRYING ACTIVITY.

**ENDNOTE**

1 THE PROJECT IS CONDUCTED IN COOPERATION WITH THE GERMAN MINING MUSEUM IN BOCHUM (DBM) AND THE FRIEDRICH-SCHILLER UNIVERSITY JENA (INSTITUTE FOR NEAR EASTERN LANGUAGES AND CULTURE), AND IN COLLABORATION WITH THE ARCHITECTURE DEPARTMENT OF THE GERMAN ARCHAEOLOGICAL INSTITUTE.

**FURTHER READING**

GERLACH, I., AND J. HECKES. 2003. "DIE STADTANLAGE VON SIRWAH: REGIERUNGSSITZ, KULTZENTRUM ODER HANDELSSTATION?" IN *MAN AND MINING: MENSCH UND BERGBAU. STUDIES IN HONOUR OF GERD WEISGERBER ON THE OCCASION OF HIS 65TH BIRTHDAY*, ED. T. STÖLLNER, 163–69. DER ANSCHNITT, BEIHEFT 1. BOCHUM: VERÖFFENTLICHUN-GEN AUS DEM DEUTSCHEN BERGBAU-MUSEUM BOCHUM.

GERLACH, I., AND H. HITGEN. 2004. "THE SABAEAN TOWN OF SIRWAH: AN INTRODUCTION TO THE LATEST RESEARCH PROJECT OF THE DAI, ORIENT-DEPARTMENT." IN *SCRIPTA YEMENICA. ISSLEDOVANIJA PO YUZHNOJ ARAVII. SBORNIK NAUCHNIH STATEJ CHEST' 60-LETIJA M.B. PIOTROVSKOGO (STUDIES ON SOUTH ARABIA. THE COLLECTION OF SCIENTIFIC ARTICLES ON THE OCCASION OF THE 60TH BIRTHDAY OF M. B. PIOTROVSKIJ)*, 210–15.

NEBES, N. 1999. "DER GROßE TATENBERICHT DES KARIB'IL WATAR IN SIRWAH." IN *IM LAND DER KÖNIGIN VON SABA*, 66–69. MUNICH: STAATLICHES MUSEUM FÜR VÖLKERKUNDE/IP.

SCHMIDT, J. 1997–98. "TEMPEL UND HEILIGTUMER IN SUDARABIEN. ZU DEN MATERIELLEN UND FORMALEN STRUKTUREN DER SAKRALBAUKUNST." *NÜRNBERGER BLÄTTER ZUR ARCHÄOLOGIE* 14: 10–26.

HOLGER HITGEN

# Jabal al-Lawdh

## AN EARLY HIMYARITE MOUNTAIN SETTLEMENT

Since 1998, at the request of Yemen's General Organization of Antiquities and Museums, the Sanaa Branch of the German Archaeological Institute (DAI) has conducted research at an early Himyarite settlement dated to the first through third centuries CE on the three-thousand-meter-high mountain massif of Jabal al-Lawdh (FIG. 1). The project is financed by the Sanaa Branch of the German Archaeological Institute and by the generous sponsorship of the Fritz Thyssen Trust, as well as by other private donations.

Jabal al-Lawdh lies south of the Wadi Bana in the province of Ibb, far from any significant routes, and is accessible only with great difficulty. In ancient times the Wadi Bana formed an important communication route connecting the south and the southeast of the country with the central plateaus and the Himyarite capital of Zafar. The latter city is situated only about twenty-five kilometers on a direct line from Jabal al-Lawdh.

The fortified settlement on Jabal al-Lawdh is one of several contemporary complexes on mountaintops along the Wadi Bana, but it is among the largest and most elaborately designed of these complexes. In addition to Jabal al-Lawdh, the excavation of the settlement on Jabal Hajaj conducted by the General Organization of Antiquities and Museums should also be mentioned here. These two projects constitute the only scientific investigations of early Himyarite culture thus far undertaken. At Jabal al-Lawdh, research is being carried out on defense and temple complexes as well as living quarters. Questions about the organization of such a settlement and its infrastructure, for example, the water supply and the traffic system, are the main issues. The function of the site has still not been clarified.

The settlement on Jabal al-Lawdh, extending over about seven hectares, takes advantage of the strategic character of the central and narrowest part of a

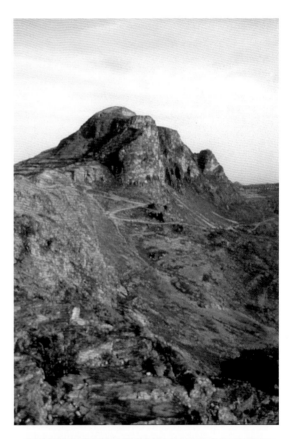

FIG 1 JABAL AL-LAWDH, VIEW FROM THE WEST

FIG 2 THE EASTERN GATE OF THE SETTLEMENT AT JABAL AL-LAWDH

mountain plateau about four kilometers in length. Large sections of the site are protected by steep rock faces, and only to the west and east do walls provide defensive measures. Whereas in the west there is a straight of closure to the settlement, the wall in the east surrounds the highest elevation of the mountain in a wide arc.

Excavation in the eastern part of the settlement has exposed one of the three or more city gates and a portion of the city wall (FIG. 2). The gateway has recessed gate chambers but is not further divided. The fact that buildings abutted the exterior and the interior faces of the city wall is also of interest. In some sections the city wall has been interrupted in order to create a connection between the buildings on each side of the wall, thereby considerably reducing the defensive strength of the wall. In erecting the wall and the gateway, it appears that less emphasis was placed on defending the settlement than on presenting a prestigiously impressive appearance. This intention is manifested,

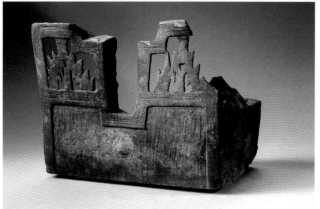

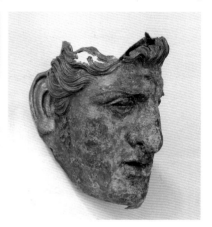

FIG 3 THIS BRONZE ALTAR ILLUSTRATES THE CATEGORY OF WORKS IN SOUTH ARABIAN TRADITION AMONG THOSE RECOVERED FROM THE HOARD FOUND AT JABAL AL-LAWDH. IBB MUSEUM.

FIGS 4A-B TWO HELLENISTIC-ROMAN BRONZE IMPORTS, ANOTHER CATEGORY OF THE METALWORK REPRESENTED IN THE HOARD: A BUST OF ATHENA AND A HELMET IN THE SHAPE OF A MASK, WITH FEATURES OF A HELLENISTIC RULER. IBB MUSEUM.

amongst other things, by the fact that the city gateway was built with much larger and more carefully hewn stones than the wall. This kind of sophisticated masonry characterizes only two other buildings encountered so far: the prestigious building described below, and a building immediately in front of the gate. The latter building is unfortunately almost completely destroyed, but it may have been one of the temples of the settlement mentioned in inscriptions.

The so-called Acropolis, the highest elevation of the settlement, presumably contained temple precincts, dwellings, or fortifications. Unfortunately, this exposed area attracted use far beyond ancient times and was regularly built upon, but the medieval buildings were not the only source of damage. South Yemeni military forces disturbed this part of the site during the bloody conflicts of the 1980s.

In contrast to the Acropolis, large sections of the surrounding settlement remain in excellent condition, thanks to a terrible fire that consumed the whole complex late in the third century CE. The conflagration presumably had some connection with clashes during the Abyssinian campaigns of conquest. After its violent destruction, the area was never settled again to a great extent, apart from the Acropolis and a few houses that were used in late antiquity (fifth to sixth century CE). A large proportion of the preserved architecture belongs to the first

three centuries CE and therefore offered archaeologists new scientific material. Archaeological research in the area was triggered by looting in 1996, during which time well over a hundred objects, mostly of bronze, were torn from their context. The General Organization of Antiquities and Museums, together with the governor of Ibb, succeeded in stopping the uncontrolled destruction and in securing the greater part of the objects, but scientific examination was still necessary to clarify the historical milieu of the finds.

The looted objects have great art historical significance for a social-historical assessment of the early Himyarite period. Apart from typical South Arabian products, such as inscriptions, altars (FIG. 3), pottery, and zoomorphic statuettes, many Hellenistic-Roman works of art have come to light: anthropomorphic statuettes depicting female Greek goddesses, such as Athena (FIGS. 4a–b) and Artemis, a sphinx, and a Roman mask helmet. A third artistic style can also be identified, one that exhibits a definite Hellenistic-Roman influence on South Arabian artistic production. This symbiosis later led to the development of Himyarite art during the fourth to seventh century CE, when foreign motifs were integrated into South Arabian art along with certain means of representation. The foreign models were never simply copied but were adapted and reworked according to local ideas and requirements. Should the photographs of these objects occasionally awaken in the observer familiar with Hellenistic-Roman art an impression of a certain provincialism, this reaction nevertheless cannot be qualitatively evaluated. The zoomorphic bronze statuettes of ibexes and bulls in particular provide evidence of the high level of mastery achieved by South Arabian metalsmiths (FIGS. 5a–b).

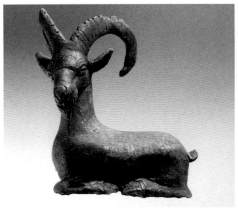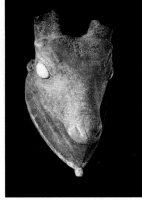

FIGS 5A-B TWO BRONZE IBEXES MADE BY LOCAL METALSMITHS. IBB MUSEUM.

The Sanaa Branch's archaeological research was able to provide evidence that the majority of the bronze objects found both during the looting and during the scientific investigation originated from a large, impressively prestigious building occupying a central position in the settlement (FIG. 6). The building can be distinguished from the other buildings examined so far not only by its layout but also by the choice of building material. Meticulously worked limestone, the source of which is a considerable distance from Jabal al-Lawdh, was used to construct the facade of this building, whereas the locally occurring volcanic stone was the typical material used for other buildings.

The prestigious building is divided into three sections. The public area, with access through the main entrance, comprises a courtyard surrounded by galleries and two large and carefully fitted-out hall-like rooms. From the courtyard one could continue through a narrow passageway to the domestic wing, which included lavatories, kitchens, working areas, and several storerooms containing numerous in situ large storage vessels. Bronze vessels and statuettes originated from the presumably private living quarters of the building on the upper floor. Apart from two stairways, however, no architectural remains of the upper floor survive. Among the finds are the furniture and door fittings suitable for the interior of rich residential buildings.

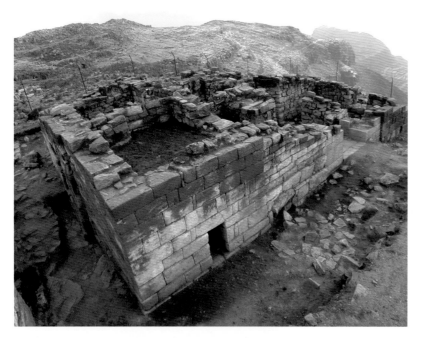

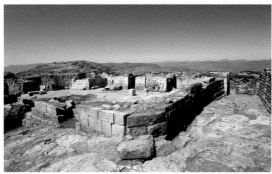

FIG 6 MAIN BUILDING
FIG 7 DOMESTIC DWELLING
FIG 8 COLLECTIVE BURIAL

Other dwellings excavated by the Sanaa Branch yielded less costly furnishings and decoration (FIG. 7). Only a few bronzes came to light in these houses, but on the other hand tools, grinding stones, and storage vessels provide evidence of a way of life oriented around agriculture. The layout of the houses is based on a pragmatically designed model, the details of size and arrangement varying from case to case. Usually only the ground floors of the buildings have been preserved, with rare traces of the rooms above. The ground floor appears to have a long, central corridor, accessible from the main entrance, from which a large number of other rooms could be reached. In these parts of the house—also in the corridor itself—working and storage areas as well as kitchens and occasionally also lavatories could be found. Other rooms were only accessible from the corridors through small low doors. Presumably such rooms were stalls for domestic animals, in particular sheep and goats. These early Himyarite houses exhibit obvious parallels in form and function to present-day buildings in the Yemeni highlands. On this analogy, living areas can be assumed for the now vanished upper floors.

The burial rites on Jabal al-Lawdh are unprecedented for pre-Islamic Yemen. In contrast to other South Arabian sites where tombs lie outside the settlements, at Jabal al-Lawdh burials were placed not only inside the walled settlement area but even within the houses themselves. Each of the buildings examined so far has at least one room reserved for burials; this room is accessible from the building's exterior. Two of these collective burials have been excavated so far. One occurs in a small room measuring about two by three meters, under the floor of which at least fourteen burials were placed close to one another in various directions and positions (FIG. 8). A few textile remains indicate that the deceased were wrapped in cloth for burial. The burial gifts are very modest, with a few small ceramic objects that may be related to the burial cult, but clothing accessories and personal possessions of the deceased occur only very rarely. These objects can be ascribed to individual burials only with great difficulty, due to later disturbances from leveling work in the preparation of field terraces. Individual finds include a few knife blades and small vessels made of stone and magnesium hydroxide carbonate. The latter material was an artificial substance in widespread use in the highlands of Yemen during the first centuries CE.

A different impression is given by a tomb in a house near the large, prestigious building. Here, only a few bodies were buried in a flat tub set into the floor of a large room paneled with *qadhat* (a wall plastering made of lime and tufa). The burials were badly damaged by later building and filling work that tore the skeletons out of place and removed some of the bones. However, a uniform direction (northeast to southwest) of their positions in the tub can be reconstructed. The deceased were adorned with valuable burial gifts and cos-

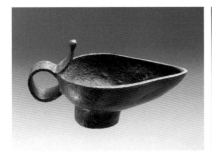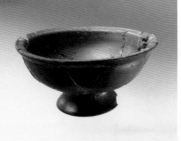

tume accessories, including small-sized ceramics, jewelry, weapons, coins, medallions, and glass vessels (FIG. 9). Both the high quality of the local art products and the high proportion of Hellenistic-Roman imported goods, including golden signet rings with cameos, earrings, and glass vessels (FIG. 10), are remarkable in this grave.

From these two completely different tombs it is clear that burial gifts reflected the social status of the deceased. This pattern is typical of the early Himyarite era when, in contrast to the preceding phases of development in South Arabia, a strong process of individualization was under way. This process found expression not only in inscriptions and architecture but especially in artistic expressions and burial rites. The excavations at Jabal al-Lawdh illuminate from an archaeological point of view various aspects of the early Himyarite culture—a culture that has received only scant scientific interest until now.

FIG 9 OFFERINGS RECOVERED FROM COLLECTIVE BURIALS: BRONZE OIL LAMP, 2 CERAMIC VESSELS, BRONZE MEDALLION, GLASS VESSEL. IBB MUSEUM.

FIG 10 GOLD JEWELRY FROM SOUTH ARABIA AND THE MEDITERRANEAN FOUND IN COLLECTIVE BURIALS, JABAL AL-LAWDH. IBB MUSEUM.

FURTHER READING

VOGT, B. 1999. "EIN SCHATZFUND UND SEINE UNABSEHBAREN FOLGEN. ALPIN-ARCHÄOLOGISCHE UNTERSUCHUNGEN DES DAI AM JABAL AL-'AWD/PROVINZ IBB." JEMEN REPORT 1: 5–7.

VOGT, B., I. GERLACH, AND H. HITGEN. 1998–99. "DIE ERFORSCHUNG ALTSÜDARA-BIENS. DAS DEUTSCHE ARCHÄOLOGISCHE INSTITUT SANAA AUF DEN SPUREN DES SABÄERHERRSCHERS KARIB'IL WATAR." NÜRNBERGER BLÄTTER ZUR ARCHÄOLOGIE 15: 9–90.

HITGEN, H. 1999. "JABAL AL-'AWD. EIN FUND-PLATZ DER SPÄTZEIT IM HOCHLAND DES JEMEN." IN IM LAND DER KÖNIGIN VON SABA. KUNSTSCHÄTZE AUS DEM ANTIKEN JEMEN, 247–53. MUNICH: STAATLICHES MUSEUM FÜR VÖLKERKUNDE/IP.

HITGEN, H. 2002. "MAGNESIUMHYDROXID-CARBONAT—EIN WIEDERENTDECKTER WERKSTOFF IN DER ALTSÜDARABISCHEN KUNST." ARCHÄOLOGISCHE BERICHTE AUS DEM YEMEN 9: 165–80.

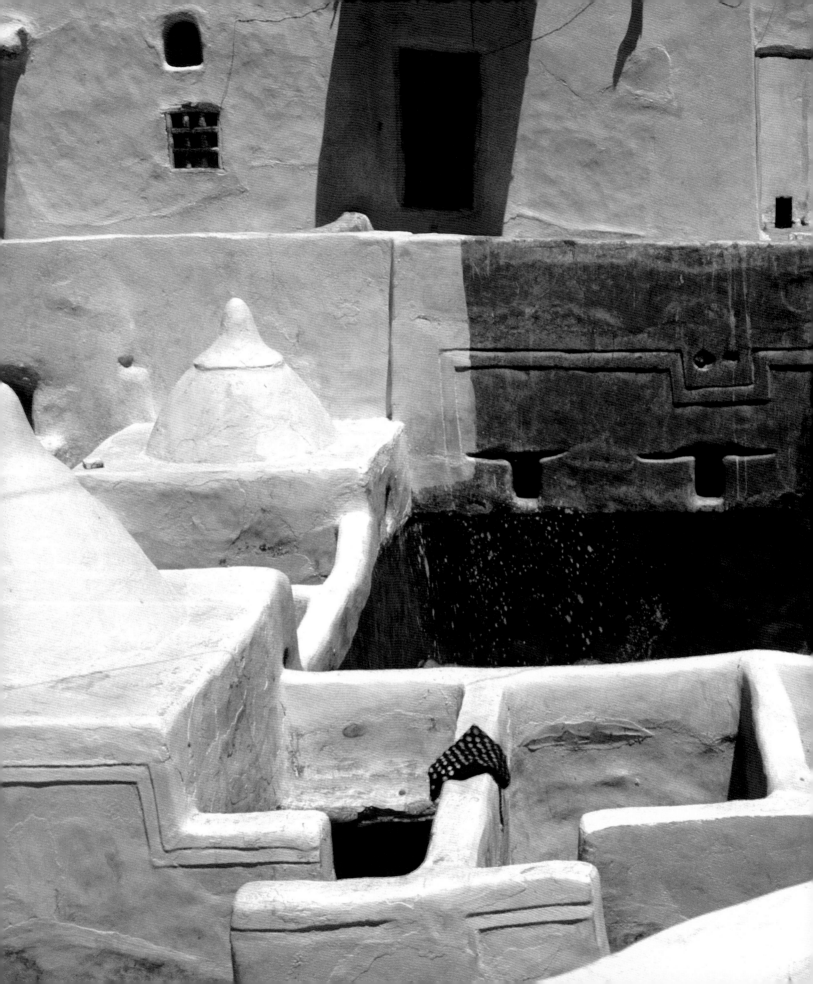

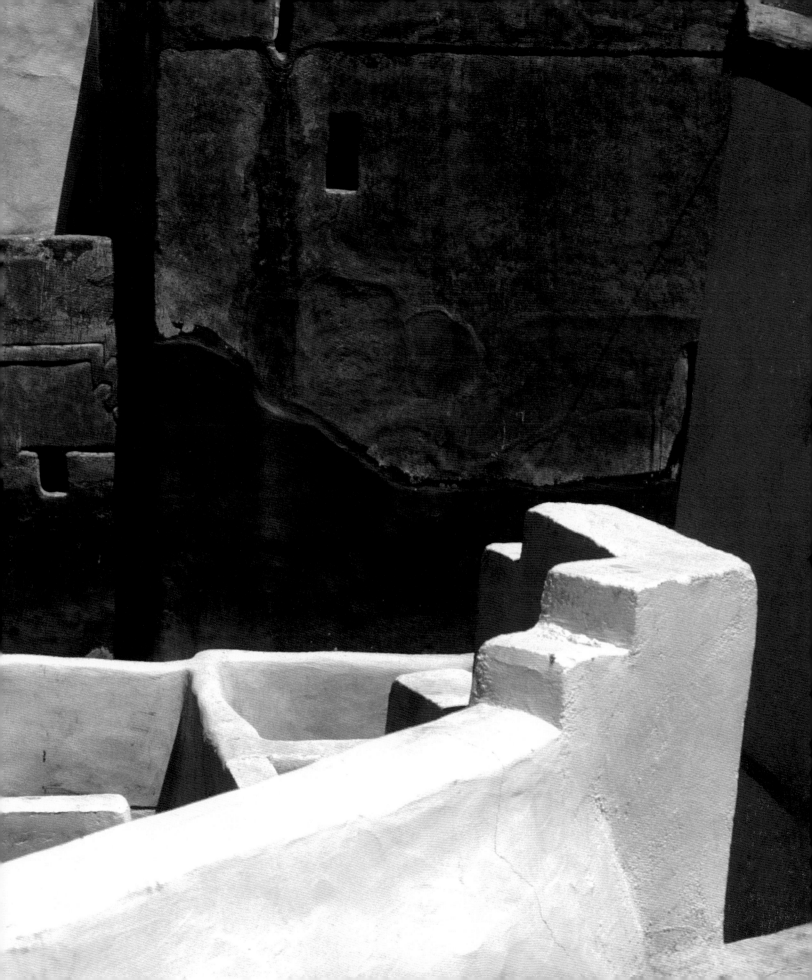

2 Religion and
Funerary Practices

ALEXANDER SIMA

# Religion

*He [the hoopoe] lingered nearby and said:*

*I have encompassed what you have previously not encompassed. And come to you from Sheba with tidings true. I have found a woman ruling over them. She has had something of everything bestowed upon her and has a great throne. I found her and her people bowing down before the sun rather than God.*

—FROM THE ANT, QURAN 27: 22–4

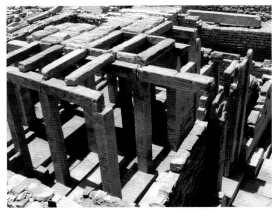

FIG 1 VIEW OF THE TEMPLE OF
NAKRAH AT BARAQISH

According to the Quran (27: 17–24), when King Solomon assembled an army of men, djinns, and birds, he noticed the unexplained absence of the hoopoe. After this bird finally arrived at the court of Solomon, it told the king that it had been to Saba and returned with the astonishing news that there reigned a queen of incredible riches in that country but that she and her people worshiped the sun.

Sun worship is thus how the Quran and the Islamic Arab tradition conceived pre-Islamic religion in ancient South Arabia. During the Islamic period the interest in ancient Yemen focused on genealogies, famous kings and heroes, and above all on the monumental buildings whose remains could be seen even after the glory of their founders had vanished—yet there was no interest in South Arabian paganism (FIG. 1). It is therefore not surprising to find in classical Arabic works on pre-Islamic Arabia only dispersed and often heavily distorted names of pre-Islamic deities. Even an expert on pre-Islamic Yemen, such as al-Hamdani, who died in 971 CE, failed to mention anything of importance on the pre-monotheistic religions of Yemen in the surviving four volumes of his *Iklil*.[1]

The only source for the religions of ancient southern Arabia, therefore, is the thousands of inscriptions that survive from ancient Yemen. These texts are dated approximately between the tenth century BCE and sixth century CE, of which some

four thousand are written in Sabaean, the language of the Sabaean kingdom in the western part of Yemen. The remaining inscriptions are written in Minaean, Qatabanian, and Hadramitic, the official languages of the homonymous kingdoms lying to the north and southeast of the Sabaean territory.[2]

## GODS AND GODDESSES

In the oldest Sabaean inscriptions originating from the oasis of Marib at the edge of the so-called Empty Quarter, the great inner Arabian desert, five deities are invoked, namely, Athtar, Hawbas, Almaqah, dhat-Himyam, and dhat-Badanum. Their sequence reflects their importance: while Athtar—behind whose name one recognizes the Babylonian Ishtar, although in southern Arabia this was a male deity—was worshiped in all South Arabian kingdoms, the other four were restricted to Saba. The second deity, Hawbas, was the female counterpart of Athtar. The third deity, Almaqah, was some form of "national" deity of Saba (FIGS. 2–4). Although Athtar, who was certainly a very old deity, ranked highest in esteem, in the official Sabaean cult the deity Almaqah played the most important role. The structure of the last two names, dhat-Himyam and dhat-Badanum, points to their female sex, but otherwise very little is known about them. In Middle Sabaean times they were often replaced by the "new" deity Shams, who was a solar deity (FIGS. 5–6).

The pantheon of the western highlands was identical with that of the Marib region. However, apart from those deities whose worship certainly reflects the political dominance of the capital Marib, the inscriptions from the highlands show some peculiarities. For instance, the most prominent male deity was Talab, who had his cult center in Riyam, north of Sanaa, together with his female counterpart who was called Nawsam. Besides the deities mentioned above there were a great number of local deities only very rarely attested in the texts. Most of them are only known by name, and since their nature, function, and cult remain in total obscurity, it is unnecessary to treat them here.

What can be said about the nature of these Sabaean deities amounts to very little, although Shams was most certainly a solar goddess. As Shams in Middle Sabaean times often replaces the older deities dhat-Himyam and dhat-Badanum, these may also have been some sort of sun deities. As for Athtar, it has been proposed that he may have been the deity of the morning star, but this simply relies on the etymological connection of his name with the Babylonian Ishtar and cannot be confirmed by any direct evidence from southern Arabia. Furthermore, the lunar nature of Almaqah and Talab is speculative and even less can be stated about the female goddesses Hawbas and Nawsam.

Since the beginning of Sabaean studies there have been a number of proposals equating the main deities with special stars, namely, Athtar as the morning star, Almaqah, and Talab as the moon, and dhat-Himyam and dhat-Badanum as the sun. However, since we are still lacking any epigraphic evidence that might substantiate this, the exact nature of these deities remains obscure. In addition, there is a complete lack of mythological texts that might have helped elucidate the internal structure of the pantheon in the way that Hesiod's *Theogony* has contributed to our knowledge of Greek mythology.

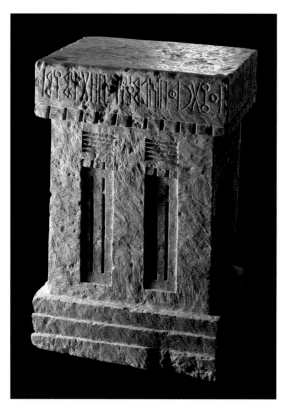

FIG 2 INSCRIBED ALTAR DEDICATED TO THE GOD ALMAQAH. MARIB, BARAN TEMPLE, 7TH–6TH CENTURY BCE. LIMESTONE; H 75 W 50 TH 38 CM. MARIB MUSEUM, MARIB M B2/4A

Only a few dispersed hints testify to the existence of such concepts. In one text (probably from Sirwah), we find an invocation of Athtar, Hawbas, Almaqah, and "the son of Hawbas," although it is unknown who this last-mentioned deity might be.[3] In one Hadramitic inscription Athtar is called "father" of the Hadramitic deity Sayin.[4] Sadly, these are the poor remnants of what was in antiquity certainly a much richer South Arabian mythology that must have been comparable to that of ancient Greece or Mesopotamia.

The pantheon of the Minaeans, who lived in the Yemeni Jawf—northwest of the Sabaean capital Marib—was quite different from their neighbors. Their main deity was Wadd, whose name probably has some connection to the root *wdd* (love), although his nature and function are unknown. In addition, the Minaeans worshiped Nakrah and certainly Athtar (with the surname dhu-Qabd), who was invoked throughout southern Arabia.

The national deity of the Qatabanians was Amm, thus they are often called "children of Amm." His name could be connected with the Semitic word for "uncle." Besides him there were two other deities of major importance—Anbay and his female counterpart Hawkam—giving rise to the tide of the Qatabanian king as "firstborn of Anbay and Hawkam." Finally, other Qatabanian deities of minor importance are Warafu, Athirat, dhat-Santim, and dhat-Zahran.

The Hadramitic pantheon is the least known in southern Arabia owing to the fact that the number of known Hadramitic inscriptions is—compared to the three other states/languages—still very limited. At the top of the Hadramitic pantheon stood a deity whose name was constantly written SYN. This name was previously thought to be vocalized as Sin and thus connected with the well-known north Semitic moon deity Sin. However, the South Arabian orthography and the testimony of the *Natural History* of Pliny the Younger point to a vocalization, Sayin, so the form Sin should be abandoned. The Hadramitic sources give no hint of his nature, and even his connection with the moon is merely speculative.

In addition to those panthea at the "national" level, there was a large number of deities of regional or local importance that cannot be discussed in depth here, although of particular interest is the religious situation in the north of the Jawf. Several early city-states existed in this region, namely, Haram, Kamna, and Nashan, with their own rather distinctive panthea. For instance, in Haram the deities Halfan, Matabnatiyan, and Yudaa-sumhu were worshiped, whereas Madahwu and Nabal were venerated in Kamna, and in Nashan a deity called Aranyada was revered. The vocalization of these names is more or less guesswork, their etymology remains rather enigmatic, and a few do not appear to be Semitic at all. When the Minaeans conquered these cities, the local panthea disappeared from the texts but worship must have continued in the epigraphic "underground." When Minaean power diminished and they finally had to give up the northern Jawf, these deities reappear in inscriptions.

From the first century onward, North Arabian people

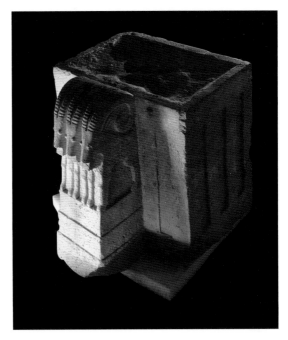

FIG 3 ALTAR WITH IBEX FRIEZE. THE JAWF, 7TH–6TH CENTURY BCE. ALABASTER: H 61 W 60 TH 50 CM. SANAA, MILITARY MUSEUM, MIM 120

FIG 4 LIBATION TABLE. MARIB, ALMAQAH, TEMPLE OF BARAN, POSSIBLY 1ST CENTURY BCE. LIMESTONE; L 84 W 36.5 TH 8.5 CM. MARIB MUSEUM, BAR 743.

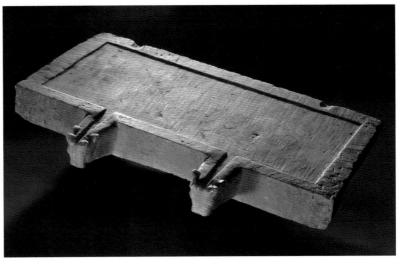

started to emigrate to southern Arabia, where they mainly served as soldiers in the Middle Sabaean army. They brought with them their own deities previously unknown in southern Arabia. Among these, the female deities (al-)Lat, (al-)Uzza, and Manat are well known, as they are mentioned in the famous Satanic verses of Sura 53 ("The star") of the Quran and in South Arabian texts of the first four centuries of the first millennium CE (FIG. 7). Their cult was confined to North Arabian immigrants; only (al-)Uzza was to some extent integrated into the South Arabian pantheon.

## RELIGIOUS INSCRIPTIONS

The inscribed material provides neither a clear picture of the nature of all those deities nor the mythological concepts of how they were interrelated, yet nevertheless they do offer some important insights into daily religious life. Most inscriptions belong to the category of dedications: many texts from old Sabaean times (about the eighth to fourth century BCE) contain only a short formula of the type "person A dedicated person B." It has been suggested that these texts bear witness to the sacrifice of human beings, but this seems quite improbable as South Arabian texts differentiate precisely between "dedicate" *(hqny)* and sacrifice *(dbh)*. Today, most specialists would agree that such texts do not testify to human sacrifice, but that the persons mentioned in such dedications were most likely given into the possession of the temple in order to fulfill some duties within it or simply to work for it. In Middle Sabaean times the formulary changes and the dedicated person is replaced by a bronze statue. Dedications of the type "person A dedicated to the deity B this bronze statue" are the most frequent type of text in the Middle Sabaean period.

Most Middle Sabaean dedicatory inscriptions are motivated by the hope that the deity will help with some problem, or they offer thanks for favor shown. There are two topics mentioned very often: victory in war and childbirth. Since the Middle Sabaean period was a time of constant war among the South Arabian states, it was quite natural that people expressed their gratitude for their return from the battlefield or for obtaining booty, and childless families or families whose children died prematurely asked for or thanked divine intervention for the survival of future offspring. Occasionally—if the deity showed favor—the dedicant promised to fulfill a pilgrimage or give some precious objects to the temple. In this context one of the most important functions of South Arabian deities has to be mentioned, namely, the oracle. All major deities were asked for oracular decisions in almost all circumstances of human life, such as when people started a war or when they hoped for children. There are a

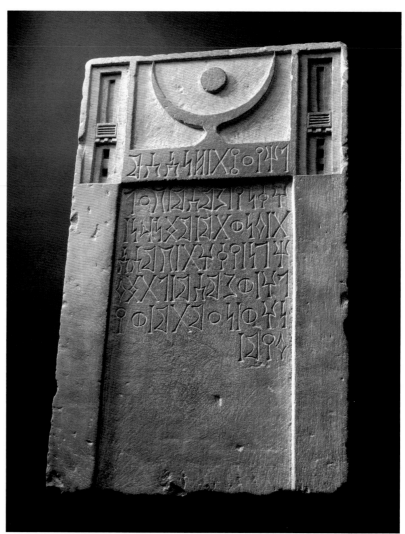

FIG 5 ALTAR DEDICATED TO THE SUN GODDESS SHAMS. POSSIBLY FROM MARIB, 4TH–1ST CENTURY BCE.

large number of texts in which some precious object is dedicated to the temple either because the dedicant had consulted the oracle or the deity had pronounced a favorable decision.

Pilgrimage played an important part in South Arabian religious life (FIG. 8). A large inscription from the third century BCE from the highland site of Riyam contains precise prescriptions as to when and how the pilgrimage to Talab of Riyam should be fulfilled, how many animals should be slaughtered during the days of pilgrimage, and what should be done in which temple.[5] Many inscriptions testify to an individual's successful pilgrimage to the temple of a certain deity, during which the temple and/or the local authorities have paid for the provisions of the pilgrim. This is also mentioned in the *Natural History* of Pliny the Younger, as his description of the religious life of the ancient Hadramitic capital, Shabwa, includes reference to the feeding of pilgrims by the deity SYN. The main temple of SYN in Shabwa is called *Im,* which may be related to Arabic *walima* (banquet) and thus confirm Pliny's story. Such cultic banquets, in which the deity feeds the pilgrims, are also attested in the inscription from Riyam mentioned earlier.

## THE RISE OF MONOTHEISM

The last three centuries of South Arabian history, the "Late Sabaean period," are often called the "monotheistic period." From the middle of the fourth century CE, the monotheistic religions of Christianity and Judaism started to replace the traditional South Arabian religions. The first monotheistic inscriptions are dated to the year 378 (or 383) CE, and from then onward there is no further witness of pagan worship. Certainly, the traditional religion did not cease overnight, but it is astonishing that pagan deities are not even mentioned after this date. Perhaps even before the rise of monotheism the traditional religions had already become weak and lost their attractiveness, but a decisive factor seems to be that the conversion started with the upper classes, as the royal family and the aristocracy were the first converts to monotheism, followed by the lower classes. This impression of a very rapid conversion to monotheism is strengthened by the fact that the epigraphic material mostly stems from the upper classes and does not reflect the situation of the lower social classes.

Byzantine church historians inform us that in the 330s CE, the Byzantine emperor Constantius (337–61) sent a Christian missionary to southern Arabia. However, his efforts appear to have been in vain: only Najran in the north (in present-day Saudi Arabia) became a famous center of the Christian religion and possibly the best known in the entire Arabian Peninsula. The monotheistic period, then, is mainly a period of Judaism. This is testified by Jewish words and phrases in Sabaean texts, even Jewish personal names, such as Yehuda, and the reference to the "tribe Israel."[6] In the Sabaean texts, "god" is called Rahmanan, the merciful, the "master of heaven and earth."

The best-known event in this last period of South Arabian history is without doubt the persecution of the Christians during the reign of the Jewish king dhu-Nuwas around 523 CE. This event is not only attested in three Sabaean inscriptions but also in Greek, Syriac, Arabic, and Ethiopic sources. The Jewish king

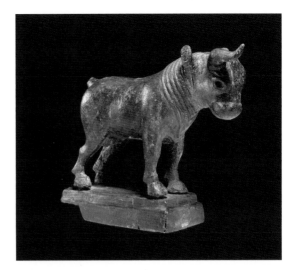

FIG 6 INSCRIBED BRONZE BULL DEDICATED TO THE GODDESS DHAT-HIMYAM. PROVENANCE UNCERTAIN, 1ST–2ND CENTURY CE. BRONZE, H 21 L 28 W 9.7 CM. THE BRITISH MUSEUM, ANE 1971-2-27,1

FIG 7 NECKLACE WITH AMULET OF THE GODDESS AL-LAT. TAMNA, PERHAPS 1ST CENTURY CE. GOLD; PENDANT H 3.4 W 4 TH 0.1 CM, CHAIN L 11.2 D 0.9 CM. THE AMERICAN FOUNDATION FOR THE STUDY OF MAN, TC 19

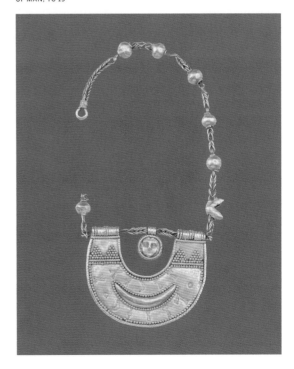

burned down Christian churches in Zafar and Hadramawt and finally attacked the center of South Arabian Christianity in Najran. The Christian population of Najran, with their leader Harith (Arethas in Greek), was slaughtered, an event that continues to be remembered in Byzantine and Oriental Christianity.

This persecution of the Christians of Najran led to a reaction from the Christian kingdom of Ethiopia, whose army invaded southern Arabia, killed the Jewish king, and established Ethiopian hegemony over at least the western part of Yemen. It was only during the following period of Ethiopian rule that Christianity played a dominant role in this region (from circa 525 to 575). The inscriptions of the Ethiopian viceroy and later king of Saba, Abraha, commence with the Trinitarian formula "in the name of god (Rahmanan!) and his Messiah and the Holy Spirit." Since there are very few Sabaean inscriptions from the period of the Ethiopian occupation, it is not known if Christianity was imposed on the whole population or whether it effectively remained a "court religion."

After the Ethiopians were defeated by the Sasanians in circa 575, the inscriptional evidence comes to an end, and the last phase of pre-Islamic Yemen remains in total obscurity until Islamic sources state that Badhan, the last Sasanian governor of the Yemen, converted to Islam in 628 CE.

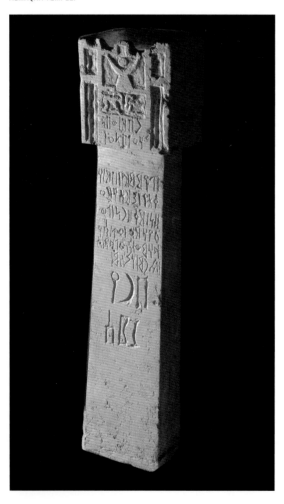

**FIG 8** INSCRIBED STELA. POSSIBLY FROM MARIB, END OF 8TH CENTURY BCE. LIMESTONE; H 85 W 40 TH 10 CM. SANAA, NATIONAL MUSEUM, YM 375. THE INSCRIPTION RECORDS THE DEDICATION OF THE STELA FOLLOWING A PRIEST'S PILGRIMAGE TO THE ALMAQAH TEMPLE.

END NOTES
1 AL-HAMDANI 1938.
2 RECENT OVERVIEWS OF THE SUBJECT OF THIS ESSAY INCLUDE BRETON 1999, 117–42.
3 GI 1720.
4 RES 2693
5 RES 4176.
6 A SYNAGOGUE HAS BEEN IDENTIFIED AT QANI.

MERILYN PHILLIPS HODGSON

# The Awam Temple

## EXCAVATIONS AT THE MAHRAM BILQIS NEAR MARIB

The Awam temple (Mahram Bilqis) near Marib, one hundred sixty kilometers east of the Yemeni capital of Sanaa, is the largest pre-Islamic temple in the Arabian Peninsula (FIGS. 1–2). Marib, capital of the kingdom of Saba, was, according to tradition, the city where the queen of Sheba lived and from which she ruled her kingdom. Mahram Bilqis ("sanctuary of Bilqis," the name for the legendary queen of Sheba in Islamic sources) is the temple's local designation. In Sabaean inscriptions it is called the Awam temple and described as Bayt Almaqah, "temple of Almaqah," the moon god who was the principal deity at Marib. Under the auspices of the American Foundation for the Study of Man (AFSM), two important series of campaigns have carried out excavations at the temple, with significant results for the archaeology and epigraphy of ancient Yemen.

The first series was launched by my brother, Wendell Phillips, who established the foundation in 1949 in Washington, D.C., with William Foxwell Albright, a leading biblical scholar and professor at Johns Hopkins University, as its vice president. In 1950, Phillips and Albright turned their attention to archaeological sites in Yemen, which had seen little scientific exploration. They selected for the first AFSM archaeological expedition in Yemen the site of Tamna, capital of the ancient kingdom of Qataban, in the Wadi Bayhan. With a team of thirty-one scientists, scholars, and specialists, AFSM conducted two highly successful campaigns there in 1950 and 1951. Excavations at Tamna yielded fine bronze and alabaster sculptures, historically significant ceramics, and major architectural monuments. Another key discovery was an inscription that provided the first proper order of the south Semitic alphabet.[1] At the nearby mound of Hajar ibn Humayd, the excavators dug through more than 15.5 meters of cultural debris containing ten visible strata. Carefully situated in the fork on the ancient incense route, the settlement at Hajar ibn Humayd was a frequent stop on the

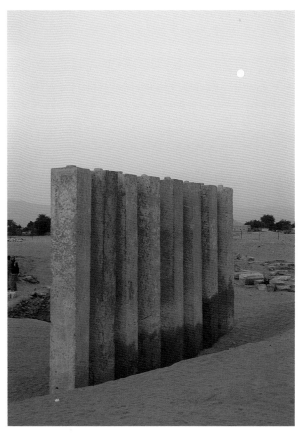

FIG 1 EIGHT PILLARS OF THE AWAM TEMPLE VISIBLE ABOVE ACCUMULATED SAND

well-traveled path. The finds from the earliest levels demonstrated that the settlement had probably been established between 1100 and 900 BCE.[2]

During these pioneering investigations, Phillips was invited to discuss the possibility of excavating the legendary temple site located three kilometers south of the ancient citadel of Marib. Few outsiders had ever been to Marib, and certainly no archaeological expedition had been allowed to excavate. When the foundation subsequently received permission to excavate, Phillips and field director Frank P. Albright proceeded to set up the expedition headquarters in Marib, not far from the monumental Great Dam on the Wadi Dhana. The Marib expedition began with determination and great enthusiasm, but it was plagued from the first day by hostile officials.

Only the tops of eight enormous pillars and upper sections of an oval wall were visible. Employing numerous local workmen and dozens of teams of oxen to remove centuries of windblown desert sand, the expedition uncovered a large hall lined with impressive pillars, stairways, and splendid bronze and alabaster sculptures.[3] Clearly, it was a much larger complex than previously imagined. Inscriptions recovered from the site, deciphered by the team's Belgian epigrapher, Albert Jamme, established the first firm footing for reconstructing the region's history.[4] On the exterior masonry wall of the enclosure, inscriptions revealed that a series of kings and priests had constructed various parts of the sanctuary. The Entry Hall, referred to as the Peristyle Hall, revealed the largest and most complete bronze statue of the seventh-century BCE ruler, the Madikarib (pl. 1). Now housed in the National Museum in Sanaa, it is the oldest datable object recovered from the interior of the Peristyle Hall. Jamme's transliterations of the pre-Islamic inscriptions, written in the Sabaean South Arabian dialect, indicated that the artifacts were primarily dedications to the ancient Sabaean moon god Almaqah. His research established the first record of historical proportion for South Arabia and remains a foundation and historical baseline for the entire region.

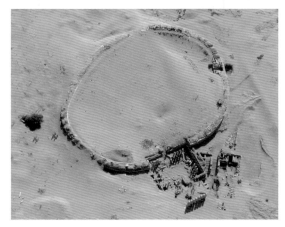

FIG 3 (ABOVE) PERISTYLE HALL, AWAM TEMPLE, PRIOR TO SAND REMOVAL

FIG 2 (BELOW) AERIAL VIEW OF THE AWAM TEMPLE (MAHRAM BILQIS), NEAR MARIB

Unfortunately, the Marib expedition ended suddenly, due to local political strife. With only four months of research and excavation completed, all expedition equipment and supplies had to be abandoned, along with the objects and inscriptions recovered. The team's written records did survive, however, and were incorporated into subsequent scholarly publications, including five volumes of archaeological reports published by the Johns Hopkins University Press. Wendell Phillips also wrote a popular and commercially successful account of the expedition in his *Qataban and Sheba*, published in 1955.[5] Phillips then moved his team to Oman, where they set up headquarters in Salalah. Over the next ten years they excavated a number of sites, including Sohar, Sumhuram, and Khawr Ruri.[6] Phillips also published accounts from the team's extensive work there, including *Oman: A History* and *Unknown Oman*.[7] Nevertheless, Phillips always hoped to return to Marib to continue excavations at the

Mahram Bilqis. Unfortunately, his untimely death prevented that wish from becoming a reality.

In 1980, I revived the AFSM in order to carry out Phillips's important work. Albert Jamme, epigrapher and original member of the Bayhan and Marib expeditions, negotiated a new agreement for permission to survey and excavate in the Wadi al-Jubah. In 1982, the foundation sponsored a team to launch a new expedition in the region and began to examine the border zone between Qataban and Saba chiefly to settle debates that had arisen over ancient Yemeni chronology. The team continued its investigations through 1987, applying its efforts to obtaining carefully excavated stratigraphic evidence. It is the pre-Islamic period that is best represented in the Wadi al-Jubah and the period upon which the project was shedding the most light; thus it became the era of principal focus for the AFSM campaign there. During geological reconnaissance work in the Wadi al-Jubah from 1982 to 1987, the team identified and recorded over one hundred sites, of which at least sixty produced stratified pottery and radiocarbon dates of the period circa 1500 BCE to 600 CE. This made it possible to defend a Late Bronze Age (circa 1550 to 1200 BCE) date for these pre-Islamic sites and give clear definition to the region's chronology.[8]

In 1997, the government of Yemen asked me to continue the work my brother had begun in Marib, and the foundation formulated a plan to carry out this goal. The team first set foot on the Mahram Bilqis site in March 1998. Conditions at the site mirrored those of the past, with only eight enormous pillars and the top of the Ovoid Precinct Wall visible above decades of accumulated desert sand, but the new AFSM team was equipped with photographs and field notes from the initial exploration and thus was able to begin its work with that important frame of reference.

Employing more than fifty local workmen and using wheelbarrows instead of oxen, the team began to remove sand and study the results. William D. Glanzman, field director, and Abdu O. Ghaleb, assistant field director, led an international team consisting of American, Yemeni, Canadian, and Palestinian scholars with expertise in geomorphology, epigraphy, archaeology, and ceramics. For the first time, the interior of the Ovoid Precinct Wall was excavated to a depth of five meters (sixteen courses). The inscriptions originally uncovered on the exterior of the Awam temple wall were exposed once again, and several important new ones were discovered. The team's surveyor generated digital topographic plans and three-dimensional models of the site, which would greatly aid future expeditions.[9]

The second season took place in December 1999, with many of the same team members and the added expertise of three Canadian ground-penetrating radar (GPR) specialists from the University of Calgary. A subsurface survey was carried out in the Peristyle Hall, Ovoid Precinct, and surrounding areas to aid in the detection of structures. Field data from this survey suggested the presence of architectural features in the Ovoid Precinct.[10] In addition to the survey, a major sand clearance operation was conducted in three trenches outside and inside the Ovoid Precinct Wall in part to assess the condition of the wall. Other team members began sifting one of the discarded sandpiles generated by the AFSM's

**FIG 4** REMOVAL OF SAND FROM THE PERISTYLE HALL USING ATV'S

**FIG 5** PERISTYLE HALL CLEARED TO PAVED FLOOR IN 2004, REVEALING REUSED INSCRIBED BLOCKS

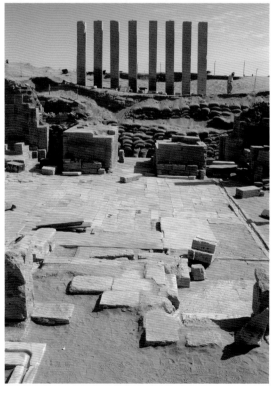

original excavation in 1952. A large quantity of artifacts was recovered and recorded, including fragments of alabaster, limestone, ceramic, copper, bronze, bone, charcoal, plaster, and mortar.

In the third season (April to May 2000), given the results of the 1999 GPR survey, we decided to remove the uppermost two meters of sand north of the Ovoid Precinct Wall by mechanical means. This saved the team countless hours of repetitive labor. New Sabaean structures and the first Sabaean fresco came to light. Excavations were also undertaken on the south side of the Peristyle Hall. The results of these three seasons proved that the Mahram Bilqis still had many more secrets to reveal. Excavations in 2000 uncovered a total of thirty-five new inscriptions in Epigraphic South Arabian.[11] By examining the many archival photographs from the original expedition, a plan of the sanctuary was converted to electronic data and computer-enhanced, and the distribution of artifacts recovered from within the excavated areas was plotted. As a result, many important relationships that had previously escaped notice, or had not been discussed in detail, were recognized.[12]

The wide publicity this project received generated great interest in the Mahram Bilqis, both from international experts and the public. The fourth AFSM season (April to May 2001) was carried out by the largest international team of scholars ever assembled for a Yemeni excavation. Among the many new discoveries were 126 inscriptions dating from the first half of the seventh century BCE to the third century CE. An inscribed bronze plaque was one of the season's most important discoveries. It was unearthed at the top of an archaeological layer dating to the third century CE, but the boustrophedon character of the inscription and its paleographical features indicate a date in the fifth century BCE. The inscription records a dedication to the Sabaean god Almaqah.[13] These inscriptions have provided significant evidence for the date of the associated architecture.

The project's fifth season, postponed because of the terrorist attacks of 11 September, 2001, took place in September 2002. The team focused on the conservation of the pillars and constructed scaffolding for their protection in preparation for the excavation of windblown sand from the Peristyle Hall (FIG. 3). Hunt Oil generously transported all expedition equipment, including four Honda All Terrain Vehicles (ATV's), wagons, and a conveyor belt, to Yemen. The task of excavation would have been expedited and would have allowed greater progress on new excavations, but, unfortunately, delays getting the ATV's through customs meant the team had to resort to the customary wheelbarrow-and-bucket method of sand removal. Some of this season's initial discoveries were not surprising, given the age of the temple and its harsh environment. Several fractures in the limestone pillar structures were observed, and significant portions of the recessed niches (false windows) were missing from position. A major architectural discovery was the appearance on the exterior of the Peristyle Hall of false windows abutting to the end of the Ovoid Precinct Wall.

We anticipated that the sixth field season (February to April 2004) would be the most productive and exciting season we had ever planned. Although progress was slow at first, the excavation of the Peristyle Hall surpassed all expectations. Incorporating two work shifts per day and utilizing our four ATV's, the monumental

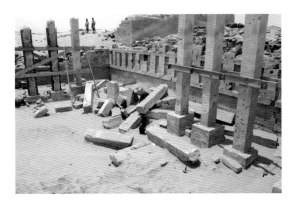

FIG 6 STABILIZATION OF LIMESTONE PILLARS IN THE PERISTYLE HALL

task was successfully completed (FIG. 4). This operation was an example of archaeology at its best: uncovering long-unseen structures, simultaneously discovering new inscriptions, and methodically analyzing the stratigraphy. The numerous epigraphic discoveries of this season were the most significant since those made by Thomas Joseph Arnaud in 1843, Joseph Halévy in 1870, Eduard Glaser in 1888, and Albert Jamme in 1952. The expedition not only rediscovered Jamme's published inscriptions within the Peristyle Hall but also found one hundred twenty new inscriptions throughout the hall: sixty in situ and sixty on blocks that were reused as building material for the pavement (FIG. 5). A veritable Sabaean library was emerging, as Mohammed Maraqten's separate article in this volume observes.

Excavations in the area adjacent to the north of the Peristyle Hall revealed a monumental doorway leading into the hall. Used as an entrance at one point, this doorway was later blocked with reused limestone blocks. The doorway is flanked by two pediments that bear two copies of a monumental inscription. The inscription mentions the Sabaean king Alhan Nahfan, dated to the beginning of the third century CE, who subjugated the rival kingdom of Hadramawt. Across from this doorway, a large courtyard was uncovered, together with a stairway leading to unidentified chambers. At one end of the courtyard were benchlike stone seats. Another major focus of the season's work was to continue excavation of the Northwest Doorway, which Wendell Phillips and his team had begun in the 1950s. When completed in 2004, the excavations exposed a massive gate consisting of interior and exterior doorways enclosing a narrow passage. Based on the details in the construction, such as bronze door sockets, pivots, and bolts for multiple doors, it was clear that the building techniques were highly sophisticated and that security for this area was of prime importance. The passage roof had been lined with timbers that had been subsequently burned, but the grain in the wood was clearly visible. Detailed drawings illustrating the location of the burnt timbers and associated mud-brick debris surrounding them were completed. In addition, a structural engineer who joined the team was able to develop and implement a stabilization program for the pillars. His expertise in the construction of ancient structures, combined with his ingenuity, allowed the creative use of materials available locally to stabilize the pillars safely until the next season (FIG. 6).

In its 2004 fall season (August to October 2004), the expedition's emphasis was on preparation of the Peristyle Hall pillars for restoration work. Hunt Oil and INTRACS generously provided a crane, crew, and support staff that facilitated the removal and transport of the pillars—which range in weight from four to nine tons—to "hospitals" located east and west of the Peristyle Hall (FIG. 7). Thirteen massive columns were transported: ten previously standing pillars, one that had fallen, and one massive standing door jamb plus its partner that had fallen. Numerous fragments were also relocated.

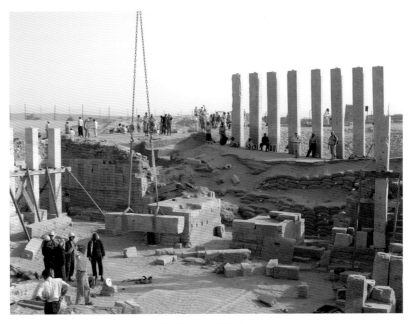

FIG 7 REMOVAL OF LIMESTONE PILLARS FROM THE PERISTYLE HALL IN PREPARATION FOR RESTORATION PROJECT

Important architectural discoveries took place in Area A, which seems to have been part of a processional route connecting the old city of Marib with the temple.[14] We uncovered additional rooms, a stairway, inscriptions, and more of the courtyard with pillars and limestone benches along the entire perimeter (FIG. 8). It seems to have been a place for contemplation or ceremony. The stonework showed that the buildings had undergone reconstruction through different architectural styles as well as functional changes. An oven and animal bones, indicating a kitchen area, were found here. A total of one hundred eighty artifacts came to light, in addition to more than sixty new Sabaean inscriptions, which are now being studied. Radiocarbon dating of samples from this area has shown that it was constructed much earlier than previously thought, closer to 400 BCE.

In February 2005, an Italian team of reconstruction experts visited the site to analyze and provide their professional diagnosis and recommendations. The implementation of their plan is scheduled for fall 2005. As of this writing, the AFSM is in final preparations for its spring 2005 season, with plans to center on the excavation of several squares of the Ovoid Precinct. Excavations will continue in the courtyard of Area A, and geological investigation of the surrounding areas will also continue. The topographic map and architectural plan will be updated based on the most recent information.

The results of the AFSM's ongoing excavations at the Awam temple amply demonstrate that the site holds all of the great potential envisaged by Wendell Phillips when he undertook his unexpectedly short, but immensely productive, season in 1951–52. In particular, the rich epigraphic harvest that has already been made will allow new chapters in the history of pre-Islamic South Arabia to be written. Further investigation of the architecture and construction methods, and continued analysis of the artifacts that have come to light, will contribute critical new information on the cultural and technological achievements of Yemen's ancient inhabitants.

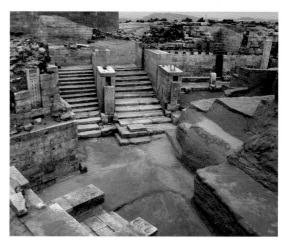

FIG 8 AWAM TEMPLE, AREA A, MONUMENTAL STAIRWAY

ENDNOTES
1 HONEYMAN 1952.
2 VAN BEEK 1969.
3 BOWEN AND ALBRIGHT 1958; CLEVELAND 1965.
4 JAMME 1962.
5 PHILLIPS 1955.
6 ALBRIGHT 1982.
7 PHILLIPS 1966; 1967.
8 FIVE VOLUMES DESCRIBING THE RESULTS OF THE WADI AL-JUBAH EXPEDITION HAVE BEEN PUBLISHED TO DATE, ALONG WITH SEVERAL SCHOLARLY ARTICLES; FOUR ADDITIONAL VOLUMES ARE PLANNED.
TOPLYN 1984; BLAKELY, SAUER, AND TOPLYN 1983; GLANZMAN AND GHALEB 1984; OVERSTREET, GROLIER, AND TOPLYN 1985; GROLIER, BRINKMANN, BLAKELY, AND OVERSTREET 1987.
9 GLANZMAN 1999; 2002.
10 MOORMAN, GLANZMAN, MAILLOL, AND LYTTLE 2001.
11 MARAQTEN 2002.
12 MOORMAN, GLANZMAN, MAILLOL, AND LYTTLE 2001.
13 MARAQTEN AND ABDULLAH 2002.
14 MARAQTEN 2004.

MOHAMMED MARAQTEN

# The Awam Temple

RECENT EPIGRAPHIC DISCOVERIES AT MAHRAM BILQIS

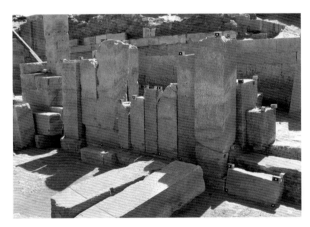

The Awam temple, or as it is known today, the Mahram Bilqis, was the main temple of the Sabaean national moon god Almaqah. There is no place in pre-Islamic Arabia, and especially in Yemen, that has yielded such a large number of pre-Islamic inscriptions. As of this writing, more than six hundred Sabaean inscriptions have been recorded from the Mahram Bilqis. Most of them were found during the excavations of the American Foundation for the Study of Man (AFSM) at the beginning of the 1950s. As a result of the recent excavations by the AFSM, more than one hundred fifty new inscriptions have come to light. These Sabaean inscriptions are not only the longest ones known but are also the most significant. Without them, it would not be possible either to write a Sabaic grammar or compile a Sabaic dictionary. The state temple Awam, which is located about 3.5 kilometers south of the ancient city of Marib, was not only the largest temple in pre-Islamic Yemen but also the most significant religious institution in the country. Its heyday stretched from the beginning of the first millennium BCE to the rise of monotheism at about the end of the fourth century CE. In addition, the Awam temple had a highly significant socioeconomic function in Sabaean society and was the main pilgrimage site in ancient Yemen.

## RECENTLY DISCOVERED AND PREVIOUSLY DISCOVERED INSCRIPTIONS AT THE MAHRAM BILQIS

Recent epigraphic discoveries have been made during the archaeological excavations at the Awam temple undertaken by the AFSM since 1998 under the direction of Merilyn Phillips Hodgson. The archaeological investigations continue the earlier efforts of Wendell Phillips carried out for AFMS at the site between November 1951 and February 1952. Seven seasons of excavation have now taken place through the AFSM's renewed efforts, and the discoveries include the excavation of

new buildings outside the temple's Ovoid Wall, significant artifacts, and a sizable collection of previously unknown inscriptions. Prior to the latest excavations, about two hundred fifty long inscriptions were known primarily from the Peristyle Hall uncovered by the AFSM and read by Albert Jamme.[1] Others were published by Mutahhar Iryani and other scholars.

In the hall, hundreds of recovered inscriptions were dedicated to Almaqah over a span of several hundred years. Dozens of inscriptions were reused in the restoration of a later pavement of the Peristyle Hall toward the end of the third century CE and the first half of the fourth century CE. In addition, dozens of inscribed bronze plaques were attached to pillars inside the Peristyle Hall and to the walls of the entrance passage of the temple on the northwest side. Many iron and bronze nails used to attach these plaques are still in situ. Fortunately, one such bronze plaque was discovered during the 2001 season.[2]

Other important inscriptions were found on the outer face of the Ovoid Precinct Wall. Since the Peristyle Hall and the temple's Ovoid Wall were reburied by sand, a first goal of the AFSM excavation in 1998 was to uncover the north and the northwest sides of the external oval wall, which was successfully excavated that year. Fortunately, most of the inscriptions from the long wall were found to be intact, and are still in situ.

The most significant epigraphic discoveries came to light in the year 2004, by which time two seasons of excavations had already been carried out. In the first season (February to April 2004), one hundred twenty long inscriptions were discovered. About half of the long inscriptions, sixty to be precise, were discovered in situ in the Peristyle Hall; the other half came from secondary reused contexts either in the pavement or in numerous structures inside the Peristyle Hall. Some of the reused inscriptions had fallen down not far from where they were first placed and could be returned to their original location. In the second season (September to October 2004), forty-six long inscriptions were found primarily in the pavement of the Peristyle Hall.

Fortunately, more than half of the long inscriptions recovered by Wendell Phillips's expedition in the 1950s were relocated this season. Many small inscriptions from the earlier expedition, however, had been removed in the intervening decades. Most of the long inscriptions published by Jamme are still in situ in the Peristyle Hall, but his publications did not include photographs or a description of their location. Yemeni scholars, namely Mutahhar Iryani, Zayd Inan, and Ahmad Sharufuddin, have also published a number of inscriptions from the Mahram Bilqis. Some of these inscriptions were also rediscovered in the Peristyle Hall. Among them is an important inscription, published by the Egyptian scholar Khalil Nami, that tells us about a South Arabian war ceremony. Perhaps the most interesting text was possibly a literary one published by Zayd Inan[3] and one similar in script and style found beside it.[4] Fortunately, all these inscriptions were relocated by the AFSM.

The most impressive aspect of the discovery of these inscriptions is the context. They are found between two rows of inscribed blocks and small pillars that were still in situ between the staircase and the southeast corner of the Peristyle Hall (FIGS. 1-2). Another row of inscribed pillars lies in the southwest part of the

Peristyle Hall (FIG. 3). Most of these inscriptions are also still in situ while others had fallen down near their original position.

We found more than one hundred inscriptions consisting of at least three lines, and others exceeding forty lines, reused in the pavement (FIG. 4). They were located in the middle, the north, and the southwest corner of the Peristyle Hall. In addition, three long inscriptions were discovered reused in the pavement between the main gate of the Peristyle Hall and the eight outer pillars.

An important epigraphic discovery was also made in the area west of the Peristyle Hall (Area A). One of the greatest finds of the season from February to April 2004 was the formal gate of the Sabaean king Alhan Nahfan, which dates from the end of the second century and the beginning of the third century CE. Two inscriptions in relief document the actual construction of the gate. Subsequently, the gate was blocked up by the end of the third century CE. Among these western gate blocks are six reused inscriptions that mention the king Nasha'karib Yu'min Yuharhib, king of Saba and dhu-Raydan. Three similar inscriptions were reused in the east side of the gate.

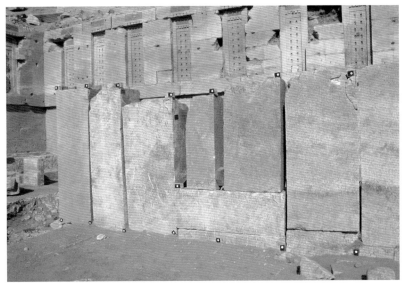

FIG 3 INSCRIBED PILLARS IN SOUTH-WEST PART OF PERISTYLE HALL

In addition, three inscriptions in black paint came to light in this area, one in monumental script and the other two in the so-called minuscule script, which was usually used for writing on palm leafstalks (petioles).

More than one hundred fifty of these new inscriptions not only increase our knowledge of the Sabaic language in general but also contribute important data to the cultural, social, and political history of ancient Yemen. These discoveries perhaps have the most significance, however, because they allow us to recheck the readings of many of the inscriptions that previously had never been published in photographs.

In my opinion, the Awam temple contains the most significant Epigraphic South Arabian documents that have been ever discovered in Yemen. Although the primary function of these hundreds of inscriptions was dedicatory, they may be likened to an actual library or repository similar to the archives kept in Mesopotamian or Egyptian temples. These records are thus one of the most important archives for reconstructing Yemen's ancient cultural history.

THE TYPOLOGY AND CONTENTS
OF THE DEDICATORY INSCRIPTIONS

The majority of the texts recovered from the temple are dedicatory. They are primarily inscribed on blocks that served as the bases for small or large statues. The inscriptions themselves usually state that so-and-so dedicated a statue of bronze for Almaqah. These statues have usually been lost in antiquity, but some have been found by the AFSM. Ordinary and important persons in the kingdom of Saba, as well as the kings themselves, made these dedications. What was the function of this temple, and why did the people of ancient Yemen make all these dedications?

First, this temple was a sacred place of "refuge," which can be determined from its name, Awam / 'wm, which means "protection, place of refuge." Another important function of the temple was "thanksgiving." The temple provided a place for ordinary people and supplicants to thank the god Almaqah, whom they believed was responsible for their safety, deliverance, protection, and healing. Thus the main purpose of the offerings was to fulfill the petition of the supplicant: to grant children, save and deliver the dedicator from a sickness, return safely from a journey or a military campaign, and the like. The newly discovered dedicatory inscriptions also increase our knowledge of the political, social, and religious history of ancient South Arabia. Take, for example, the topic of international relations of ancient Yemen: two new inscriptions provide considerable new information. One mentions a royal messenger, who joined an embassy of the Himyarite king Shammar Yuhar'ish (first third of the fourth century CE) who was sent to Ethiopia.[5] After his return, he gave a dedicatory offering to Almaqah for his safety. Another inscription mentions two royal messengers also from the time of Shammar Yuhar'ish, who carried out a journey to the Roman caesar (kysr) in Syria-Palestine ('smt).

Several inscriptions were dedicated by women. In one example, a woman who had suffered a stillbirth made a pilgrimage to the Awam temple and gave thanks to Almaqah, since he saved her own life.[6]

## WALL INSCRIPTIONS

On the primary exterior oval wall of the Awam temple, several engraved inscriptions, which span several generations, chiefly record the temple's building activities. These building inscriptions document the construction of the temple from at least the seventh century BCE until the first century CE. In the 1998 season, we uncovered an inscription previously published by Jamme.[7] Its companion inscription had been removed from the temple after excavation, however, and in the 2004 season we were able to recover just one inscribed block from it.[8] Unfortunately, Jamme published most of these inscriptions without corresponding photographs.

## LEGAL INSCRIPTIONS

By 2004, we had identified twelve long legal documents among the inscriptions. These inscriptions were found primarily in Area A, engraved on the passageway proceeding towards the northwest corner of the Peristyle Hall. A few examples from these texts illustrate their contents and importance.

One group provides data about the regulations for visiting the temple. Others contain proscriptions against letting animals enter the sacred precinct of the Awam temple. If a person's animal went inside the temple, the owner of the beast had to pay a penalty to the king. The inscription continues: "and if camels, horses, mules, baggage camels and donkeys should enter [the sacred precinct of the temple] a penalty should be paid for every single (offending) livestock."[9]

A decree for the protection of the visitors or pilgrims to the temple also has been discovered. This inscription furnishes information about a road connecting the old city of Marib with the Awam sanctuary.[10] Another two-line Middle Period Sabaic rule is inscribed on the exterior Ovoid Wall of the temple, mentioning that visitors are not allowed to stay in certain specified places within the temple.[11] Other inscriptions deal with the organization of (animal) sacrifice at the Mahram Bilqis.[12]

Several inscriptions provide information about public law. A proscription against homicide was discovered in the 2002 season.[13] This royal stricture prohibits the killing of temple patrons. If a homicide has been committed, the person responsible for the murder will be executed in a like manner. Furthermore, a legal document from the time of Nasha'karib Yu'min Yuharhib, king of Saba and dhu-Raydan, and his servants Saba and Fayshan (end of the third century CE) adds several decreed rules as well. Among them is punishment against anyone who steals from the temple of the deities (*mhrmt / 'l'ltn*) and against anyone who robs the cemetery (*qbrn*). In addition, a twenty-line legal document discovered last season was reused in the pavement of the Peristyle Hall.[14] This text provides a wealth of data concerning the regulation of social affairs at the temple.

Finally, we have new discoveries about the real estate property of Almaqah. One legal document describes the regulation of the cultivated land of Almaqah, which belongs to the Awam temple, *'r / 'lmqh / b'wm* "The land of Almaqah in Awam."[15] In this text, the name Awam is used not only as a name for the temple but to designate the whole surrounding area.

## DATING OF THE INSCRIPTIONS AND THE CONSTRUCTION OF THE AWAM TEMPLE

Most of the recently discovered inscriptions are from the Middle Sabaic period (first century BCE to the end of the fourth century CE), and in particular from the time of Ilsharah Yahdub and his brother Ya'zul Bayn (mid-third century CE) or his son Nasha'karib Yu'min Yaharhib. We have also found some inscriptions stretching back to the eighth and seventh centuries BCE (Early Sabaic period) as well as some from the Late Sabaic period (end of the fourth and perhaps the early fifth centuries CE).

ENDNOTES

MB REGISTRATION SIGLUM OF INSCRIPTIONS
    DISCOVERED BY THE AFSM EXCAVATIONS
    AT THE AWAM TEMPLE (MAHRAM BILQIS).
    L998-2004
JA INSCRIPTIONS PUBLISHED IN JAMME 1962.
1 JAMME 1962.
2 MB 2001 I-20.
3 MB 2004 I-94.
4 MB 2004 I-95.
5 MB 2004 I-99.
6 MB 2004 I-109.
7 JA 552–557.
8 JA 551.
9 MB 2000 I-7.
10 MB 2002 I-20.
11 MB 1998 I-10.
12 MB 2000 I-110.
13 MB 2002 I-5.
14 MB 2004 I-100.
15 MB 2002 I-6.

BURKHARD VOGT

# Conservation and Tourism

## THE ALMAQAH TEMPLE OF BARAN

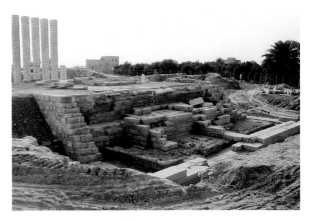

**FIG 1** BARAN TEMPLE. REAR VIEW OF TEMPLE PLATFORM, WITH FOUNDATIONS OF EARLIER BUILDINGS (9TH CENTURY BCE)

The sanctuary of Baran, which has been continuously excavated since 1988, had suffered severe damage from weathering and uncontrolled access by visitors, and signs of decay were visible everywhere. For this reason, we decided to carry out interim consolidation measures on the monument. This undertaking developed into the first comprehensive conservation project on an archaeological site in Yemen, which, at least for the Marib oasis, makes it a model for such endeavors. The experience gained here was later applied to similar projects, such as the program at the Great Dam of Marib begun in 2002. The work carried out at Baran through 1998 was financed exclusively by the German Archaeological Institute (DAI). For work in 1999 and 2000 we are grateful for the substantial support of the Ministry of Economic Cooperation of the Federal Republic of Germany as well as from numerous donations from German companies.

The Almaqah temple of Baran was one of the most important sanctuaries of the Sabaean capital (FIG. 1). Founded at the latest in the ninth century BCE in the midst of ancient fields in Marib's southern oasis, the temple precinct developed from a comparatively simple temple to a complex that encompassed the sanctuary proper, workshops, a temple kitchen, and other smaller working quarters. The precinct was used continually for at least 1,500 years before it was abandoned, covered with windblown sand, and then used as a stone quarry in the middle of the twentieth century. This long history perhaps offers the explanation for why four temple buildings were erected in turn, each upon the foundation walls of its predecessor with lateral extensions gradually expanding the surface area of the sanctuary a considerable distance westward. The rebuildings and expansion, together with simultaneous sedimentation in the outer enclosure of the precinct, introduced considerable differences in ground

consistency and height that very strongly influence the appearance of the now completely revealed ruins.

The basic consideration in carrying out the excavation work was our desire to preserve the temple in its architectural and stratigraphical development, its basic proportions, significant differences in height, and its very varied ancient building materials. Thanks to a safe and visitor-friendly guide route, the complex was then to be made accessible to a broad public.

As the condition of the ruins only rarely gives clues about the former elevation of the individual buildings, reconstructive measures had to be kept at a reasonable minimum. In its present condition, the appearance of the sanctuary can therefore be regarded as scientifically secure, and the measures carried out have obviously been proven successful during the time since completion of the work. The techniques and building materials used in the conservation were intended to be reversible, and an effort was made to render the conservation measures relatively inconspicuous but still perceptible by surface decoration and occasionally also by color modification of certain materials. In addition, solutions that would have required technically sophisticated expertise were avoided as far as possible, because the subsequent need for continual maintenance of the monument could hardly have otherwise been fulfilled given prevailing local conditions. A further aspect of the conservation was involvement of specialized Yemeni professional workers who were able to apply their experience in traditional building techniques and materials.

The conservation measures were planned in advance within the framework of the overall program, but the concrete realization of each measure required constant adaptation to the current local conditions, which in turn led to a continuous exchange of information between architects, archaeologists, and others concerned. Despite the handicaps described here, we still succeeded in keeping the overall costs low in such a way that, bearing in mind the general development plans for the district of Marib, they appear to be reasonable and justifiable.

## RECONSTRUCTIVE MEASURES

Our main task was to secure the five and a half monolithic limestone pillars that were erected during the sixth to fifth century BCE to mark the entrance area of the temple proper (FIG. 2). The first step was to rebuild the platform to its original level, with low walls moved slightly inward. Accurately separated by inserted plastic strips, the six pillar pedestals were integrated with each other in a base plate made of concrete. The bases of the pillars, which are set by only 1.5 centimeters into their appropriate pedestals, were individually enlarged to double the base area using steel tentering produced in Germany especially for this purpose, so that extreme winds and even earthquakes would cause less damage and so that the pillar bases on the whole would be protected against erosion. Damaged parts of the monumental stairway leading up to the propylon were repaired, and the two stringboards of the steps were adjusted and secured.

The temple podium east of the propylon suffered in particular from stone quarrying in the 1940s, when the outside wall of the platform was demolished along almost its entire length and the stones were reused for building the gover-

FIG 2 WESTERN FORECOURT AREA WITH GALLERIES

FIG 3 SOUTHERN GALLERY WITH TEMPLE FORECOURT DURING THE CONSOLIDATION WORK

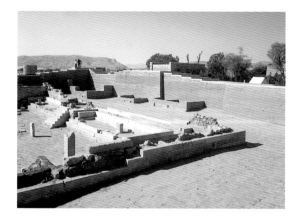

nor's palace in Marib. As a result, the ancient, artificially deposited core of the platform was laid bare, and in the few years following the archaeological excavation several occasions of heavy rain and the strong wind caused very severe erosion, endangering the remnants of the central temple cella and the plaster in the inner courtyard. For this reason, solid supporting walls were erected on the preserved foundations of the platform walls, again shifted slightly inward, to secure the remaining ancient substance of the building and its fill material. However, supporting walls were not placed on the eastern part of the platform, which had been particularly damaged by the stone quarrying. Here, the foundation walls of the former buildings of the temple, dating back at least to the ninth century BCE, are now visible in unaltered form. On the platform itself the foundations of the ambulatory were reconstructed in part and the position of the pillars were indicated with pillar stumps in selected places. The measures carried out on the temple platform and the propylon reconstructed the most significant portions of the sanctuary so that the visitor can gain an idea of the impressive monumentality of the site.

FIG 4 CONSOLIDATED MUD-BRICK WALL ON THE WESTERN SIDE OF THE FORECOURT

## WALL FACEWORK

In the temple forecourt, which dates to the fifth century BCE, parts of the damaged steps and limestone facework had to be replaced or carefully repaired. In the galleries of the forecourt some alabaster benches had to be adjusted and paving slabs reinstalled (FIG. 3). The stone altars were put back where we had found them during the excavation. We also took great trouble with the consolidation of the much better preserved south gallery of the forecourt. Here, individual pillar stumps were replaced in their original positions, and the cast of a complete, approximately three-meter-long votive relief was fixed into the back panel.

## QADHAT

The galleries on the eastern side of the forecourt were heavily damaged, probably around the time of Jesus, when the original wall paneling with alabaster reliefs (FIG. 4) and the alabaster benches ripped out and replaced by a thick plastering or constructions made of *qadhat*. This waterproof and weatherproof plastering mixture is still produced in Yemen today according to traditional recipes, and this same material was therefore used in conservation work, such as sealing the tops of walls. In areas where the use of *qadhat* was not appropriate, open rubble and rubble-packed walling were consolidated with mortar, e.g., on the well in the forecourt or in the outer walls in the northeast area of the temple precinct.

## MUD BRICKS

Tens of thousands of sun-dried bricks were produced from local loam. The bricks were used without exception for the repair of the outer mud-brick

surrounds in which heavy eroded bricks had to be replaced with new ones (FIG. 4). These walls were also given a modern drainage system, plastered on their faces with loam mortar, and their tops covered with two layers of baked bricks anchored in loam or plaster to provide protection against the effects of the weather.

## DRAINAGE

The whole outer area was carefully leveled and the site enclosed with a modern steel fence. Despite the low precipitation of the region, the larger areas within the sanctuary and the outer areas were all sloped slightly outward to facilitate drainage of water. In the outer courtyard large drainage pipes were laid underground to carry rainwater into an adequately sized water tank south of the sanctuary.

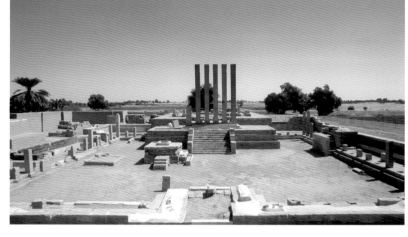

FIG 5 TEMPLE PLATFORM WITH NEWLY ERECTED GALLERY, PROPYLON, AND WELL IN THE FORECOURT, FOLLOWING CONSERVATION

## GUIDE ROUTES

Opening the Baran sanctuary to tourists made it necessary to lay a visitors' path that leads from the asphalt road to the northwest bastion of the outer mud-brick surrounding wall. Here, the wall was extended to form a visitors' platform that is accessible via a concealed modern steel stairway and from which the visitor can view the whole temple complex (FIG. 5). Visitors can reach the outer courtyard in the north via a hardened entrance originally built in late ancient times, from which they can proceed into the forecourt of the sanctuary. A small ancient passage in the northeast of the surrounding wall allows access to the rear outer area of the temple. The temple podium, with its ambulatory and central cella, can be viewed from a second visitors' platform with a separate stairway. At all-important points along the pathway, notice boards have been erected or affixed with short texts in Arabic, German, and English to explain the history and function of the individual components of the temple.

**FURTHER READING**

SCHMIDT, J. 1997–98. "TEMPEL UND HEILIGTÜMER IN SÜDARABIEN. ZU DEN MATERIELLEN UND FORMALIN STRUKTUREN DER SAKRALBAUKUNST." *NÜRNBERGER BLÄTTER ZUR ARCHÄOLOGIE* 14:10–35.

VOGT, B., W. HERBERT, AND N. RÖRING. 2000. *"ARSH-BILQIS": DER TEMPEL DES ALMAQAH VON BAR'AN IN MARIB.* SANAA: DEUTSCHES ARCHÄOLOGISCHES INSTITUT.

BURKHARD VOGT

# Death and
# Funerary Practices

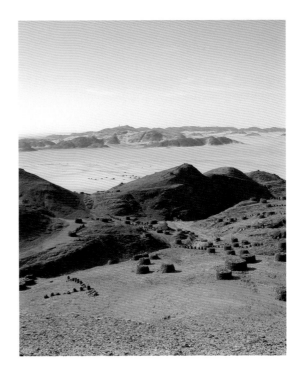

The ancient South Arabians believed in an afterlife and the existence of an inner essential self. As in many early societies, the purpose behind the arrangements made and the care and expenditure invested in the burial customs was not only the destiny of the dead but also the manifestation and preservation of the social order. This is suggested by representative funeral monuments, the preparation of the corpses for final disposal, post-funerary attendant rites, food offerings, and other grave goods, as well as by written sources. Inscriptions have been found on many tombs, gravestones, and accompanying grave goods: in most cases these record the name of the deceased and his or her genealogical and tribal affiliation.[1] Others report on the purchase and the construction of tombs or express a warning that, for example, the god Athtar will slay those who desecrate the burial. Explicit references to an underworldlike realm of the dead or a South Arabian god of death, however, are unknown.

The afterlife was also linked in a more visible manner to this life and the sphere of religious worship in particular. To benefit beyond death from divine assistance, man sometimes sought to construct his final resting place in the vicinity of temples outside the towns. The most prominent example is the temple of Awam in the oasis of Marib, which, as the national sanctuary of the Sabaeans and the major pilgrimage center of all southern Arabia, also became a central burial place (FIG. 1). Further amalgamations of religious and funeral rites were manifested in the construction of mortuary chapels, such as in the cemeteries of Tamna and Shuka, and also the design of mausolea with pillared porticoes at Marib and Tamna, which replicated the architecture of South Arabian podium temples.

TYPES OF BURIAL

In general, graves were arranged in cemeteries located immediately outside the

FIG 1 (BELOW) AWAM TEMPLE
CEMETERY, FUNERARY STELAE

FIG 2 (ABOVE) JABAL RUWAIQ, TURRET
TOMB CEMETERY CONSTRUCTED IN THE
3RD MILLENNIUM BCE

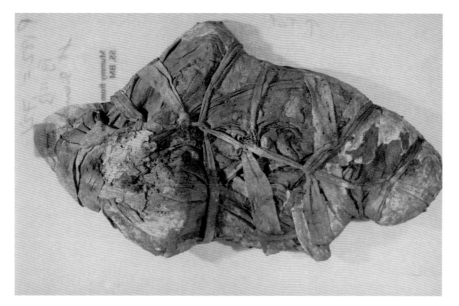

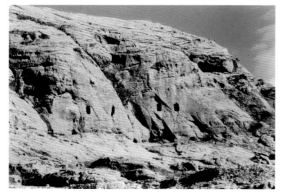

FIG 3 (BELOW) SHIBAM AL-GHIRAS, ROCK-CUT TOMBS CONTAINING MUMMIES

FIG 4 (ABOVE) WRAPPED MUMMY, MID-1ST MILLENNIUM BCE, SHIBAM AL-GHIRAS

town walls, within abandoned intramural areas of settlements, or sometimes inside houses. Similarities in the orientation of tombs or corpses can only be distinguished on a local basis. During the first millennium BCE the South Arabians inaugurated a prolific tradition of funerary architecture that varied greatly through space and time. The types of collective, multiple, and single burials, the use of building materials, and the furnishing of tombs were planned to reflect the status of the deceased (as well as of the bereaved), and the builders took special action to minimize looting.

The lengthiest tradition was that of collective burials, which dates at least to the third millennium BCE, while the latest have been recorded on the Jabal al-Lawdh, where they were found in the basement of houses possibly occupied as late as the fourth or fifth century CE.[2] The nomadic component of first-millennium-BCE society continued the use and construction of the overground turret tombs in particular, thousands of which were traced in the desert far away from any settlement (FIG. 2). Since these align with trade routes it has been proposed that they represent people who were also in charge of the caravan trade in frankincense, aromatics, and other commodities.[3] Such tombs housed the remains of several individuals, who were placed side by side or one on top of the other without visible spatial borders, thus expanding the social organization of the community of the living into the world of the dead. Multiple burials were also common during the heyday of the South Arabian kingdoms in the first millennium BCE but are locally documented, for instance, in the highlands or the port town of Qani, as late as the fifth century CE. Among these were rock and cave tombs that were planned as clan and family crypts, whereas single burials in rock tombs are less well known. They were cut into slopes and steep escarpments, which would require the abilities of mountaineers both during construction and burial; nevertheless, they failed to escape systematic looting. The best-known examples are those in the Yarim, Sanaa, Kawkaban, and Mahwit highland areas. Their architecture shows a wide variation in size, design, and execution, ranging from small single chambers to several rooms with rectangular, circular, or oval plans. The walls, sometimes plastered with gypsum, have smaller niches for the deposition of funerary sculpture and other grave goods, or larger alcoves in which the bodies were placed in a flexed position (in other cases the bodies were simply placed on the floor). Access to the caves was provided by a door in a facade, which, unlike the rock tombs of northern Arabia (such as Madain Salih), bears little or no architectural ornamentation. However, more attention was paid to those that were dug into the slopes because of the rubble and other detritus as well as the need for repeated opening of tombs during successive funerals. Entrances were furnished with a dromos-like access, sometimes with ornamented ashlar masonry, as at Shabwa.[4]

The cave tombs at Huraydah and Raybun give a glimpse of burial customs in Hadramawt during the first half of the first millennium BCE. Tomb A5 at Huraydah contained forty-two individuals of all age groups and both sexes. The crania and long bones were grouped with mostly complete pottery vessels laid out on the floor without clear separation. It seems possible that the bones were removed from the alcoves of the tomb after the decomposition of the soft tissue. A secondary, ossuary-like arrangement of skeletal remains is eventually suggested by a separate group of fifteen crania set in two rows without the mandibles or any grave offerings.[5]

At Raybun some cave tombs were supplemented with camel burials farther downhill, which were made during the later occupation of the cave tombs.[6] In addition, in 1983 a number of mummies were discovered in rock tombs at Shibam al-Ghiras near Sanaa dating from the second half of the first millennium BCE (FIG. 3). The bodies, bearing traces of rudimentary embalming, were found in a flexed position and wrapped in a large leather bag and accompanied by a few personal grave goods (FIG. 4).[7] The custom of mummification thus may be expressive of a notion that the soul was incarnated in the body and consequently that the body was essential for a proper afterlife.

Funerary architecture reached its fullest development with the construction of multistoried mausolea in the Hayd ibn Aqil cemetery outside the ancient Qatabanian capital of Tamna and the Sabaean necropolis of the Awam temple in Marib. Both cemeteries contain multiple burials, that is, a high number of individuals belonging to well-defined social units buried together in one place but in clearly separated loculi. It implies that both mausolea and cemeteries witnessed lengthy use, which at Hayd ibn Aqil may have ceased with the abandonment of Tamna in the second century CE and which at Marib lasted at least from the ninth or eighth century BCE to the fourth century CE. The inventories of both cemeteries provide the most reliable reference system for the classification of South Arabian grave goods so far.

The Hayd ibn Aqil cemetery is situated on the slopes of an outcrop. The mausolea, surviving to a height of two to four meters, were built of quarried schist and possessed several superimposed chambers separated by floors made from slabs. Each chamber comprised eight to ten crypts of about two meters in length and one meter in width arranged at regular intervals on both sides of a central corridor.[8]

The Awam necropolis at Marib developed into a proper and well-organized city of the dead with some 20,000 to 30,000 burials, an enclosure wall, and a system of alleys.[9] To meet the needs of an agricultural community highly dependent on the precious irrigated fields of the oasis, most of the mausolea were designed as tomb towers that were not unlike the presumed tower houses of contemporary cities. The dead thus may have been conceptualized as residing in their tombs.

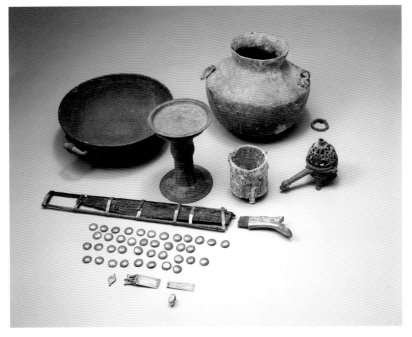

FIG 5 GROUP OF OBJECTS RECOVERED FROM A SINGLE, RICHLY EQUIPPED BURIAL. WADI DURA, GRAVE 3, 1ST–4TH CENTURY CE. FINGER RING, GOLD, D 2.1 CM; BELT BUCKLE, SILVER, L 9.5 CM; BUTTONS, SILVER, EACH D 2.7 CM; BUCKLE, SILVER, L 10.3 CM; SWORD AND SCABBARD, SILVER AND IRON, L 55  W 10 CM; BASIN, BRONZE, D 36 CM; INCENSE BURNER, BRONZE, D 10.5 CM; VESSEL, BRONZE, H 27 CM; INCENSE BURNER OR LAMP, BRONZE, H 21.7 D 15.4 CM; LADLE, SILVER WITH GOLD, H 16.3 CM; BOWL, SILVER, H 12 D 20 CM; CONTAINER, SILVER, H 7.1 CM. ATAQ MUSEUM, ATM 296/1, 296/ 3–8, 296/21–22, 298, 298, 300

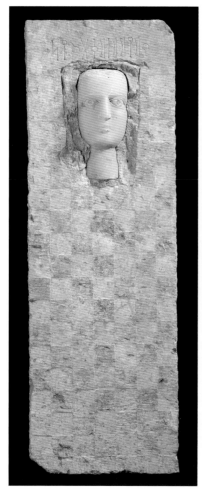

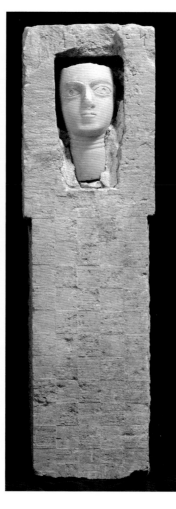

FIG 6 FUNERARY STELA. MARIB,
6TH–4TH CENTURY BCE. LIMESTONE,
ALABASTER, AND GYPSUM; H 102
W 24 TH 18 CM. MARIB MUSEUM,
AW 98 A 2344

FIG 7 FUNERARY STELA. MARIB,
6TH–4TH CENTURY BCE. LIMESTONE,
ALABASTER, AND GYPSUM; H 93
W 24.5 CM. MARIB MUSEUM, AW 98
A 2345

Preserved to a height of almost nine meters, these tombs possessed three to four floors, of which the lowest was sometimes cut into bedrock. Up to two hundred individuals, probably the commoners, were placed in such tombs. A second type, reserved for the upper echelons of Sabaean society, were monumental templelike tombs with porticoes raised on a podium. Unique is a mausoleum with four pillars inside, most probably used as the burial place of the ruling family of Saba. Thus the architecture of the necropolis is believed to mirror the stratification of Sabaean society.

The marginally drafted and pecked limestone ashlar masonry of the Awam tombs was of the highest quality. They frequently carried sixth- or fifth-century-BCE inscriptions that report the construction of the structures by one or several builders and mention the deceased's ancestry, tribal affiliation, and sometimes rank, such as sheikhs, priests, or high-ranking courtiers. The exterior of the tombs was sometimes furnished with the engraved bas-reliefs of masks of the deceased. Niched gravestones with a calcite-alabaster image and the name of the deceased, along with larger groups of ceramic vessels and other offerings were often found in front of the monuments.

Hypogea, combining characteristics of mausolea and cave tombs, were built into level ground or on slopes. Their circular or rectangular chambers could be reached through a shaft or a dromos-like entrance. They could receive either single or multiple burials, as at the rock-cut hypogea at Kharibat al-Ahjar near Dhamar.[10] A larger concentration of early-first-millennium-BCE hypogea was discovered at as-Sawda in the Jawf, where the subterranean tombs were built completely from ashlar, showing a set of internal niches, and furnished with a monumental gate. The tombs from Kharibat al-Ahjar date to around the turn of the Christian era, while the latest ones, attributed to the period between the second and the fifth century CE, were excavated just outside Qani, the port on the Indian Ocean coast. Here the tombs were made from basalt, and their position was marked on the surface by a rectangular alignment of stones.[11]

As in other parts of the ancient Near East, multiple burial sites were gradually replaced by a preference for individual burial. This was introduced by the third century BCE and was eventually inherited and modified by the current Islamic practice. Subterranean pit interments and cists were the most common grave type spread all over South Arabia. These were usually excavated into sediments along the wadis. From time to time a stone circle was laid out on the surface to identify their location. Both subtypes were stratigraphically related, for example, in the Wadi Dura where they have been dated to the second or third century CE. Usually, the corpses were laid in a flexed or extended position directly in the earth or in an oblong niche that was carved out along the bottom of the pit. The niche was then

blocked with transversally set random stones or mud-bricks or, such as in the Raybun XVII cemetery, the pit was closed with capstones and the shaft refilled with rubble. Generally, the furnishing of the pit and cist burials was rather poor; the rich unplundered burials from Wadi Dura are certainly an exception (FIG. 5). Some scholars hold the view that in certain areas this type of tomb represents a nomadic or perhaps the new Arabic-speaking immigrant population.[12]

The most common mode of burial during the period of the South Arabian kingdoms was the articulated burial. Some of these received additional treatment through rudimentary artificial mummification, such as the use of hygroscopic plants and wrapping in cloth bandages and leather. In Yemen the removal of the viscera, well known from ancient Egypt, has not yet been directly attested except for the single stray find of a pottery lid that can be attributed to a canopic jar. Most recently, a number of such mummies was discovered in Himyarite pit and cist graves at Shaub near Sanaa, indicating that embalming could be afforded by the ordinary dead.[13]

A flexed position for bodies was customary throughout the entire first millennium BCE while extended skeletons lying on the back or on the left or right side have been documented mainly after the third century BCE. A fragment of a stone basin from the Awam cemetery may be interpreted as part of a sarcophagus, and wooden coffins have been recorded at the Himyarite site of Jabal al-Lawdh.[14] Disarticulated burials have only been recorded at Huraydah Tomb A5 while the practice of cremation was postulated for only one of the tombs in Hayd ibn Aqil.[15] The unplundered Grave 3 in Wadi Dura and an infant burial at Shaub[16] suggest that during the late pre-Islamic period the burials of high-ranking and ordinary persons alike included grave goods of precious metal (see FIG. 5).

GRAVE GOODS AND FUNERARY STELAE

During almost the entire first millennium BCE the dead were accompanied by objects that were specifically made as funerary offerings and were required for use in the next world: these included stone sculptures ranging from statuettes, busts, and portraits to reliefs and gravestones. They identified the tombs as individual resting places and helped to keep the memory of the deceased alive. Among these were anthropomorphic statuettes shown standing rigidly or seated with arms bent, perhaps in a gesture of adoration. A short inscription on the base gave the name of the deceased (or the dedicant). An archaic variant in limestone, with angular contours, has turned up from grave plundering and is said to originate mainly from the Minaean graveyards of the Jawf and date, purely on stylistic grounds, to the seventh or sixth century BCE. It is also worth mentioning that identical pieces are at present displayed in the National Museum of Asmara, where they are said to come from the early layers of the Eritrean port town of Adoulis. More advanced variations of this type in alabaster, sometimes with attached personal ornaments in bronze, seem to appear by the end of the sixth or fifth century BCE, as attested by a stratified find from the Baran temple in Marib.

Another widespread custom was to portray the features of men, women, and

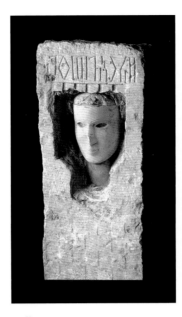
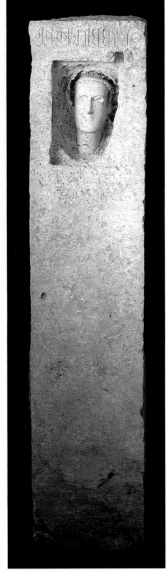

FIG 8 AWAM TEMPLE CEMETERY. FUNERARY STELA MADE OF LIMESTONE ENCLOSING A CARVED ALABASTER HEAD OFTEN BEAR AN INSCRIPTION NAMING THE DECEASED.

FIG 9 AWAM TEMPLE CEMETERY. SOME FUNERARY STELAE WITH NICHES COULD BE CLOSED WITH A DOOR, AS THE BRONZE WALL PLUGS INDICATE.

children, as known from large numbers of calcite-alabaster heads especially from Marib and Tamna. They are provisionally dated to the sixth to fourth century BCE. Although executed in the round, they were once fitted with gypsum into the niches of gravestones. Many complete examples with the name of the depicted individual have recently been discovered in front of the mausolea outside the Awam temple at Marib (FIGS. 6–9). The eyes and eyebrows were sometimes inlaid with bitumen, shell, and glass, whereas the headdresses were molded from gypsum and occasionally painted black.

Reported only from Qatabanian territory were plain geometric stelae (FIG. 10), or gravestones with simple incised depictions of animals, such as from Shuka,[17] a sun and crescent motif or a human or bull's head (pl. 10). Many of these carried the name of the deceased or less frequently a short dedicatory inscription: most probably these date around the turn of the Christian era.

Also deserving of notice are two other distinctive types of gravestones: eye stelae and those with a narrative content. Face plaques were introduced into South Arabia by the last centuries BCE. The standardized depiction is usually reduced to a pair of eyes, occasionally complemented by a nose and mouth. The name of the deceased, where noted, appears to be Arabic, thus reflecting the arrival of new immigrants from whom the present-day population of Yemen may have descended. Very similar items have also been found in the far northwest of the Arabian Peninsula.

Gravestones with narrative scenes—either in an architectural or landscape setting or between floral designs—were illustrated with noteworthy achievements and events during life. There were also scenes showing hunting or banqueting (FIG. 11). The influence of the Romanized Levant is evident and more directly suggested by a fourth-century-CE gravestone from Shabwa with the representation of Herakles.[18] The intrusion and acceptance of beliefs and iconographic elements from the Roman sphere into South Arabian mortuary practices thus may have been stronger than suggested by the sporadic occurrence of Athena, Isis-Fortuna, and other "exotic" depictions.

Foreign influence may also find expression in a considerable number of objects from the possibly first-century-BCE provincial Qatabanian graveyard of Shuka, where small plaster sculptures were unearthed, made in the shape of separate human limbs, such as arms, legs, and breasts.[19] Except for the curious instance of a life-size bronze hand from the British Museum, no such objects have previously been found in Yemen. They recall ex votos, for instance, from Epidauros in Greece, where devotees of Asklepios, the Greek god of medicine, expressed by limb surrogates their gratitude for convalescence.

Most characteristic of multiple burials in the first-millennium-BCE mausolea and cave tombs were miniature offerings, of which thousands have been collected, consisting of tiny metal, ceramic, and stone vessels, incense burners, offering tables, and altars. Strangely, the same was also true for weaponry, which was otherwise absent from the graves of this period. Reduced to the smallest possible scale, all of these possessed "life-size" counterparts in contemporary settlements and temples, suggesting that death was regarded only as a transformation into a different state of being but with the same needs as this life. They thus may

have taken into account the limited space inside the tombs and manufactured these objects specifically for ritual use in the cemeteries and temples. This was particularly true also of another group of artifacts, the ostraca. Neck fragments of earthenware bottles, lug handles, and perforated potsherds, originally perhaps tied on the corpses, record the names of those buried there.

Another major category of grave goods was personal belongings, either instruments of office or representative of functions in life that may have been considered to be useful in the afterlife or taboo for the bereaved. Among these were jewelry, seals, clothes, and stone, metal, and ceramic vessels. The second- or third-century-CE Grave 2 in the Wadi Dura demonstrates that personal valuables, such as ivory artifacts, inherited luxury weapons, and silver and gold tableware, could also be sealed in the grave.[20] The personal belongings of the deceased may thus have presented an opportunity to advertise through tokens the wealth of the deceased and his or her former status in the community, as the composition and the number of mortuary offerings were determined by the social status of the family. Exotic commodities, such as ivory, imported glassware, or bronze statuettes, may also indicate a more affluent dead. It is interesting to note that to a large extent this social differentiation was limited to the grave goods, whereas little effort was spent on the exterior of the tombs.

Some of the burials from the later South Arabian period were accompanied by animals, preferably camels, that were taken alive to the graves or a separate pit nearby, where they were ritually slaughtered.[21] The meat of these camels was not consumed. Although the meaning and motives of such actions are unclear, the camel was perhaps regarded, as in early Islamic traditions, as the mount of its owner on the day of resurrection. This tradition, which can be traced all around the Arabian Peninsula and also in Meroitic Sudan, could have been reserved for caravan merchants and nomads. In the earlier part of the first millennium BCE a similar custom was practiced, although the camel was substituted by a terracotta camel figurine. Other important adjuncts in the death rites were food sacrifices of sheep and goat, whose meat was deposited with the human burials. Death rites did not terminate with the disposal of the corpse: as portrayed on gravestones, the bereaved participated at banquets held in their presence, possibly on the occasion of their anniversaries. They were believed to propitiate the spirit of the deceased or to mitigate the malice of the god.

The epigraphic evidence indicates that during the first millennium BCE South Arabia witnessed stable political conditions, first under the hegemony of the Sabaeans, later under the Qatabanians. This resulted in a kind of collective identity that was expressed by common rituals and the worship of a main god, performed jointly by all the tribes of the kingdom. The individual played a lesser role, and family, kin, and tribe were certainly more important as is shown by the practice of collective and multiple burials. A differentiation of individual status can barely be recognized. Consequently, the composition of funerary inventories within a multiple burial is rather uniform. Only elite groups, such as the ruling families, the courtiers, and the priests, were treated differently.

The Middle South Arabian period, however, was characterized by major political and social instabilities as well as by cultural transformations. Some

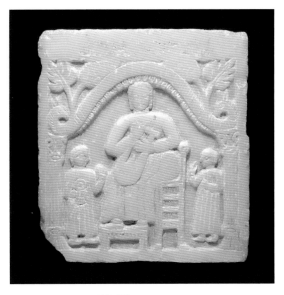

FIG 11 FUNERARY STELA. PERHAPS FROM TAMNA, 1ST CENTURY CE. ALABASTER: H 29 W 27 TH 8 CM. THE BRITISH MUSEUM, ANE 2002-1-14, 1

regions still retained old traditions while others developed new burial customs. The most prominent change in mortuary practices was, then, the introduction of single burials in an extended position. From about the turn of our era individual identity was defined through allegiance toward the ruling dynasty. For the living this ideology led to more egalitarian treatment of the individual, while in mortuary customs, and despite the diminution of grave types, status was expressed through the personal belongings of the deceased.

Almost nothing can be said about burial practices during the last centuries before the coming of Islam—a statement that coincides with the poor state of archaeological knowledge. We are faced with the difficulty of assessing to what extent an increasing regional particularism and a cultural exhaustion and attrition affected the entire sphere of death rites. Obviously, the tombs and their furnishings were more unpretentious and therefore escaped the attention of the archaeologists. The introduction of monotheistic religions and ensuing changes in traditional eschatologies may also have contributed profoundly to this development.

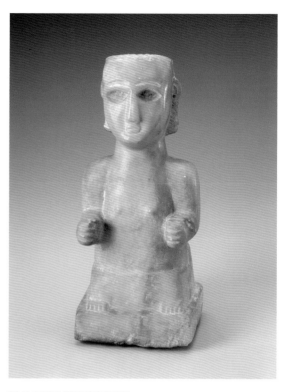

FIG 12 STATUE OF SEATED FIGURE. TAMNA, 1ST HALF OF 1ST CENTURY CE. ALABASTER; H 34.5  W 15  TH 14.5 CM. THE AMERICAN FOUNDATION FOR THE STUDY OF MAN, TC 1518

ENDNOTES

1 VOGT, DE MAIGRET, AND ROUX 1999; BRETON 1999, 143–57.

2 HITGEN 1999.

3 DE MAIGRET 1996; SEE ALSO ROBIN, THIS VOLUME.

4 ROUX 1992.

5 CATON-THOMPSON 1944.

6 SEDOV AND GRIAZNEVITCH EDS. 1996, 117–43.

7 BASALAMA 1998; BRETON 1999, 145.

8 CLEVELAND 1965, 173–75, PLANS I–II, PLS. 108–20; PHILLIPS 1955, PL. OPPOSITE P. 117.

9 HITGEN 1998; GERLACH AND HITGEN 2000; GERLACH 2001; SEE ALSO GERLACH "AWAM TEMPLE CEMETERY", THIS VOLUME.

10 ILLUSTRATED BY VOGT, DE MAIGRET, AND ROUX 1998, 238.

11 SEDOV 2001, 34.

12 BRETON AND BAFAQIH 1993.

13 VOGT AND GERLACH 2002.

14 CATON-THOMPSON 1944; CLEVELAND 1965.

15 BRETON AND BAFAQIH 1993.

16 VOGT AND GERLACH 2002.

17 SEIPEL ED. 1998, 335–36, NOS. 285–86.

18 ROBIN AND VOGT EDS. 1997, 214.

19 SEIPEL ED. 1998, 335–36, NOS. 179–82.

20 SIMPSON ED. 2002, 205–206, NOS. 305–307.

21 SIMPSON ED. 2002, 99 NO. 114, FOR REFERENCES; SEE ALSO BRETON 1999, 154–55.

IRIS GERLACH

# The Awam Temple Cemetery

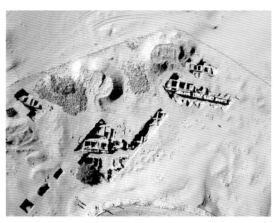

Since 1997 the Sanaa Branch of the German Archaeological Institute (DAI) has been carrying out research on a Sabaean cemetery that borders immediately on one of the most significant sanctuaries in southwest Arabia, the Awam temple in the oasis of Marib (FIG. 1). This temple of the Sabaean god Almaqah is testimony to the excellence of early Sabaean building technology. In the north a propylon consisting of eight pillars and peristyle courtyard forms the main entrance to an irregularly oval enclosure, the wall of which is approximately 260 meters long and originally stood probably over sixteen meters high. The oval shape of the outer wall is similar to that of the Almaqah temple in Sirwah, and these two temples were in fact built by the same Sabaean ruler, Yadail Darih, in the middle of the seventh century BCE. The architecture, contents, and functioning of the temple are still largely uncertain because archaeological excavations have not yet been carried out over large areas. The entrance hall and small sections of the cemetery area were examined in the 1950s by a team from the American Foundation for the Study of Man (AFSM). Since 1998 the AFSM has continued its work in the temple, while the German Archaeological Institute has been researching the outer parts of the sanctuary, including the cemetery. Closely connected with the sanctuary and the Almaqah cult, the Sabaean necropolis immediately south of the temple wall spreads across approximately 1.7 hectares of land. The cemetery was a burial place for the Sabaean "upper class," beginning with the erection of the temple in the seventh century BCE at the latest, and it remained in use up to the fourth century CE.

Archaeological investigation of the cemetery area began with a geomagnetic survey carried out by the Bavarian State Conservation Office. The survey identified relatively clearly the layout of tombs near the surface of the site. The aerial pictures taken from a hot-air balloon by the Johann Wolfgang Goethe University

FIG 1 AERIAL VIEW OF AWAM TEMPLE WITH THE CEMETERY AREA ADJACENT IN THE SOUTH.

FIG 2 AERIAL VIEW OF AWAM TEMPLE CEMETERY.

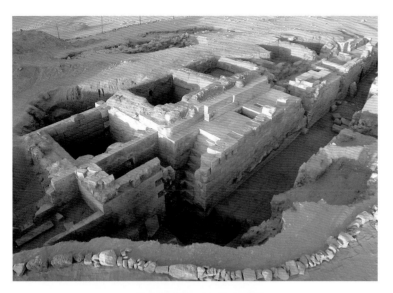

of Frankfurt am Main also attest to the close spacing of the burial monuments evident on the surface (FIG. 2). The archaeological excavations revealed these structures to be stone mausolea comprised of as many as four stories and up to nine meters in height.

Most of the mausolea are arranged in subsurface deposits: the older examples date to the first half of the first millennium BCE and are built on bedrock; the more recent ones are set into the accumulating sediment left by artificial irrigation. A labyrinthine system of narrow passages connected the individual tombs, which usually are set immediately next to each other. In later phases of the cemetery, reconstruction of existing monuments and construction of new buildings blocked older accesses. The walls of the older mausolea are usually built in a "double face" construction; tufa or coarsely hewn limestone was used for the inner face, whereas carefully smoothed limestone slabs were used for the outer face. The red-painted inner plastering of lime or clay is still apparent in most of the tombs. Holes for beams and bearings indicate the position of the original stories. Based on recovered architectural elements, the top of the tombs can be reconstructed as a flat roof surrounded by a toothed frieze.

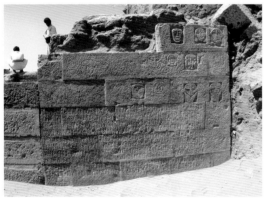

**FIG 4 (ABOVE)** TOMBS DATING FROM THE SIXTH TO FIFTH CENTURY BCE WERE BUILT CLOSE TO ONE ANOTHER ALONG SMALL NARROW PASSAGES.

**FIG 3 (BELOW)** CARVED IMAGES OF THE HEADS OF THE DECEASED DECORATE THE OUTER FACADES OF MANY TOMBS.

The entrance to the tombs was in the upper story, from which wooden ladders or even stone steps led down into the depths of the interior. The entrances themselves were carefully closed with limestone slabs after the final use of the tombs. The deceased were laid, presumably in a crouched position, in the individual stories without any particularly obvious separation. Unfortunately, the state of preservation of the tombs, which were plundered and destroyed both in antiquity and more recently, provides no further details. The bones did not remain in an articulated position. Anthropological examination reveals that bodies of men, women, and children were placed in the tombs, with adult men representing 60 to 70 percent of the total. A careful estimation of the bone material discovered so far implies that about twenty thousand individuals were buried in the whole of the cemetery area identified so far during its more than thousand years of use. Very rarely, preserved fabric remnants in the tombs originate both from the clothing of the deceased and from the cloth possibly soaked in resin especially for the burial to prevent premature decay. Regrettably, the extent to which the bodies were subjected to a kind of mummification cannot be determined. Such a process was usual, for example, in the Shaub/Sanaa cemetery, which the Sanaa Branch of the German Archaeological Institute also studied and that dates to the first to second century CE.

Inscriptions dated to the sixth to fifth century BCE provide information about which Sabaeans were given their final resting place in the cemetery of the Awam temple (FIG. 3). These texts specify the names of the owners or builders of the tombs, along with their father's name and usually also the name of their tribe or clan. Furthermore, the texts record the area, expressed in fractions (e.g., an eighth, a quarter, etc.), of the acquired shares of the tomb, which presumably served as the burial place of the appropriate family. Only seldom do the texts

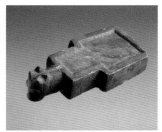

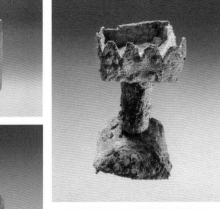

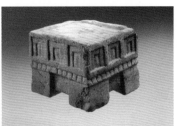
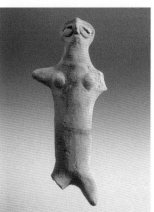

FIG 5 TYPICAL BURIAL OFFERINGS ARE OBJECTS OF DAILY LIFE, IN MINIATURE SCALE.

FIG 6 (BOTTOM, FAR RIGHT) TYPICAL GIFTS WERE FEMALE FIGURINES MADE OF CLAY, PAINTED WITH RED STRIPES.

mention the social status of the owners or builders. The few titles that give clues about this important subject suggest that the owners and builders were servants of *mukarrib*s (Sabaean rulers), tribal leaders, or priests. The cemetery area was not divided according to the social status of the deceased. Thus, the social status of the owner of the tomb did not diminish—as presumed at first—with the distance of the tomb from the temple wall. Elaborate monumental mausolea are found not only relatively close to the shrine but also near the southern boundary of the cemetery (FIG. 4).

In the latter area, an excavated tomb dating from the fifth century BCE surpasses any other tomb known so far in its architectural arrangements. The rectangular tomb was built above ground, with the lower stories divided into two chambers, whereas the upper story, of which only a few remains still exist, consists of a single room. The entrance is novel. A platform was placed in front of the tomb chambers, which could be reached via a steep staircase with extremely narrow treads set on the side. Rising from the platform are five pillars of which only the stumps or the insets still remain. This type of tomb evidently adapted elements of sacred architecture, as is apparent not only from the pillars but also from the toothed friezes that decorate the top edge of the stringers.

Despite the poor state of preservation in the interior of the tombs, the archaeological excavations were able to provide evidence of an extensive range of burial gifts and costume accessories that were placed in the tombs with the deceased. Of these burial gifts, the most common appears to be miniature, handmade vessels. The largest group of these is made up of miniature beakers and bottles, often with a lid; hundreds of these have been found. However, the finds also include personal belongings: apart from jewelry, such as necklaces, finger rings, and

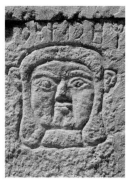 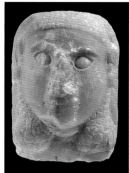 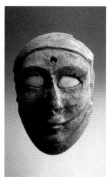 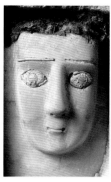 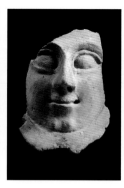 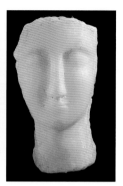

FIG 8 HEADS OF THE DECEASED WERE DEPICTED IN A WIDE RANGE OF STYLES.

bracelets, miniature images of objects connected with everyday life but made mainly for the tomb are also included in the inventory. Among other items, miniature offering plates decorated with the heads of ibexes or bulls, cosmetic vessels, and small incense burners are worth mention in this connection (FIG. 5).

Terracotta figurines of women (FIG. 6) and dromedaries can also be counted among the burial gifts. The women are depicted nude with widely outstretched arms and short legs. Like the dromedaries, the female figurines are painted with red stripes. Imports from the Egyptian-Phoenician culture area—scarabs, sphinxes, and small faience amulets—reflect contacts via the caravan routes between the Sabaean kingdom and the Levant (FIG. 7).

A characteristic of the Sabaean cult of the dead is the representation of the deceased by a depiction of the head in relief or in the round, along with his name. The Sabaeans appear to have attached great importance to "recognition" beyond death. For example, niches were set into the outer facades of the tombs next to the inscriptions, where images of the deceased in the form of heads made of clay or, more often, alabaster, were placed (FIG. 8). Likewise, engraved bas-reliefs of masks on the walls of the tombs symbolize the faces of the dead. These shapes are idealized and abstract, and they do not correspond to a portrait in the real sense. Individualization was achieved only by the name inscription that always accompanies these depictions. The pictures were thereby assigned individually to the deceased, which meant that their identity was still deeply rooted in the memory of later generations.

With regard to the funerary stelae that were presumably leaned against the outside of tombs, these represent the most elaborate kind of individualizing burial monument (SEE VOGT "DEATH," FIGS. 5–8). Alabaster heads, or less frequently busts, were affixed with gypsum in the niches of these high, oblong limestone stelae (FIG. 9). Above the niches the name inscription of the deceased is engraved. The alabaster heads depict men, sometimes bearded, and women; facial features, such as eyes and eyebrows, were mounted with another material, possibly glass paste, and the beard was represented by small drilled holes partly painted black. Headdresses molded from gypsum adorned the otherwise bare skull of some heads.

Small holes in the sides of the niches indicate that the

FIG 7 A PENDANT WITH THE IMAGE OF A BIRD AND A CARVED IVORY SPHINX REFLECT CONTACTS BETWEEN THE SOUTHERN ARABIAN PENINSULA AND EGYPTIAN-PHOENICIAN CULTURAL CIRCLES.

niches could be closed off with doors made of bronze or wood. The doors were probably opened for certain cult rituals in order to pay tribute to the deceased. A simpler way of identifying the dead was effected by means of so-called ostraca—fragments of pottery on which the names of the deceased were scratched after firing—that were placed in the tomb as burial gifts. The ostraca, some of which were attached to corpses, therefore assured the possibility of identifying the deceased.

The cemetery of the Awam temple must be considered in close connection with the adjacent sanctuary. It can be assumed that the temple priests also exercised control of the "cemetery regulations." The inscriptions fixed to the outer walls of tombs, stating details about the built and acquired shares of tombs, made it clear, for example, that an individual was not at liberty to build and sell tombs at will. Also, the clear delimitation of the cemetery's boundary by means of a row of tombs built closely together indicates a central cemetery administration. A portion of this line of tombs has been excavated in the south. Unfortunately, inscriptions that would provide information about exactly how the burial practices and funeral rites should be imagined are still lacking. Comparable studies of Sabaean cemeteries, such as are being carried out in conjunction with excavations by the German Archaeological Institute in the necropolis of the city of Sirwah, may lead to some recognition of this aspect of Sabaean culture in the future.

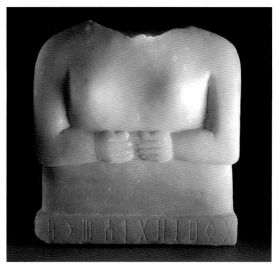

FIG 9 FUNERARY BUST INSCRIBED WITH THE NAME OF THE DECEASED. 2ND–1ST CENTURY BCE. ALABASTER

**FURTHER READING**

ALBRIGHT, F. P., 1958. "EXCAVATIONS AT MARIB IN YEMEN," IN R. LEB. BOWEN AND F. P. ALBRIGHT, EDS., *ARCHAEOLOGICAL DISCOVERIES IN SOUTH ARABIA*, 235–38. PUBLICATIONS OF THE AMERICAN FOUNDATION FOR THE STUDY OF MAN, VOL. 2. BALTIMORE: JOHNS HOPKINS PRESS.

*ARCHÄOLOGISCHE BERICHTE AUS DEM YEMEN* 9: 2002, CONTRIBUTIONS BY I. GERLACH, N. RÖRING, J.-C. BESSAC AND J.-F. BRETON, S. JAPP, AND N. NEBES.

GERLACH, I., 1999. "DIE GRABUNGEN DES DEUTSCHEN ARCHÄOLOGISCHEN INSTITUTS SANAA IM SABÄISCHEN FRIEDHOF DES AWAM-TEMPELS IN MARIB," IN *IM LAND DER KÖNIGIN VON SABA. KUNSTSCHÄTZE AUS DEM ANTIKEN JEMEN*, 113–15. MUNICH: STAATLICHES MUSEUM FÜR VÖLKERKUNDE/IP.

GLANZMAN, W. D. "DER AWAM-TEMPEL (MAHRAM BILQIS)," IN *IM LAND DER KÖNIGIN VON SABA. KUNSTSCHÄTZE AUS DEM*

*ANTIKEN JEMEN*, 110–12. MUNICH: STAATLICHES MUSEUM FÜR VÖLKERKUNDE/IP.

HITGEN, H., 1998. "THE 1997 EXCAVATIONS OF THE GERMAN INSTITUTE OF ARCHAEOLOGY AT THE CEMETERY OF AWAM IN MARIB," *PROCEEDINGS OF THE SEMINAR FOR ARABIAN STUDIES* 28: 117–24.

HITGEN, H., 1998. "DIE SABÄISCHE TOTENSTADT AM ALMAQAH-TEMPEL VON AWAM IN MARIB," IN W. SEIPEL, ED., *JEMEN. KUNST UND ARCHÄOLOGIE IM LAND DER KÖNIGIN VON SABA'*, 247–49. VIENNA: KUNSTHISTORISCHES MUSEUM.

VOGT, B., GERLACH, I., AND HITGEN, H., 1998–99. "DIE ERFORSCHUNG ALTSUDARABIENS. DAS DEUTSCHE ARCHÄOLOGISCHE INSTITUT SANAA AUF DEN SPÜREN DES SABÄERHERRSCHERS KARIB'IL WATAR," *NÜRNBERGER BLÄTTER ZUR ARCHÄOLOGIE* 15: 9–155.

SABINA ANTONINI

# Images: Gods, Humans, and Animals

FIG 1 MALE HEAD. TAMNA, 1ST HALF
OF 1ST CENTURY CE. ALABASTER;
H 20.5 L 15 CM. THE AMERICAN
FOUNDATION FOR THE STUDY OF
MAN, TC 1588

FIG 2 FUNERARY STELA. KHAWLAN,
3RD–2ND CENTURY BCE. ALABASTER; H
30 W 12 TH 12 CM. SANAA, NATIONAL
MUSEUM, YM 9054

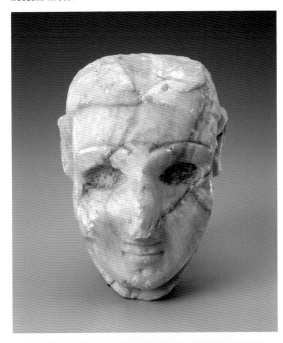

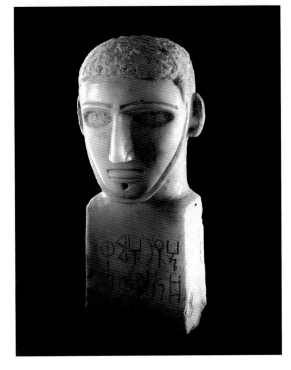

The lack of stratigraphic and contextual information available for many arti-
facts from ancient South Arabia often prevents the establishment of a precise
chronological attribution for artistic production. The problem is further com-
pounded by the conservatism and formulaic modes of representation that char-
acterize not only statuary but also other categories of ancient South Arabian
remains. Yet it is this very stylistic and iconographic homogeneity of the sculp-
ture that forms such an individual and original image in the art of the southern
Arabian Peninsula in the first millennium BCE.

The elements that characterize the figurative art of pre-Islamic Yemen are
ruled by a precise stylistic canon. The geometricizing of volumes, a dispropor-
tionate relationship between face and body, the compact dimensions of statues,
the predilection for pronounced angles, and above all, the schematic treatment of
the body in contrast to the detailed rendering of facial features establish the typi-
cal, independent "artistic physiognomy" of this geographical region.

Although the majority of sculptural finds come from Hayd ibn Aqil, the
cemetery of Tamna (Qataban), and can all be assigned to the mature period of
South Arabian art (second half of the first millennium BCE), the Sabaean and
Minaean regions also furnish evidence of artistic production. A comparison of
the forms of artistic expression unique to these three different regions reveals
affinities, but also differences, in iconography and local stylistic traits. A mas-
tery of form and the delicate plasticity of clear, fluid planes distinguish the sculp-
tures of Tamna, where one finds a delicacy in the modeling, soft contours, and a
greater search for naturalism, even though the basic template of an art governed
by convention remains apparent (FIG. 1). In the heads of the Jawf region, the
modeling and structure seem more imprecise and fleeting, the facial features
joined, the contours angular. In particular, the way in which the nose joins with

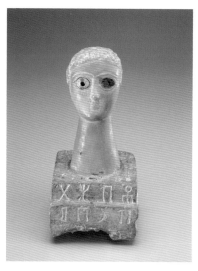

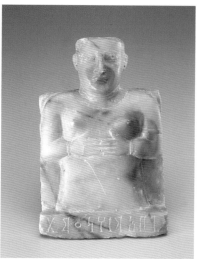

the arch of the eyebrows to form a T-shape, and the form of the mouth—small and immobile, with thick lips—distinguish this type of the Jawf region (FIG. 2). These same features are found in a group of statuettes of seated figures (the "ancestors") and in the stelae with human faces. Both of them are Minaean works probably of North Arabian origin.

With the exception of certain statues and reliefs, chiefly the small heads from the temple of Nakrah at Baraqish and the famous figures, known as Banat Ad, carved on the walls and pillars of the temples of the Jawf, all other categories of human representation seem to derive from a funerary context. The best-known class consists of heads with a long neck, which are found in the Sabaean assemblages as well as in those of Qataban, especially in the period of Qatabanian hegemony (FIG. 3). These heads, male and female, were probably inserted into small cuboid bases or into niches hollowed out on the upper parts of stelae. The rectangular plaques decorated with a schematic human face in relief had the same purpose, i.e., as a symbolic portrait (FIG. 4; PL. 16). The region of Qataban has produced numerous alabaster statuettes of standing figures on a base on which is usually inscribed the name of the donor; both statue and base are carved from a single block. The arms are bent and extended in front, the fists closed to hold an object (PLS. 23–24). The "ancestors" are shown in the same posture but seated. These statuettes, made of limestone or sandstone and measuring from fifteen to thirty centimeters in height, symbolize the deceased seated on a stool or bench, an iconographic tradition common in Syria-Palestine.

Of unknown archaeological context is a homogenous group of reliefs depicting a human figure standing on a base in the pose of a worshiper, the arms folded at waist height with hands joined. The presence of holes indicates these votive plaques were attached to a wall. Earlier, and probably contemporary with the Sabaean *mukarrib*s (eighth to the beginning of the seventh century BCE), are the images of Banat Ad, or "daughters of Ad," an ancient people mentioned in the Quran. These female figures, perhaps priestesses or demigoddesses, were carved on the walls and pillars of the temples of Haram, Qarnaw, Nashan, and Nashq in Yemeni Jawf. Processions of animals accompany the figures—ibex and ante-

FIG 3 FUNERARY STELA WITH INSCRIBED BASE. TAMNA, 1ST HALF OF 1ST CENTURY CE. ALABASTER; H 21 W 10 TH 10 CM. THE AMERICAN FOUNDATION FOR THE STUDY OF MAN, TC 1884

FIG 4 FACE STELA. TAMNA, 1ST HALF OF 1ST CENTURY CE. LIMESTONE; H 14.9 W 21 TH 7 CM. THE AMERICAN FOUNDATION FOR THE STUDY OF MAN, TC 40

FIG 5 STELA OF FEMALE FIGURE. TAMNA, 3RD CENTURY BCE–MID-1ST CENTURY CE. ALABASTER; H 24.3 W 16.5 TH 7.1 CM. THE AMERICAN FOUNDATION FOR THE STUDY OF MAN, TC 1557

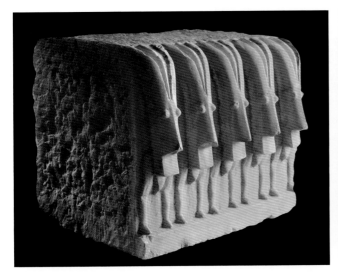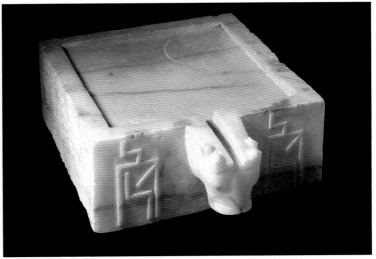

FIG 6 IBEX FRIEZE. MARIB, 5TH
CENTURY BCE. ALABASTER; H 39 W 53
TH 35 CM. MARIB MUSEUM, BAR 906

FIG 7 INSCRIBED LIBATION TABLE.
AS-SAWDA, LATE 8TH-EARLY 7TH
CENTURY BCE. ALABASTER; H 18
W 47 TH 47 CM. SANAA, NATIONAL
MUSEUM, YM 16243

lope, ostriches, and pairs of entwined serpents—all creatures that recur in the South Arabian iconographic repertoire. Ibex and antelope in particular, depicted crouching and standing, decorate thrones, offering tables, and the friezes of religious monuments in southern Arabia (FIG. 6). These animals were connected with rites of the sacred hunt and slaughtered in honor of a deity, which in return guaranteed the fecundity of flocks and the fertility of the soil. The animals themselves thus became symbols of the gods. The antelope, for example, was certainly the sacred animal of the god Athtar; the bull, common on libation tables but also present on Qatabanian funerary stelae, was the animal attribute of the Sabaean god Almaqah, protector of irrigation, life, and fertility (FIGS. 6–7; PL. 10). The serpent, invested with an apotropaic significance, was generally shown in association with the god Wadd, the national deity of the kingdom of Main.

While a long list of deities is named in inscriptions, it is extremely difficult to draw a detailed picture of the South Arabian pantheon's iconography without mythological texts. Identifications are rarely certain. Among the bronze statues found at Marib, for example, the large figure, which might have been thought to represent the god Almaqah, was that of a dedicator by the name of Madikarib. Another well-circumscribed category of reliefs, dating to the last centuries before the common era, depicts a female figure (PL. 26). The French scholar Jacqueline Pirenne identified her as the goddess dhat-Himyam, but more likely she represents the donor, portrayed in the attitude of a worshiper. The right arm is raised in the gesture of blessing; the stomach is plump, the chest heavy. The sheaf of wheat held in the right hand suggests the cult of a deity who protects life, fertility, and regeneration, and thus of agriculture and the production of grain.

FURTHER READING

ANTONINI, S. 2001. *LA STATUARIA SUDARABICA IN PIETRA*. REPERTORIO ICONOGRAPHICO SUDARABICO, VOL. 1.

PARIS: ACADÉMIE DES INSCRIPTIONS ET BELLES-LETTRES/ROME: ISTITUTO ITALIANO PER L' AFRICA E L'ORIENTE.

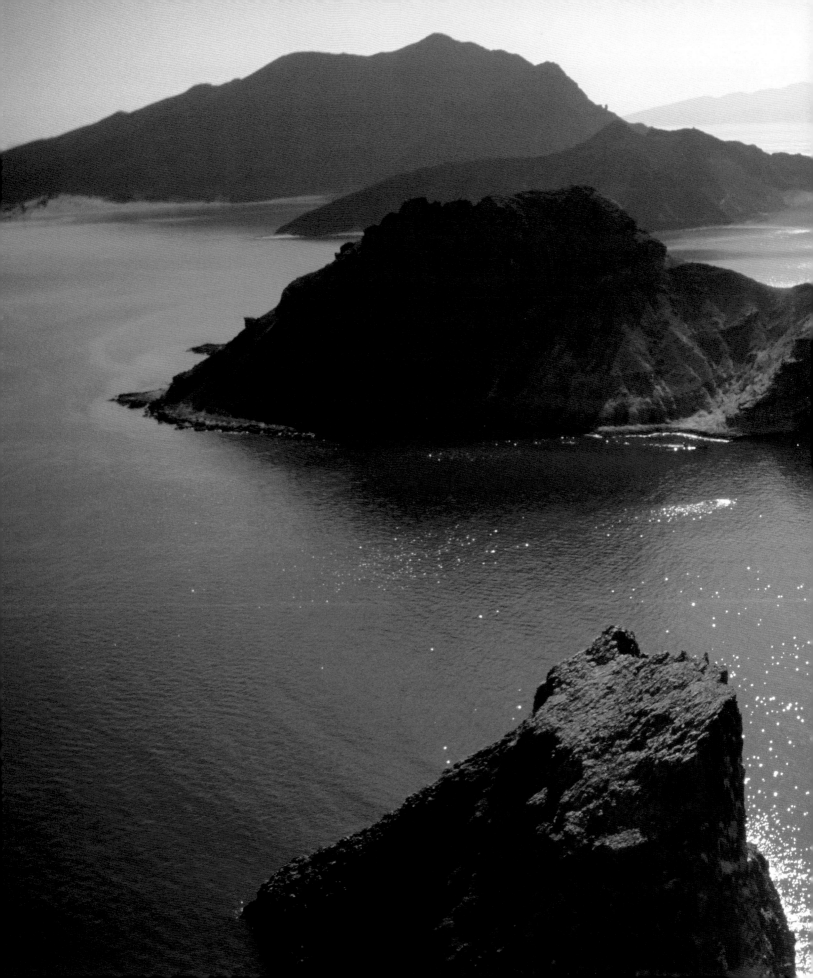

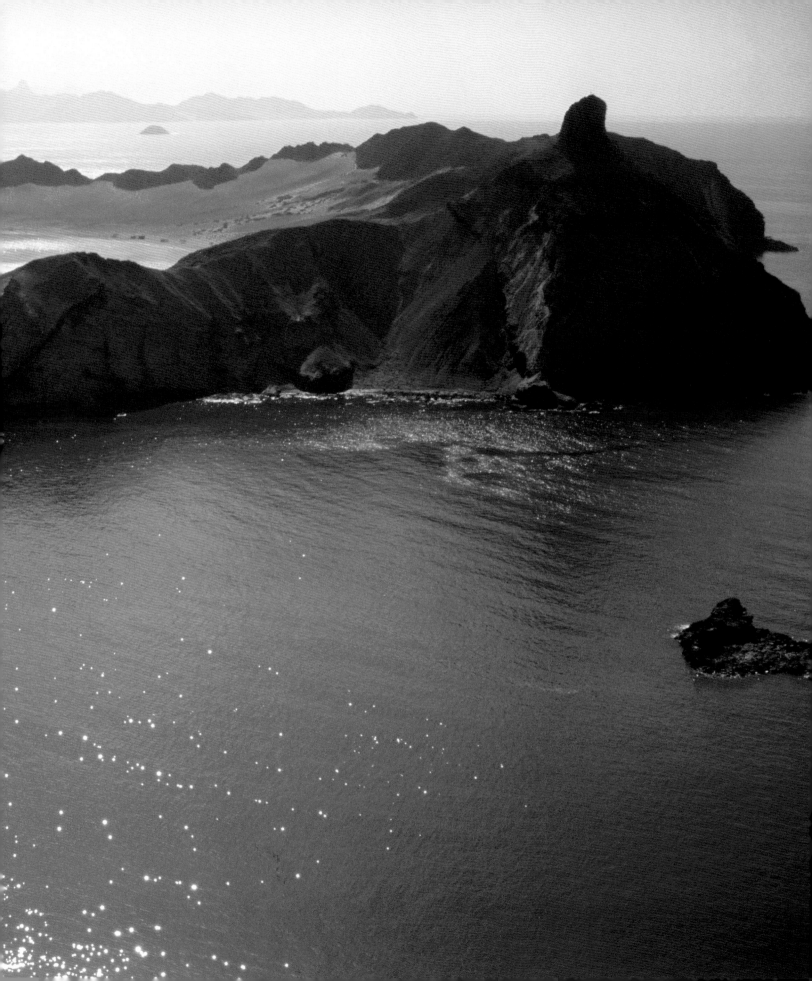

3 Trade and
Technology

NIGEL GROOM

# Trade, Incense, and Perfume

*The chief products of Arabia are frankincense and myrrh.* —PLINY 12

In about 450 BCE the Greek historian Herodotus wrote that "Arabia is the only place that produces frankincense, myrrh, cassia, cinnamon, and the gum called *ledanon* . . . the whole country exhales a more than earthly fragrance," supplementing this information with notes about the problems the Arabs had in collecting these materials.[1] He also recorded that the Persian emperor Darius (521–486 BCE), whose writ then extended as far as Egypt, was receiving one thousand Babylonian talents in weight, or nearly twenty-five tons, of frankincense annually from the Arabs as a "voluntary tribute."[2] Pottery sherds with letters inscribed in the old South Arabian script, relics of merchants from South Arabia, have been found near Aqaba and possibly date to a period slightly earlier than Herodotus.[3] Around 600 BCE the Greek poetess Sappho referred to frankincense and myrrh in her verses.[4] There seems no doubt then that the great trade in Arabian incense was flourishing by the time of Herodotus, and probably earlier.

How much further back the Arabian aromatics trade goes is still uncertain. In Queen Hatshepsut's temple at Deir al-Bahri near Thebes, a fresco of circa 1500 BCE shows Egyptian sailors traveling in a fleet of ships to the far distant land of Punt.[5] The most important commodity they collected from there was *ntyw*, which Egyptologists translated as frankincense. Since true frankincense trees grow only in South Arabia and Somalia, it was long held that the Egyptians sailed to these places to obtain it. Scholars now discount this, believing that *ntyw* was either an inferior form of incense obtained from another species of frankincense tree or, more probably, an inferior variety of myrrh, both of which are found in the region of present-day Eritrea. Recently it has even been proposed that the riches of Punt may have been in Uganda, reached after a long voyage up the Nile to Lake Albert.[6]

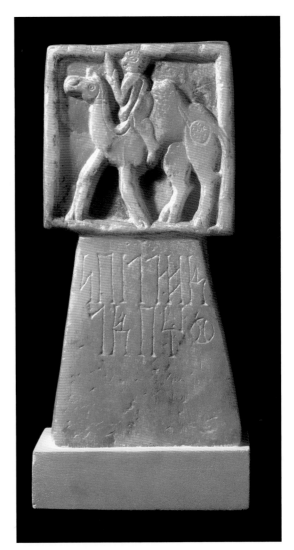

FIG 1 INCENSE BURNER SHOWING A CAMEL RIDER. SHABWA, CIRCA 3RD CENTURY CE. ALABASTER: H 32  W 15 TH 8 CM. THE BRITISH MUSEUM. ANE 1937-5-7,1=125682

Very relevant to the problem of when trade began is the legendary visit to Solomon by the queen of Sheba. As the dates of Solomon are approximately known, this would have happened in circa 950 BCE and is often explained as a meeting about trading. Even so, the Old Testament story is clouded in fable, and there are reasons to doubt its validity. The earliest known South Arabian ruler for whom there is inscriptional evidence reigned over Saba much later, in circa 800 BCE. The South Arabian monarchs were invariably male; the notion that any ruler in South Arabia would have visited Jerusalem in those days is almost preposterous. There were, however, queens in North Arabia in later centuries, and there are apparent references in the Old Testament to a Sabaean people living there, from which the legend could have derived.[7]

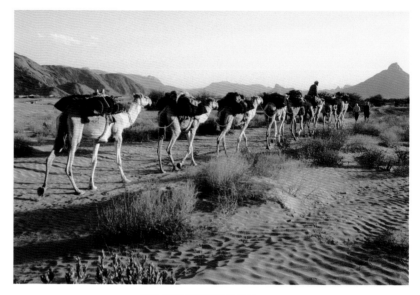

FIG 2 CAMELS IN THE RAMLAT AS-SABATAYN, EAST OF MARIB

The reference in two eighth- and seventh-century royal Assyrian inscriptions to contemporary Sabaean rulers suggests commercial contacts by that time.[8] However, the use of frankincense as such is not apparent in Mesopotamia until some time later, and scholars have now determined that frankincense and myrrh were not used by the Israelites in their rituals before the seventh century BCE.[9] All in all we cannot therefore assert on present evidence that the trade in aromatics from South Arabia began before the end of the eighth century BCE.

In circa 300 BCE the Greek botanist Theophrastus provided some descriptions of the South Arabian trees that produced aromatic gums, together with the statement that they grew in Saba, Hadramawt, Qataban, and Main.[10]

> Frankincense and myrrh . . . are found in the Arabian peninsula about Saba, Hadramawt, Qataban and Main *(Mamali)*. The trees of frankincense and myrrh grow partly in the mountains, partly on private estates at the foot of the mountains, wherefore some are under cultivation, others not. —THEOPHRASTUS 9.4

This is the earliest mention in literary sources of the last three of these kingdoms, which all seceded from Saba starting in circa 430 BCE. There is further information from other classical authors, but the bulk of our knowledge of the incense trade comes from the Roman writer Pliny, mostly obtained by him from earlier sources and in regard to the trade by sea from the *Periplus of the Erythraean Sea*. Pliny stated that the Minaeans (from the tiny kingdom of Main) had "originated the trade and chiefly practice it" and described the major part they played in it.[11] A surviving stela in the marketplace of Tamna, Qataban's capital in what is now Wadi Bayhan, bears this out; it is inscribed with the market regulations ordained by the king in circa 110 BCE and records the special trading status enjoyed by Minaeans in the city.[12] A century later Main had completely disappeared from history.

## FRANKINCENSE AND MYRRH

The principal aromatics carried along the incense route were frankincense and myrrh (FIG. 1). Frankincense was the incense par excellence, sometimes mixed with other fragrant materials but used by the Romans in enormous quantities on its own. It burns with a pure white and very fragrant smoke, which wafted men's prayers to heaven and pleased or propitiated their gods as much as it fumigated their homes, countered bad drains, and provided cures for their ailments. Frankincense, also known as *olibanum* (Arabic, *luban*), is a white gum resin that exudes in drops from cuts made in the branches and trunk of a small tree *(Boswellia sacra)* growing wild in inland areas of Arabia from Hadramawt eastwards as far as Dhofar, where most of it is found today. Other types of frankincense, some of high quality, come from other species of *Boswellia* (particularly *B. carteri* and *B. frereana*) found in the more eastern parts of northern Somalia. A very inferior sort is obtained from *B. papyrifera*, which grows widely from Sudan and Ethiopia to East Africa, and also *B. serrata*, found in India. Curiously, the island of Soqotra has several species of frankincense-producing *Boswellia* that are unique to it.

Myrrh (in Arabic the word means "bitter," to describe its taste) was also used in incenses, but its primary value was in medicines, perfumes, and in Egypt, embalming. In early perfumery, where it was used in the form of an extracted oil called *stacte*, it had the longest life of any scent known and was of special value as a "fixative," able to make other perfume ingredients mixed with it last much longer. It does not in itself have a strong scent. In the classical world it was also sometimes added to wine to give it astringency. It is a darker, more oily gum resin than frankincense, coming from a small and very thorny tree (*Commiphora myrrha* and other species) mostly found in the Yemen mountains west of Hadramawt, but growing widely as far east as Dhofar and as far north as Asir, as well as in Somalia and elsewhere. Pliny recognized different types of myrrh coming from Somalia and from different geographical areas of South Arabia.

## TRADE BY LAND

The earliest Minaean merchants harvested frankincense not far from Shabwa and, because their crop was regarded as sacred, they were not allowed to encounter women or funeral processions while tapping the trees. As the trade expanded they sought more easterly groves. Eventually the demand was so huge that supplies were brought by sea both from the Horn of Africa ("the Far Side") and from Dhofar. Dhofari frankincense, a monopoly of the king of Hadramawt, was plentiful and of the best quality. It was shipped to Qani, the port for Shabwa, in boats and on rafts from Moscha, the site of which probably lay somewhere west of present-day Salala. The climate and conditions in Dhofar were so bad that the king used slaves and prisoners to collect and load it. Soon after 50 CE a new port was established farther to the east at Khawr Ruri, populated by immigrants from Shabwa. At about the same time the facilities at Qani, which also received gums from the Somali ports, were improved.

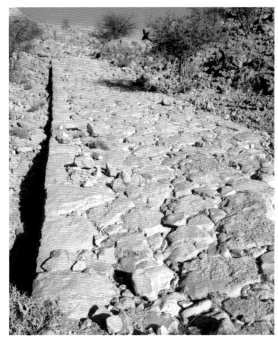

**FIG 3** PAVED CARAVAN ROUTE TO THE NORTH OF SIRWAH

Until well into the first century CE, and perhaps for some while after, all frankincense off-loaded at Qani was carried by camels to the temple at Shabwa (FIG. 2). A partly paved road led north over the mountains from Qani to Shabwa, where the temple priests took a portion of each load before the consignments were sold to merchants, originally all Minaeans, for onward conveyance. If the Qani merchants taking these loads up to Shabwa deviated from the highway to escape paying their temple dues, they faced the death penalty.[13]

From Shabwa, the waterless Empty Quarter of central Arabia compelled the incense caravans to trudge westward towards Main. Later, different routes skirting the Ramlat as-Sabatayn were used, but in Minaean times, when Qataban was at its most powerful, they seem to have threaded through southern hills and wadis, calling at Tamna, the capital city, where the Qatabanian king took his share as customs duty. Caravans of myrrh joined the route all along this stretch. In circa 210 BCE a spectacular mountain pass called Mablaqa was constructed just south of Tamna, providing a short cut for caravans on the next stage of their journey to the Sabaean city of Marib. They then headed northwards through Main and Najran (FIG. 3). At some point, most probably Najran, another remarkable group of long-distance traders joined the scene. These were the Gerrhaeans, who crossed the width of Arabia to obtain South Arabian aromatics for Mesopotamia and the Gulf region. It was evidently a very profitable venture, for the Greek geographer Strabo recorded, "From their trafficking both the Sabaeans and the Gerrhaeans have become richest of all"; other writers, even more carried away, averred that the columns of their houses were covered with silver and gold, and the doors and ceilings encrusted with close-packed gems.[14]

The main route continued northward, passing through Yathrib (now al-Madina) but keeping well to the east of Makka. The Minaeans had a substantial colony at Daydan (near Madain Salih), an important halting place, and the road then led on to Petra and Gaza, from where, until Alexandria became Rome's industrial capital, the aromatics were shipped into Europe. Sometimes the Minaean merchants seem to have traveled on with their goods: the Minaean inscription on a wooden sarcophagus of 264 BCE from Memphis (now in the Cairo Museum) shows it contained the body of Zaydil bin Zayd, a Minaean trader who "imported myrrh and calamus for the temples of the gods of Egypt," while a Minaean altar of the second century BCE has been found on the Greek island of Delos.[15] Between Tamna and Gaza, Pliny said, were sixty-five stages. The total journey from Shabwa was about 2,750 kilometers and would have taken two to three months at a normal camel's pace (FIG. 4). All along the way, Pliny noted, the merchants "keep on paying, at one place for water, at another for fodder, or the charges for lodging at the halts, and the various *octrois* [duties]: so that expenses mount up to 688 *denarii* per camel before the Mediterranean coast is reached; and then again payment is made to the customs officers of our empire."[16] Shipping across the Mediterranean added to the cost, and the merchants in Rome had to make their profit, so Roman citizens paid six *denarii* a pound for top-quality frankincense, more than most of them could earn in a fortnight, while a pound of myrrh, of which there were many varieties, cost the perfumers and apothecaries from eleven to sixteen *denarii*.[17]

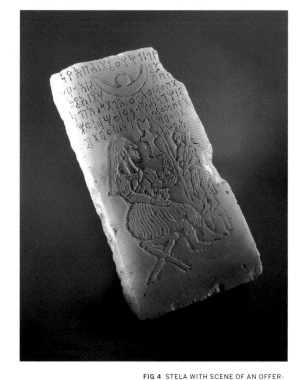

FIG 4 STELA WITH SCENE OF AN OFFERING TO THE SUN GODDESS SHAMS. TANIM, CIRCA 1ST CENTURY CE. ALABASTER; H 20.6 W 10.5 TH 4 CM. SANAA, NATIONAL MUSEUM, YM 386

## RED SEA TRADE

The incense road seems to have lasted for a long time after the alternative seaborne trade began to develop. This may have been due partly to the strong control over the handling of frankincense exercised in Hadramawt by the king and priests, and partly to the climatic timetable. Ships had to wait for seasonal winds, but camels could carry the new harvest of frankincense to the Mediterranean more quickly. Eventually internal wars in Arabia diminished the overland trade, probably well before the demand for frankincense collapsed after Rome accepted Christianity (which did not use incense in its rituals until circa 450 CE). The inauguration of imperial Rome at the turn of the millennium heralded a vast expansion of sea trade from Egyptian Red Sea ports with Arabia, the Horn of Africa, and especially India, which must ultimately have undercut the land-borne commerce.

The principal port of southwest Arabia in the time of the Roman Empire was Mouza, on the Himyarite Red Sea coast some thirty-two kilometers from the present-day inland town of Mawza, although the identification has not yet been confirmed through excavation. It was not a harbor, but provided very good anchorages. Mouza belonged to the increasingly powerful Himyarites, who were eventually to take over the entire region (FIG. 5). Its merchants enjoyed considerable trade with African ports across the Red Sea, such as Avalites near the Bab al-Mandab, Adoulis near present-day Massawa, and no doubt Sosippi, corruptly placed in Ptolemy's map of circa 150 CE on the Arabian shore but most likely to have been Assab. From these places they and Greek-Egyptian traders obtained ivory, tortoiseshell, rhinoceros horn, and some aromatics in exchange for a variety of clothing and fabrics, ornaments, tools, cooking pots, weapons, and even olive oil and wine.[18] In addition, despite difficult sailing conditions at the northern end of the Red Sea, numerous small Arab craft plied between Mouza and Leuke Kome (now Aynuna), bringing aromatics and other goods for Petra.

Mouza sold Yemeni products, chiefly myrrh and alabaster, to the merchants of Egypt, who brought with them for exchange all sorts of clothing and cloth, blankets, cloaks and girdles, together with saffron, storax, cyperus (an ingredient of Kuphi incense, from *Cyperus rotundus*), unguents, wine, and grain (FIG. 6).[19] Many of these were probably at first brought overland by returning incense caravans. Mouza also had a major interest in a route that visited the Somali ports on the Horn of Africa, perhaps going on to Soqotra (which belonged to the king of Hadramawt and had some Greek settlers) or continuing south to tropical Africa, called Azania, as far as Rhapta near present-day Dar es-Salaam. Used by ships of Roman Egypt as well, this route was developed by the Himyarites. The *Periplus* recorded that Azania was "by some ancient right" subject to Karibil, the Himyarite king; was ruled by his provincial governor, who lived inland from Mouza near present-day Taizz; and was taxed on his behalf by Mouza merchants who had settled in the country.[20] The principal luxury goods obtained on this route were frankincense, myrrh, and other aromatics, cinnamon, ivory, tortoiseshell and nautilus shell, and rhinoceros horn, and there was also a market for slaves.[21] To buy these items, the

FIG 5 MEASURING BUCKET. GHAYMAN, LATE 4TH–EARLY 5TH CENTURY CE. BRONZE; H 22 D 30 CM. SANAA, NATIONAL MUSEUM, YM 282. USED AS AN OFFICIAL MEASURE, THE BUCKET IS INSCRIBED ON ONE SIDE WITH HIMYARITE ROYAL MONOGRAMS; ON THE OTHER, A TWO-WORD INSCRIPTION, PERHAPS A PERSONAL NAME.

Arab and Greek-Egyptian merchants offered the goods sold on the Red Sea coast, together with, at the wealthier ports, silver, ironware, "numerous types of glass stones," and to retain the goodwill of the local people in Azania, wine and grain (FIG. 7). To enter this trade, merchants from Egypt had to buy the favors of the Himyarite king when they first reached Mouza. This was done with costly gifts, such as "horses and mules, vessels of gold and polished silver, finely woven clothing, and copper vessels."[22]

Many of the Greek-Egyptian merchants sailed on from Mouza following the Arabian shore, perhaps stopping for freshwater at Okelis, an ancient South Arabian port just north of the Bab al-Mandab (the area is now too sensitive militarily for archaeological investigation) or Eudaimon Arabia, now Aden, where the water was sweeter, though access was difficult during the southwest monsoon. Eudaimon Arabia, the *Periplus* noted, had formerly been the port where ships following the earliest coastal route from India would meet ships from Egypt to exchange their goods. Clinging to the coast, the traders then proceeded to Qani, where they would present further costly gifts, this time for the king of Hadramawt. Qani was another busy port, not only receiving aromatics from Moscha and other coastal villages in Hadramawt and Somalia but also trading with Oman, Scythia, and Persia as well as India. The *Periplus* advised merchants to take the same goods there as they sold in Mouza, including wheat and wine, together with clothing, copper, tin, coral, and storax.[23] Apart from frankincense they could load up there with aloe, which may have been locally grown *Aloe vera* or *Aloe perryi* from Soqotra, used for skin treatment then as now.

Many merchants, including those of Mouza, went on to India, originally to Barbarikon at the mouth of the Indus, or Barygaza on the Narmada River, later to ports farther south, where a huge array of exotic luxury goods could be obtained. To engage in this rich trade they had to purchase the goodwill of the king with comparable largesse. The *Periplus* recommended gifts such as "precious silverware, slave musicians, and beautiful girls."[24] The journey to Barygaza was for a long time a coastal one, but toward the end of the last century BCE the Greek-Egyptians, with their exceptionally sturdy vessels that were able to withstand the buffeting of the monsoon storms, began to exploit a newly discovered sailing technique that used the strong southwest monsoon wind to get them there and the lighter northeast monsoon wind to return by. On the outward journey this meant heading due east into the open sea as soon as they had passed Ras Fartak, the prominent headland between Qani and Moscha, and allowing the wind to take them northeast after a number of days, varying according to the port for which they were aiming. In later times huge Roman vessels collecting pepper and other spices sailed to South India directly after picking up water at Okelis. Ships returning late in the season sometimes had to pass the winter at Moscha, exchanging Indian goods for frankincense, but "neither covertly nor overtly can frankincense be loaded aboard a ship without royal permission; if even a grain is lifted aboard, the ship cannot sail, since it is against god's will."[25] Sometimes the return journey from India was made via Soqotra and the "Far Side" ports, where Somali aromatics were taken on board in exchange for those more basic Indian goods that their

FIG 6 JAR AND LID, PROBABLY A CONTAINER FOR PERFUMED OINTMENT. HAJAR IBN HUMAYD, MID-1ST CENTURY BCE-2ND CENTURY CE. ALABASTER; H 10.4 D 9.5 CM. THE AMERICAN FOUNDATION FOR THE STUDY OF MAN, TC HI 11

impoverished inhabitants could afford: grain, rice, ghee, sesame oil, cotton cloth, and sugar.

In all this trading, as will become apparent, the merchants from Egypt were almost exclusively seeking luxury goods for Rome, from which they stood to make enormous profits. In Egypt itself the transport of this valuable cargo was highly organized. The Ptolemies built a chain of fortified stations with watering points across the desert from the Egyptian ports of Myos Hormos and Berenike to Koptos on the Nile, from where cargo was taken down the river by boat to Alexandria. "At Alexandria . . . where frankincense is worked up for sale," Pliny wrote, "no vigilance is sufficient to guard the factories. A seal is put upon the workmen's aprons, they have to wear a mask or net with a close mesh on their heads, and before they are allowed to leave the premises they have to take off all their clothes."[26]

## OTHER FORMS OF INCENSE

Of course, the "perfumes of Arabia" comprised much more than frankincense and myrrh, although these were the two most important of the aromatic materials brought to Rome. As well as gums there were bdelliums and balsams. We have the early names of many of these items, but their botanical identification is by no means complete and they still present problems. Until very recently, for example, it was believed that Pliny's "scented myrrh," opopanax in modern perfumery, came from a variety of the tree *Commiphora erythraea*, which grows in Arabia, Somalia, and Eritrea; now it has been found to derive from *C. guidottii*, confined to eastern and southern Somalia, a discovery puzzling for scholars, who had supposed it might be the *ntyw* incense once brought by the ancient Egyptians from the land of Punt.[27]

Among artifacts retrieved in archaeological excavations in South Arabia have been a number of small incense altars, usually cubes of stone some five to ten centimeters high (FIG. 8). Many of them have the names of incenses inscribed in letters of the early South Arabian alphabet on one or more sides.[28] These have provided the local names of several different incenses used in South Arabia at the time, mostly, as far as we can see, locally grown materials.

> **LDN** (in South Arabian script the words are unvowelled) is recognizable as ladanum (or labdanum). Herodotus described it as "an ingredient in many kinds of perfumes" and "what the Arabians chiefly burn as incense" (here presumably referring to Arabians from North Arabia, where it grew).[29] It is an oleoresin exuded from the leaves of the rock rose *(Cistus incanus)* and other species of *Cistus*. It was also called goat's beard because it clung to the beards of grazing goats, from which it was collected by combing. It is still used in perfumery today.
>
> **QLM** identifies with calamus, also known as scented reed, which Pliny described as having "a specially fine scent that attracts people even from a long way off." There is inscriptional evidence of a third-century BCE Minaean merchant who sold calamus (as well as myrrh) in Egypt. It was

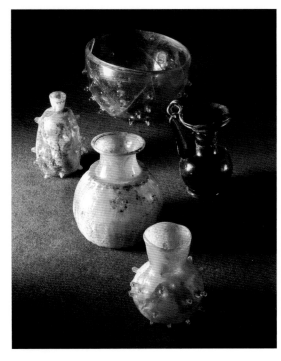

FIG 7 BOWL, BOTTLES, AND JUGLET. THE JAWF, 2ND–3RD CENTURY CE. GLASS; DIMENSIONS RANGE FROM H 6.5– 7.7 D 3.2–10 CM. SANAA, MILITARY MUSEUM, MIM 101–5

also a constituent of Egypt's famous Kuphi incense. It was probably lemongrass, also known as camel grass *(Cymbopogon citratus)*. The calamus oil used in modern perfumery comes from a different plant, sweet flag *(Acorus calamus)*.

**KAMKAM** and **DARW** are closely connected. The former, as cancanum, was described by Dioscorides as the gum of an Arabian tree resembling myrrh, while the latter, *tarum* in Latin, was noted by Pliny as always found in conjunction with cancanum.[30] The two are thought most likely to be respectively the gum and wood of the mastic tree *(Pistacia lentiscus)*, which grows in South Arabia and the Horn of Africa.

**QUST** on the altars is clearly costus, which the *Periplus* listed as an export from Barygaza in India. As used in perfumery today it comes from a North Indian herb called *Saussurea lappa*, native to the Himalayas. The earlier classical sources mention a "white" Arabian variety that the Arabians used themselves and was regarded as the best.[31] Theophrastus even described it as one of the principal plants used in Greek perfumery. If it did indeed originate in South Arabia this variety may have come from the plant *Costus arabicus*.

Additional names on the South Arabian incense altars include **LBNY**, which is frankincense. Oddly enough, this does not occur very often, suggesting it was not routinely used in domestic religious rituals in South Arabia. **RND** appears most frequently; it has not yet been identified but may be an Arabian variety of spikenard spoken of by both classical and Islamic authors. Others will no doubt be revealed as more such altars are discovered.

Surprisingly, the aromatic that it is most difficult to reconcile with our information about the ancient Arabian incense trade is cinnamon, which occurs frequently in the texts, usually in conjunction with cassia, to the extent that the two seem to be synonymous or at the very least two varieties of the same species. Herodotus mentioned both as coming from Arabia, and Pliny even reported from an early source that they were brought to Arabia from Africa on rafts that came to Okelis in the days when it belonged to the king of Qataban in the third century BCE.[32] Cinnamon as we know it today *(Cinnamonum verum)* grows only in the Far East. Many scholars have held, and some indeed still do, that it must have been reaching the Horn of Africa by sea from the earliest days and that the Arabs concealed this to protect their trading interests. This, however, does not conform with what we know about the essentially coastal nature of maritime trading in earliest times. Botanists have suggested that, as has happened in other cases, cinnamon and cassia may originally have derived from now-forgotten African or Arabian plants before similar but superior products from India began to be imported in Roman times and took on their names. Despite descriptions of the plants provided by the classical authors, no suitable candidates have yet been identified by botanists, but a proposal that the plant concerned was one known to early Arab authorities as *Qirfa* (the present

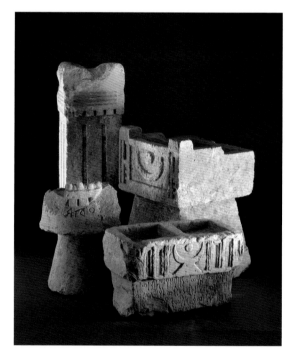

FIG 8 THREE INCENSE BURNERS. MARIB, BARAN TEMPLE, 7TH CENTURY BCE–1ST CENTURY CE. LIMESTONE; H 30–55 CM. MARIB MUSEUM, BAR 1197, 404, 843, AND 873. IN FRONT, A VOTIVE ALTAR WITH TWO COMPARTMENTS. POSSIBLY FROM DHAMAR, 3RD–4TH CENTURIES CE. LIMESTONE; H 18 W 31 TH 16 CM. SANAA, NATIONAL MUSEUM, YM 8777

Arabic word for cinnamon), which grew both in the Horn of Africa and in Arabia, may provide a solution to this perplexing problem.

In addition to cyperus, one other aromatic differs from the rest in that it was an import into Arabia (both to Mouza and to Qani) rather than an export. This was storax, a gum deriving from a tree *(Styrax officinalis)* that grows in Syria and Asia Minor. Pliny described it as a "pleasant, almost pungent scent," and the Arabs used it to fumigate their clothes and houses and to drive out snakes from the groves when they were collecting frankincense.[33] Here botanists face another problem because, although they are quite sure their identification is correct, the modern tree for some unknown reason no longer produces any gum, but perhaps, as with cinnamon, a little mystery is not amiss in a trade so surrounded by mystique.

**ENDNOTES**

1 HERODOTUS 3, 106–13.

2 HERODOTUS 3, 97; REPEATED BY PLINY 12.40.

3 CRONE 1987, 16.

4 QUOTED BY MÜLLER 1978, COL. 708, LINES 40–58, OR SEE CRONE 1987, 17.

5 SEIPEL ED. 1998, 56; ON THE IDENTIFICATION OF PUNT SEE FOR INSTANCE BRADBURY 1996.

6 THE HISTORY OF THE ARABIAN AROMATICS TRADE IS DISCUSSED AT GREATER LENGTH BY MÜLLER (1978) AND GROOM (1981; 1995; 1997); A COLLECTION OF PAPERS ON THE SAME SUBJECT HAS BEEN EDITED BY AVANZINI (1997).

7 GROOM 1981, 38–45.

8 SEE ROBIN, THIS VOLUME; THE SECOND OF THESE REFERENCES IS NO EARLIER THAN 689 BCE.

9 HARAN 1960; SEE ALSO CRONE 1987, 15.

10 THEOPHRASTUS 9.4.

11 PLINY 12.30.

12 BEESTON 1959.

13 PLINY 12.32.

14 STRABO 16.4.19.

15 SAYED 1984; BEESTON 1984; SEIPEL ED. 1998, 293, 295, NO. 164.

16 PLINY 12.51–70.

17 PLINY 12.51–70.

18 *PERIPLUS*, CHS. 6, 17.

19 *PERIPLUS*, CH. 24.

20 *PERIPLUS*, CH. 23.

21 *PERIPLUS*, CH. 24.

22 *PERIPLUS*, CH. 24.

23 *PERIPLUS*, CH. 28.

24 *PERIPLUS*, CH. 31.

25 *PERIPLUS*, CH. 32.

26 PLINY 12.32.

27 THULIN AND CLAESON 1991.

28 SEE SIMPSON ED. 2002, 95–96, NO. 101. A SIMILAR INCENSE BURNER IN THE MUSÉE DU LOUVRE IS INSCRIBED WITH THE TERMS *HADHAK, LADANUM, RAND,* AND *DARW* (CALVET AND ROBIN EDS. 1997, 104 NO. 4).

29 HERODOTUS 3, 115.

30 DIOSCORIDES I, 24/33; PLINY 12.98.

31 DIODORUS SICULUS 2.49.3; DIOSCORIDES I, 24/33.

32 PLINY 12.42; SEE ALSO CRONE 1987, 253–63.

33 PLINY 12.55.

UELI BRUNNER

# The Beginnings of Irrigation

The climatic evolution of the last ten millennia, that is, the geological era known as the Holocene, has played a decisive role in the mastery of irrigation. Although research in this area is still in its infancy, it has already begun to yield some results. Until the fifth millennium BCE, the climate seems to have been markedly wetter than it is today. At that time, a major hydraulic system existed in central Yemen. The water flow of the great valleys—Wadi al-Jawf, Wadi Dhana, Wadi Bayhan, and Wadi Markha—opened into the Wadi Hadramawt, ultimately to empty into the Indian Ocean. The valleys were filled with sparse savannah vegetation and populated with abundant fauna, to which numerous rock drawings testify. Living conditions for human inhabitants were relatively easy: as hunting and gathering were adequate for subsistence, irrigation was not necessary.

In the fourth millennium began a period of dessication: rivers flowed less abundantly, vegetation grew scarcer, and food resources diminished. In order to maintain the same living conditions, irrigation was needed to produce part of the food supply. Most likely this began with the scattering of seeds into the silt of the wadis following the seasonal floods, since rainfall was inadequate to support dry farming. Gradually, the moisture of the silt was preserved by means of rudimentary dams, which on the one hand served when needed to bring water into the fields, and on the other to increase cultivable land, normally situated above flood level. Farmers undoubtedly observed that this simple irrigation system brought very fertile deposits into the fields.

Several places at Marib document this method of improving the land through irrigation. Small berms to retain the water were built on basalt rocks; deposited upstream, the irrigation silts would in a few decades furnish new cultivable land. It was important, however, that this newly produced and thus fragile soil not be

FIG 1 TERRACED FIELDS, YEMENI HIGHLANDS WEST OF TAIZZ

carried away by the floodwaters. At Marib it was protected by a vein of metamorphic rock, cut open by a canal to empty the overflow of floodwater.

The system that initially was a blessing—the accumulation of silt on the fields—over the centuries became a problem, however. With each annual flooding the level of the fields rose, in certain cases as much as a centimeter per year. After a thousand years, the level of the fields would have risen ten meters. It is precisely this feature that allows us to determine an initial (and unavoidably very approximate) date for the introduction of irrigation. With chronological reference points available through radiocarbon analysis of samples, the range and median figures can be calculated. Each meter in height corresponds roughly to a century. Thus, at Marib, irrigation began in the third millennium BCE; farther south, in the Wadi Markha, it probably began about a thousand years earlier.

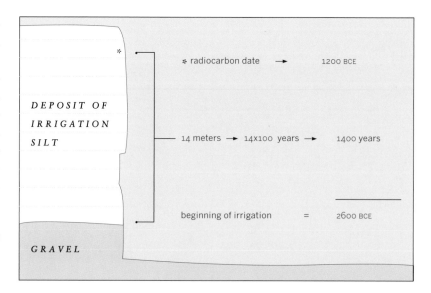

These dates correspond astonishingly neatly to those of a gradual dessication of the climate in South Arabia. In the Wadi Markha, one can sketch an outline of the development of artificial irrigation. It seems to have begun along the secondary wadis (phase 1). Here, the amounts of water trapped and diverted onto the fields were not significant; the system could be managed by means of simple earthen dams and small irrigation basins made of stone. These small secondary wadis served as a testing ground for controlling the much greater quantities of water in the major valleys. The most advantageous arrangement was to direct the runoff into the plain (phase 2), thereby reducing the velocity of the water and where a large surface was available to improve the fields. When the climate had reached its present degree of moisture, these fields were undoubtedly in danger of being covered with sand by the desert winds. It was thus necessary to transfer the system into the secondary valleys to protect them from the wind (phase 3). This development was complete by the first millennium BCE, after more than two thousand years of experience. This experimentation was simple, since it did not require control over more than a few cubic meters of water. In the major valleys, by contrast, following the rains, thousands of cubic meters per second gush down the slopes. Thereafter, irrigation was used in the classical period for extensive areas of cultivable land.

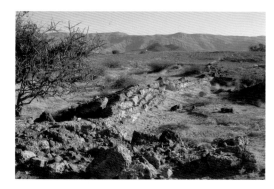

FIG 2 EXAMPLE OF DATING THE BEGINNING OF AGRICULTURE THROUGH STRATIFIED DEPOSIT

FIG 3 DAM WITH SLUICE BUILDING IN THE OASIS OF SIRWAH

BURKHARD VOGT

# The Great Marib Dam

NEW RESEARCH BY THE GERMAN
ARCHAEOLOGICAL INSTITUTE IN 2002

The work begun on the Great Marib Dam in autumn 2002 is a joint venture of the Commission for General and Comparative Archaeology (Bonn) and the Sanaa Branch of the German Archaeological Institute (DAI). The work arose from a project to conserve the Great Dam and open it to tourists. This project was supported by the Yemeni government's application to UNESCO to register the ancient oasis of Marib as an item of world cultural heritage. After its positive experience in consolidating and developing the Almaqah temple of Baran in Marib, the Ministry for Economic Cooperation of the Federal Republic of Germany and the Society for Technical Cooperation undertook the financing of the first phase of the conservation measures on the Great Dam.

The DAI's Sanaa Branch intensively examined (in particular during the 1980s) the Great Dam, the last in a succession of at least seven ancient dams at Marib, but this research was restricted entirely to monumental remains visible on the surface. The consolidation work now begun therefore offers the chance to carry out archaeological research of selected system components for the first time—a rarity for a purely functional construction of this size. The first campaign in 2002 has already produced results that put quite a different light on the dam's functioning and chronology.

The dam at the mouth of Wadi al-Sudd probably last ruptured during the lifetime of the prophet Muhammad, as we know from the Quran. The surviving ruins—floodwaters tore through only the central section of the 620-meter-long earthen dam—were still well preserved during the tenth century CE, as al-Hamdani described in the eighth book of his *Iklil*. The two stone sluice constructions founded upon the bedrock of Jabal Balaq on the north and south banks of the Wadi Dhana survived remarkably well the subsequent passage of time (FIG. 1). The North Sluice in particular was protected by large quantities of

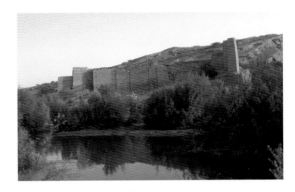

FIG 1 MARIB, GREAT DAM, SOUTH BUILDING

119

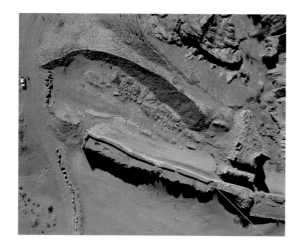

water-laid sediments and later accumulation of windblown sand (FIG. 2). Serious damage did not occur until the 1940s and later, when both sluice constructions were used as stone quarries.

Each of the structures contain as components an outflow sluice area supported by massive pillars, an overflow sill that allowed floodwater discharge (FIG. 3), and a settling basin in which incoming water could subside before flowing through the main conveying channel. Excepting the settling basin's southern side (which was an earthen dam reinforced with stones on the interior face), the North Sluice consists of massive walls, the interior of which are casemates packed solid with rubble and earth, and the outer faces of which are covered with limestone blocks.

In 2002 large quantities of sediment and sand were removed from the northern end of the reservoir, the settling basin, and the northern apron (FIG. 4). This procedure reached natural soil in the reservoir above the double outflow and in a small sondage within the settling basin (FIG. 5). The excavation showed that only half of the North Sluice protrudes above the surface, implying an actual height of about fourteen meters and a length of 145 meters. These are truly monumental dimensions.

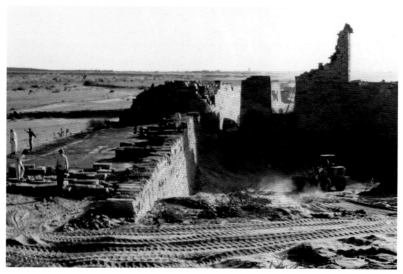

Practically all of the North Sluice in its present condition is made of reused limestone blocks. Part of this material certainly was taken from the immediately preceding dam structures that had once stood on the same spot as the North Sluice or not too far away. Older architectural elements were also used in building the North Sluice, in which may be recognized fragments of architraves and even complete monolithic pillars with toothed capitals that had been removed from older sacred buildings. Nearly fifty Sabaean inscriptions (or fragmentary inscriptions) have been discovered so far on the North Sluice. The inscriptions are sometimes found in the fill of the casemates or set into the facing of walls—sometimes upside down or covered with plaster. This situation would be evidence enough to assume that the inscribed blocks had been reused, but also in almost all cases the inscriptions contain no reference to the building or the function of the North Sluice. Epigraphic examination provides evidence that many of the inscriptions— mostly legal texts and building and votive inscriptions—originated from the city area of Marib: from fortification walls, from other buildings related to the irrigation system within the oasis, and from the Awam temple cemetery.

Although the builders always attempted to make continuous, even courses by selecting reusable limestone blocks of uniform thickness, joints at irregular heights can frequently be seen. Whereas in older irrigation systems, for example, those from the first millennium BCE, the blocks were laid without cement, in this case clamps and dowels made of lead-coated iron had to be used in order to give the masonry sufficient stability, especially in those parts of the sluices and floodwater overflow sill areas that were subjected to great pressure. In addition,

**FIG 2** AERIAL VIEW OF NORTH SLUICE OF THE DAM

**FIG 3** NORTH SLUICE OF THE DAM WITH OVERFLOW SILL IN THE FOREGROUND AND DOUBLE SLUICE

the occasionally diverging joints were given a sealing finish of *qadhat*, a material that was possibly developed around the time of the birth of Jesus (FIG. 6). *Qadhat*, a plaster mortar made of slaked lime and a high proportion of volcanic ash and a little river sand as aggregate, is still manufactured today in Yemen according to ancient procedures. It is used in traditional buildings for sealing roofs and plumbing units, and it is also applied in our conservation work. The mechanical sealing achieved by continuous hammering, which gives the mortar a special elasticity, is particularly time-consuming. For this reason, large areas of the inner, upstream masonry of the ancient Great Dam had been coated with *qadhat*, whereas the opposite wall was roughly finished with irregular lava chunks held together only with an exterior layer of *qadhat*.

As far as is evident to date, reused stone material, iron clamps, and sealing with *qadhat* are typical features of the North Sluice from its foundations to its top. In contrast to the South Sluice, where remains of the original sixth-century BCE masonry are still preserved, the appearance of the North Sluice indicates a considerably later date of construction. An exception to this generality is the recognizably worked bedrock in the reservoir, which should very probably be assigned to an earlier structure. Even so, the state of the North Sluice reflects construction in several phases. Joints are signs of possible extensions of the settling basin wall to the east; the massive enlargement of the overflow sill and the newly discovered buttressing walls on the north side of the settling basin wall (FIG. 7) point in the same direction. A different intensity of patina on the stones of one of the sluice gates structures indicates extensive repairs or restoration. Apparently repeated instances of damage during irrigation operations had to be prevented with additional stabilization or reinforcement measures.

A relatively thin, comblike wall was later added to raise the height of the sills of the sluice gates and of the floodwater overflow sill, and supplemental copings coated with *qadhat* also raised the height of the sluice gate structures and of the settling basin walls. These measures can be explained by changes in flow properties or by heavy deposition of sediments in the reservoir and in the settling basin.

However, perhaps the most distinct indication of the phasing of various construction and repair activities is supplied by the inscriptions discovered in the area of the North Sluice, for which paleographic dating and the names of individual rulers provide chronological clues. The reused stones with inscriptions leave us certain that the structures fundamental to the functioning of the North Sluice (and therefore in fact the whole North Sluice) cannot have been built until after the middle of the third century CE. Two very detailed late Sabaean inscription stelae of the rulers Surahbiil Yafur and Abraha, found a century ago in the immediate vicinity of the floodwater overflow sill, plus another intact inscription of Abraha discovered in 2002 directly north of the stilling basin, provide more specific chronological evidence. All three inscriptions describe in great detail the complex construction project involving coordination of a large number of workers. We must now regard these inscriptions as documenting the construction or fundamental extension of the North Sluice, probably after its complete destruction or at least severe damage. The inscriptions date to the years 456 and 548 CE, but the texts do not allow a definitive assignment to either

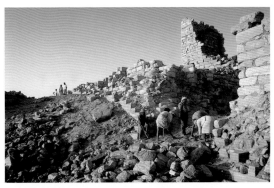

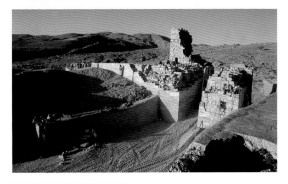

**FIG 4** NORTHERN APRON OF THE SLUICE BUILDING DURING THE UNVEILING

**FIG 5** SLUICE AREA BEFORE UNVEILING AND CONSERVATION

**FIG 6** WESTERN STILLING BASIN WITH SLUICE DURING CONSERVATION

of the two rulers named in the inscriptions. The first radiocarbon dates on samples taken from the bottom of the settling basin at both the South and North Sluice, and from the *qadhat* plastering of a newly discovered wall in the settling basin of the North Sluice, fall consistently in the fifth to sixth century CE. The dates therefore confirm the period of construction mentioned in the inscriptions.

There can now be no doubt that the North Sluice did not take its present shape until late antiquity—only shortly before the final destruction or the abandonment of the irrigation system of Marib. At this point in time the system seems to have reached the limits of its technical possibilities. In the tenth century al-Hamdani claimed that the thick accumulation of oasis sediment, the very high surface of which irrigation could no longer reach, was the reason for the failure of the system, quite aside from the collapse of the earthen dam. In fact, breach of the dam and other technical problems only partially explain the end of the irrigation system at Marib; other great irrigation systems in the zone along the edge of the desert were also abandoned at the same time. Marib had noticeably lost a great deal of political and probably also economic significance when the Yemeni capital was established in the highlands and when foreign trade shifted from caravan to sea routes. For this reason we may now assume that the inhabitants and the political authorities remaining in Marib did not possess enough strength to organize themselves for a renewed communal enterprise. Perhaps, however, they did not see any necessity to repair the dam and put it back in operation.

**FURTHER READING**
SCHALOSKE, M. 1995. "UNTERSUCHUNGEN DER SABÄISCHEN BEWÄSSERUNGSANLAGEN IN MARIB." *ARCHÄOLOGISCHE BERICHTE AUS DEM YEMEN 7.*
SCHMIDT, J. 1982. "BAUGESCHICHTLICHE UNTERSUCHUNGEN AN DEN BAUANLAGEN DES GROßEN DAMMES VON MARIB." *ARCHÄOLOGISCHE BERICHTE AUS DEM YEMEN* 1: 9–20.
VOGT, B., W. BRETTSCHNEIDER, U. BRUNNER, W. HERBERG, AND N. RÖRING. 2003. "DER GROßE DAMM VON MARIB, REPUBLIK JEMEN."

NEUE ARCHÄOLOGISCHE UND BAUHISTORISCHE FORSCHUNGEN DES DEUTSCHEN ARCHÄOLOGISCHEN INSTITUTS 2002." *BEITRÄGE ZUR ALLGEMEINEN UND VERGLEICHENDEN ARCHÄOLOGIE* 23: 49–00.
VOGT, B. 2004. "TOWARDS A NEW DATING OF THE GREAT DAM AT MARIB: PRELIMINARY RESULTS OF THE 2002 FIELDWORK OF THE GERMAN ARCHAEOLOGICAL INSTITUTE." *PROCEEDINGS OF THE SEMINAR FOR ARABIAN STUDIES* 34: 377–88.

**FIG 7** ROUNDED SLUICE PILLAR WITH REMAINS OF RENDERING AND RECENT DESTRUCTION

**FIG 8** THE NORTH SLUICE AFTER ITS UNVEILING

4 Gallery of Works

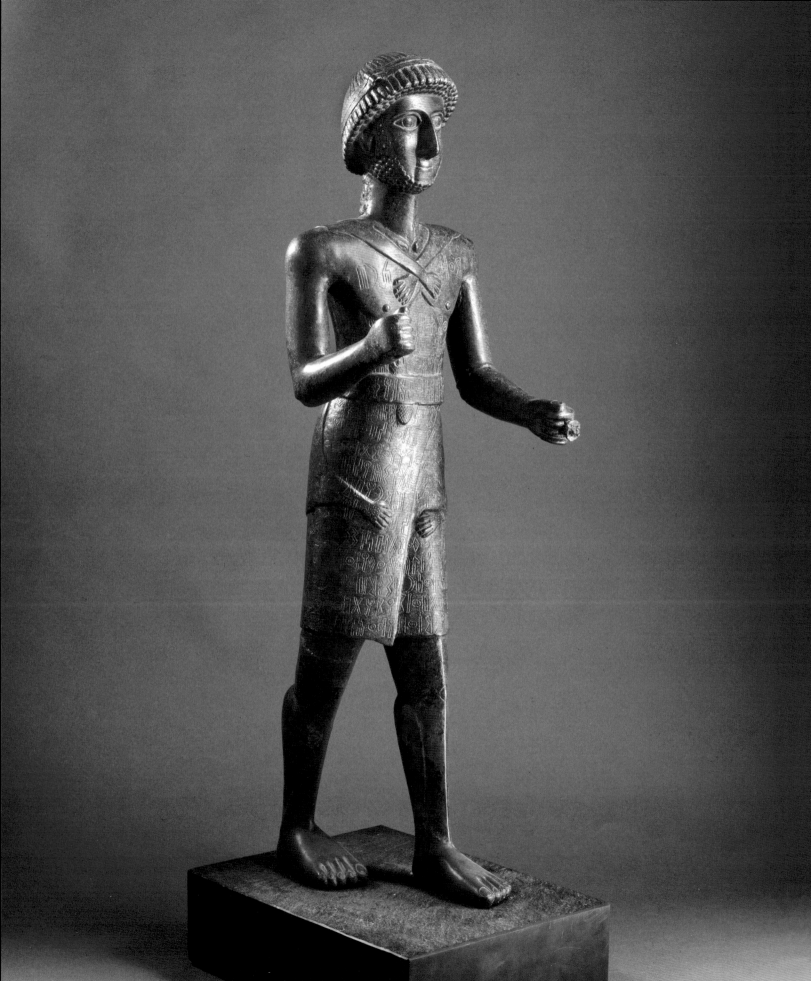

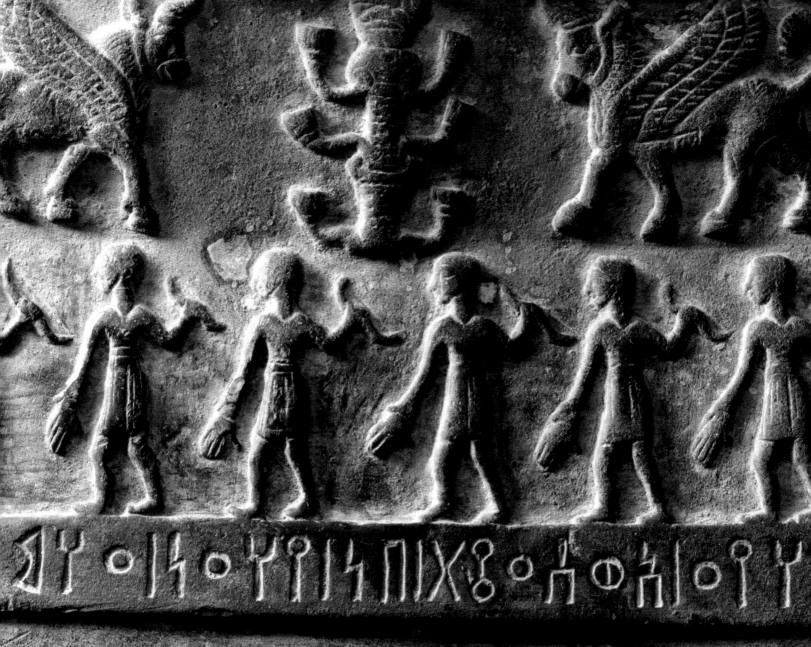

< 1  STATUE OF MADIKARIB   Marib, 6th century BCE   Bronze; H 93  W 27  H of head 15 cm   National Museum, Sanaa, YM 262

< 2  (DETAIL) FRAGMENT DEPICTING A MILITARY VICTORY   Marib, 5th century BCE   Bronze; H 46  W 38  TH 1 cm   National Museum, Sanaa, YM 13981

3  ALTAR DEDICATED TO THE DEITY RAHMAW   Probably from Marib, 6th century BCE   Tin-bronze; H 66  W 110  TH 34.5 cm

The British Museum, ANE 1970–4,1–2=135323 and 135324

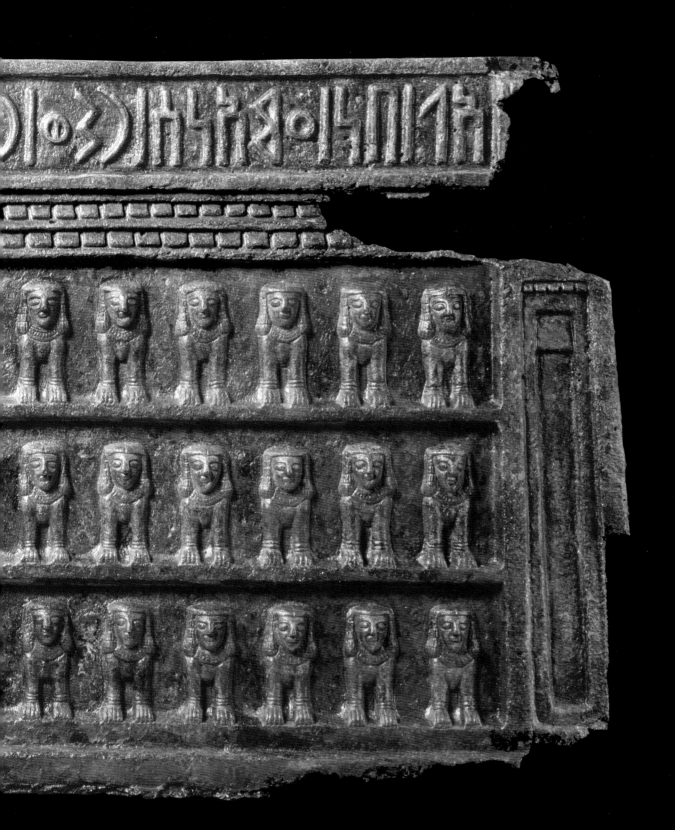

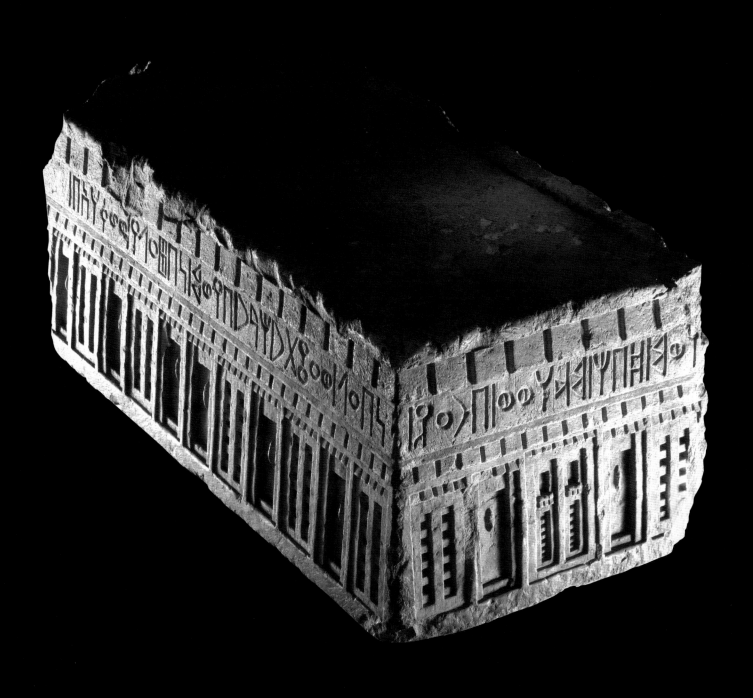

4  MINIATURE TEMPLE  Kamna, circa 8th century BCE  Limestone; H 40  L 80  TH 50 cm  Military Museum, Sanaa, MiM 3630

5 INCENSE BURNER  Tamna, 1st half of 1st century CE  Limestone; H 11.5  W 9.7  TH 9.7 cm  The American Foundation for the Study of Man, TC 2011

6 INCENSE BURNER  Tamna, 1st half of 1st century CE  Limestone and paint; H 10 W 8.4 TH 8.2 cm  The American Foundation for the Study of Man, TC 1955

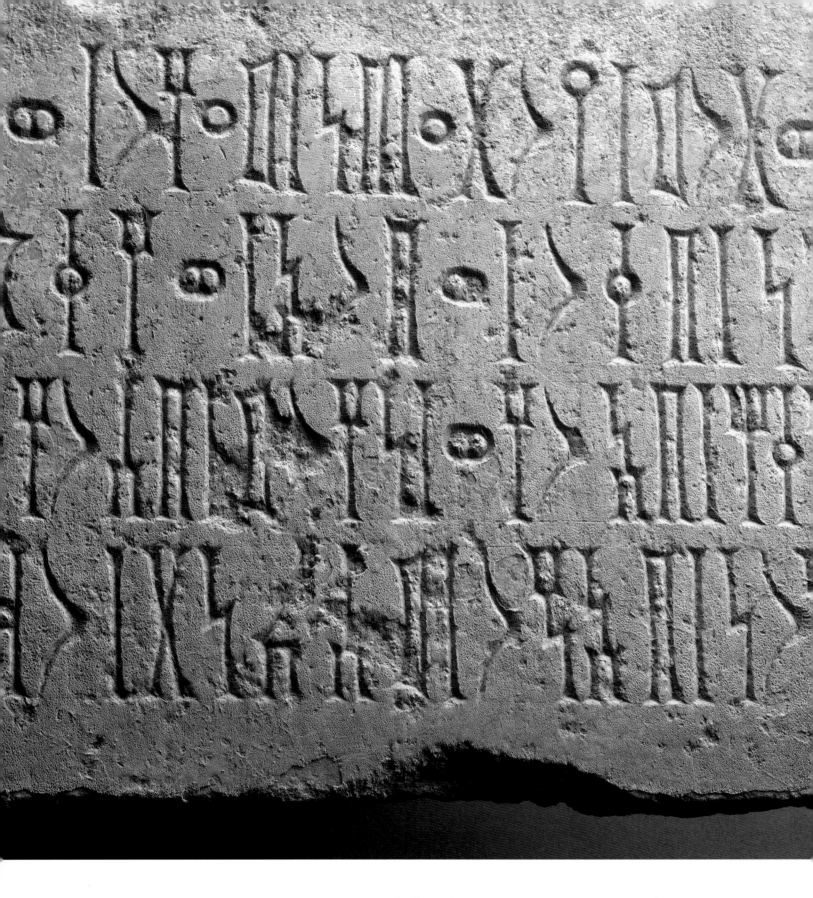

7 (DETAIL) STELA COMMEMORATING THE DIGGING OF A WELL   Wadi Akhirr, mid-1st century CE   Limestone; H 35  W 53 cm   Bayhan Museum, BAM 672

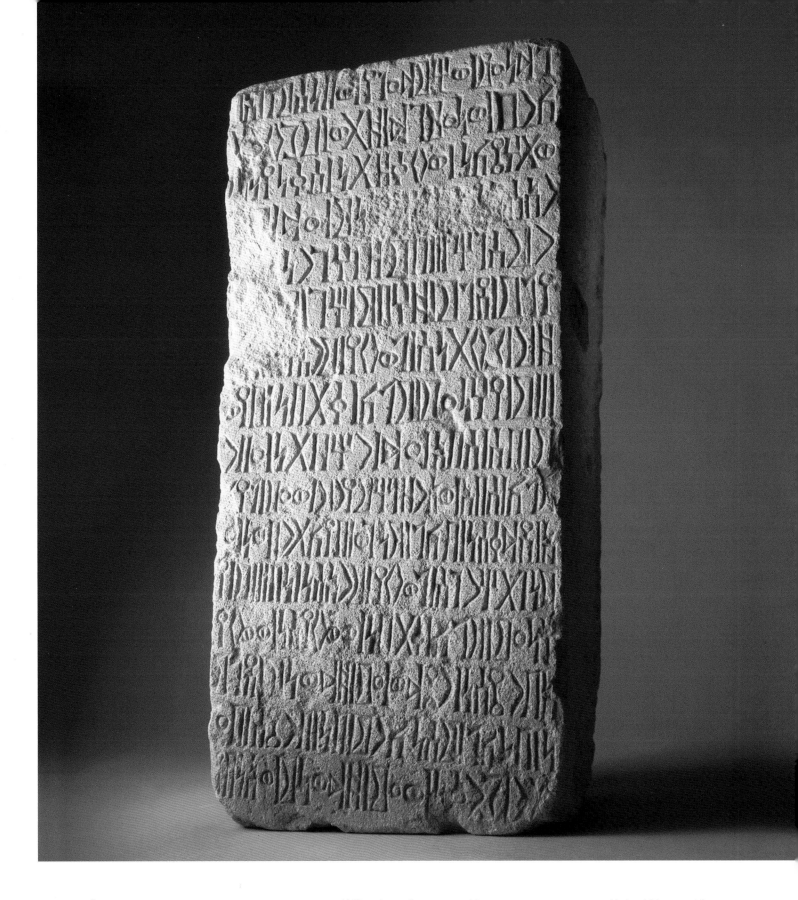

8 STELA MENTIONING LAST KING OF QATABAN   Al-Hinu, late 2nd century CE   Limestone; H 50 W 24 TH 14 cm   National Museum, Aden, NAM 511

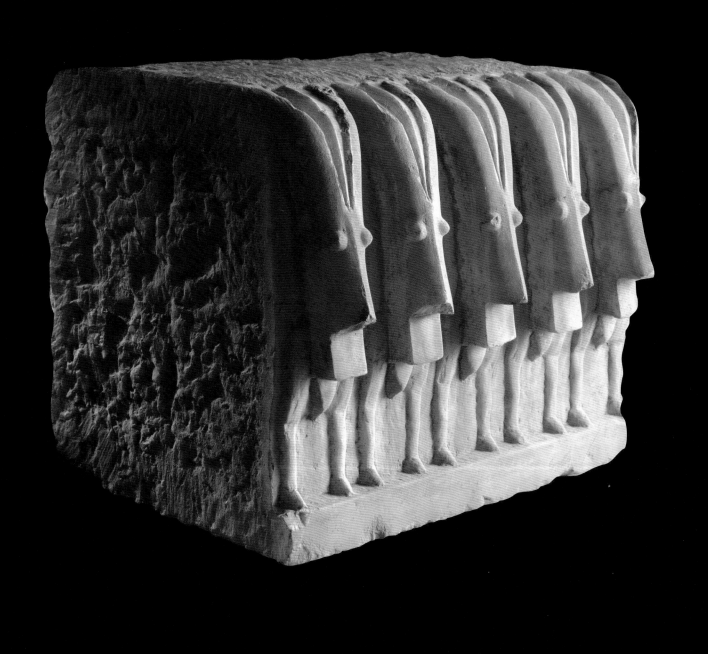

9  IBEX FRIEZE    Marib, 5th century BCE    Alabaster; H 39 W 53 TH 35 cm    Marib Museum, BAR 906

10  STELA WITH BULL'S HEAD   Tamna, 1st half of 1st century CE   Alabaster; H 27.5  W 21.5  TH 10 cm   The American Foundation for the Study of Man, TC 1686

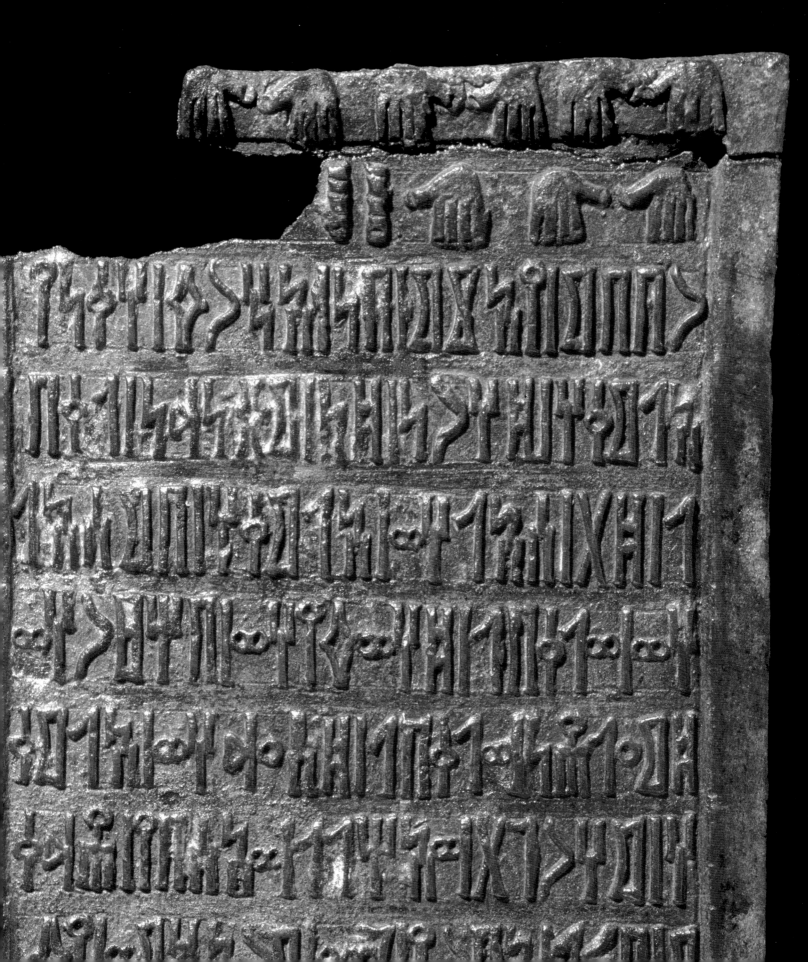

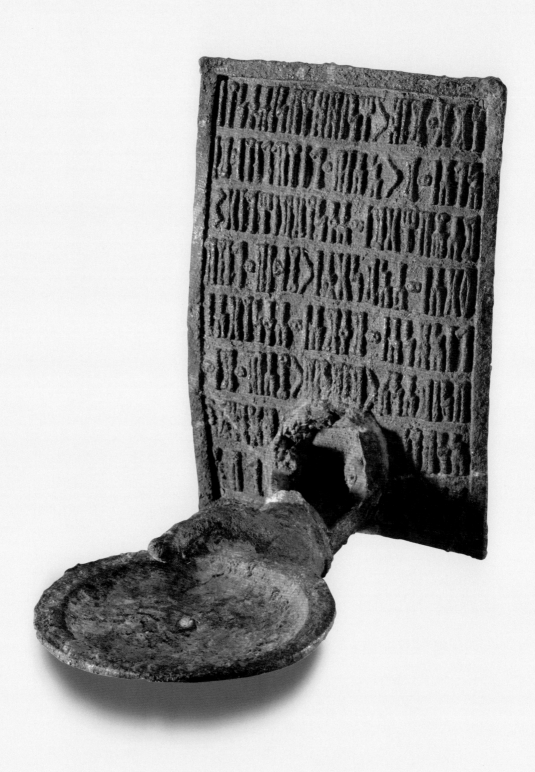

11 (DETAIL) INSCRIBED PLAQUE MENTIONING BATTLE BETWEEN SABAEANS AND ARABS IN THE JAWF
Amran, 1st century BCE   Bronze; H 31.5   W 18.5   TH 2 cm   The British Museum, ANE 1862–10–28,9= E48461

12 INSCRIBED PLAQUE WITH LAMP EXTENDED BY HAND   Tamna, 1st half of 1st century BCE
Bronze; H 20.5   W 14.2   D 11.6 cm   The American Foundation for the Study of Man, TS 1121

13 NECKLACE WITH AMULET OF THE GODDESS AL-LAT  Tamna, perhaps 1st century CE   Gold; pendant H 3.4  W 4  TH 0.1 cm, chain L 11.2  D 0.9 cm   The American Foundation for the Study of Man, TC 19

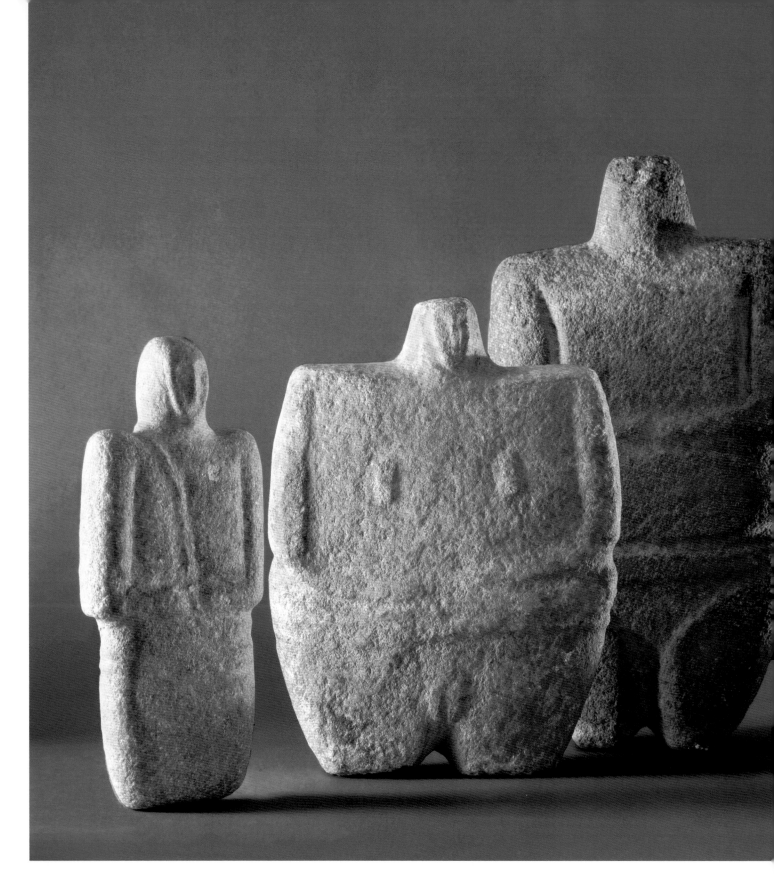

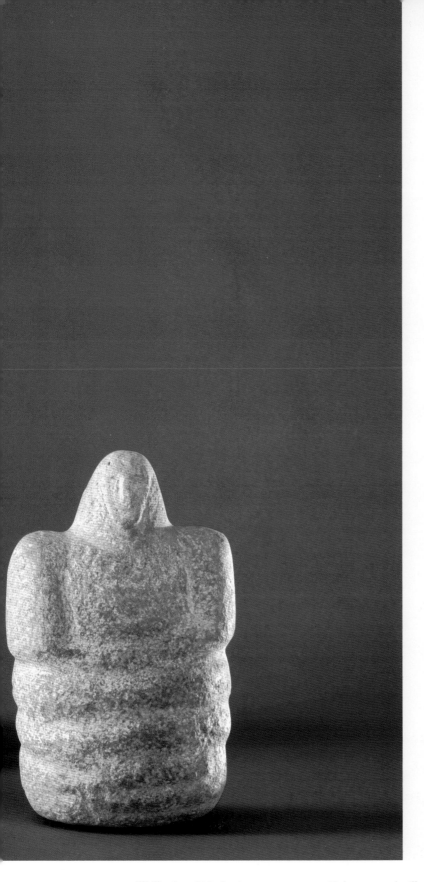

14 STATUETTES Highlands and Marib, circa 3000–1000 BCE Hadramawt, 2nd millennium BCE (far right) Granite; H 17.5–33 cm
Sayun Museum, SM 2644, 2645; National Museum, Sanaa, YM 12964; Marib Museum, BAR 1

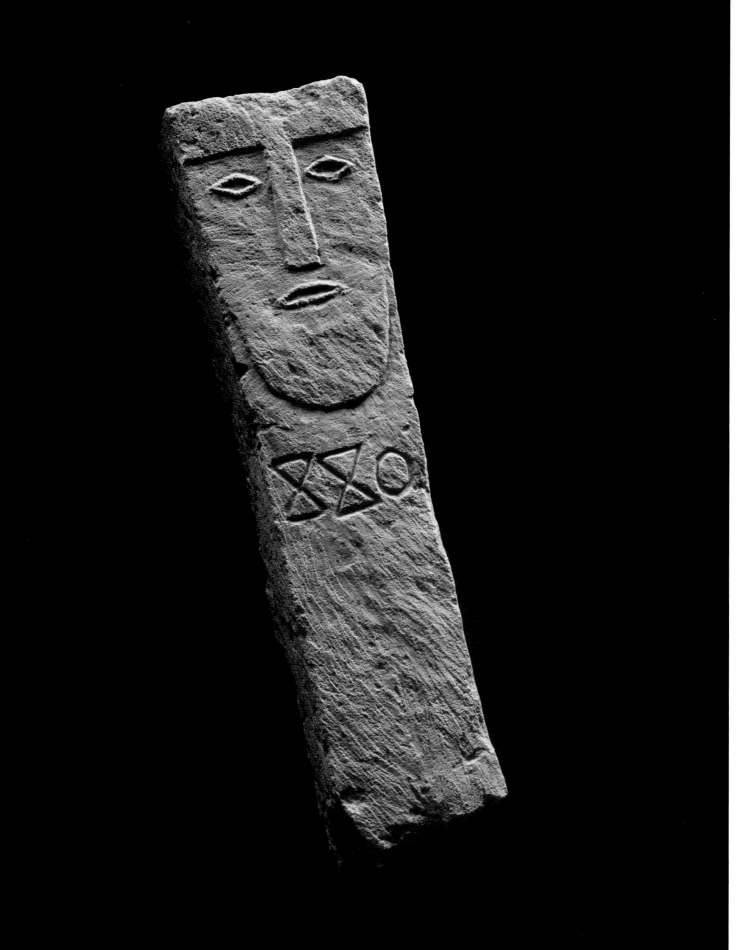

15 FUNERARY PILLAR STELA   Possibly from the Jawf, date uncertain   Limestone; H 38 W 19 TH 8 cm   National Museum, Sanaa, YM 1121
16 FACE STELA   Tamna, 1st half of 1st century CE   Limestone; H 14.9 W 21 TH 7 cm   The American Foundation for the Study of Man, TC 40

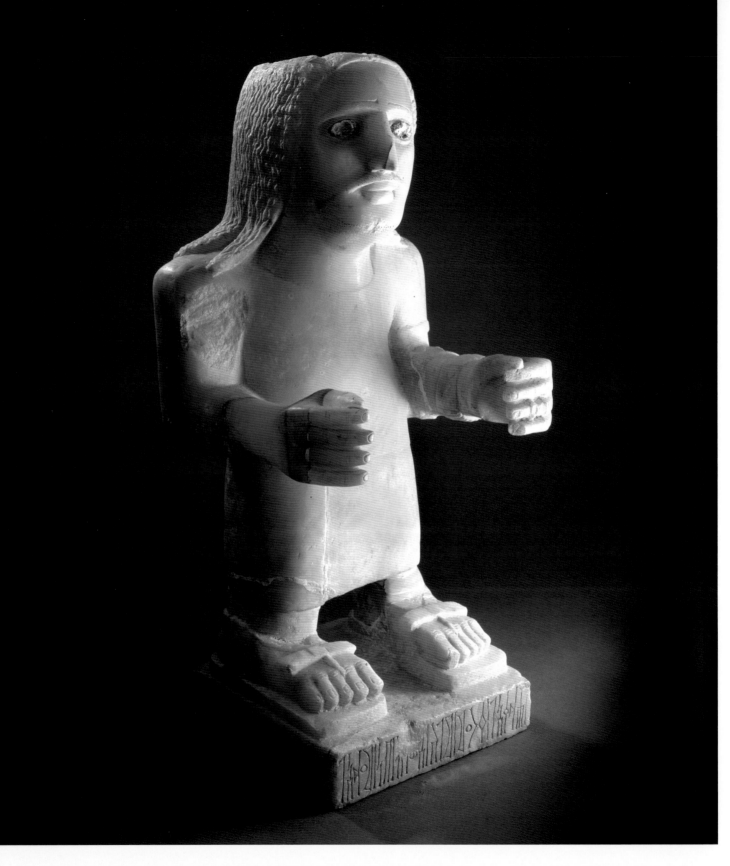

17  STATUE OF YASUDUQIL FAR, KING OF AWSAN   Wadi Markha, 1st century BCE   Alabaster; H 70  W 31  TH 26 cm   National Museum, Aden, NAM 611
18  STATUE OF MAADIL SALHAN, KING OF AWSAN   Wadi Markha, 1st century BCE   Alabaster; H 88  W 28  TH 15 cm   National Museum, Aden, NAM 612

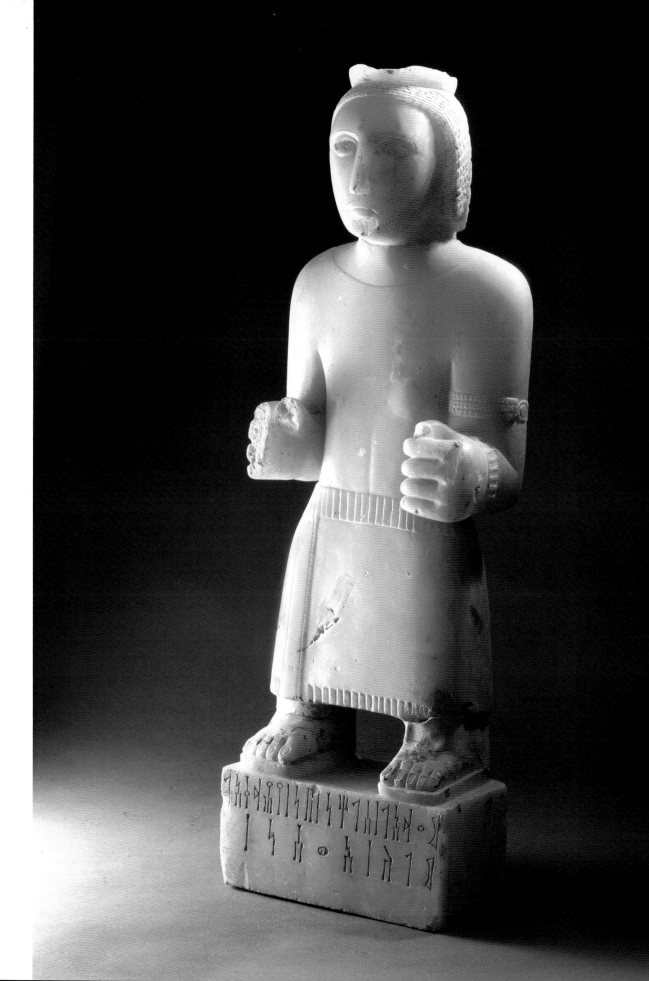

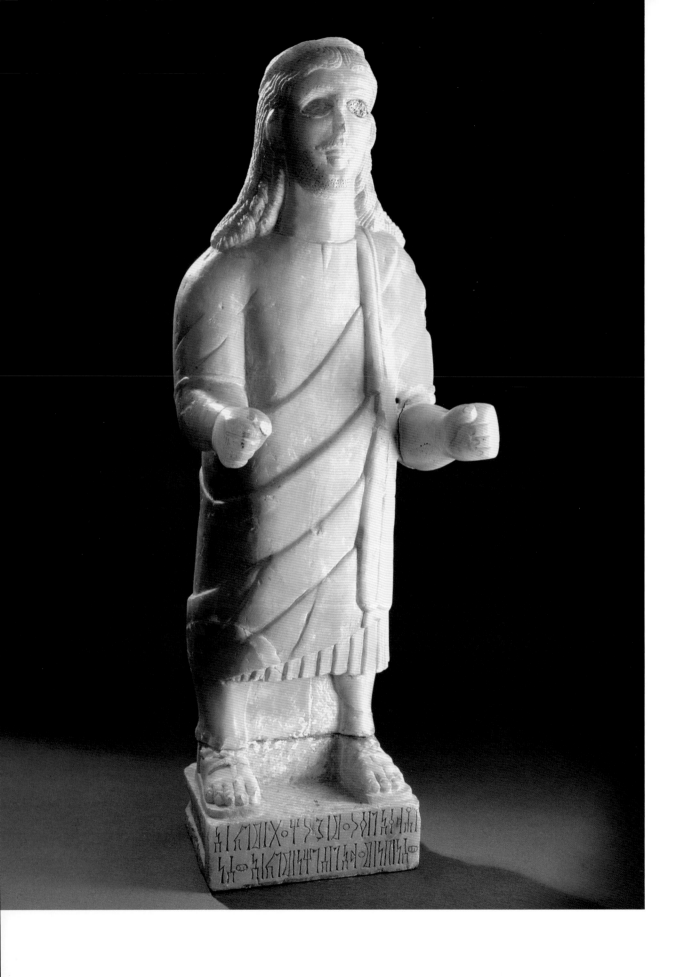

19  STATUE OF YASUDUQIL FAR SHARAHAT, KING OF AWSAN  Wadi Markha, 1st century CE  Alabaster; H 70  W 28  TH 19 cm  National Museum, Aden, NAM 609

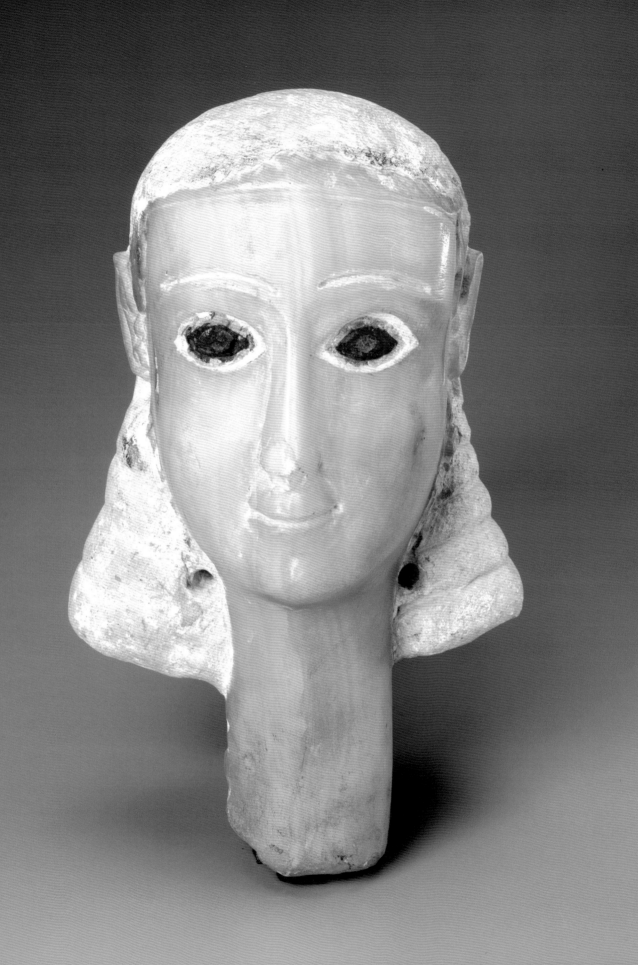

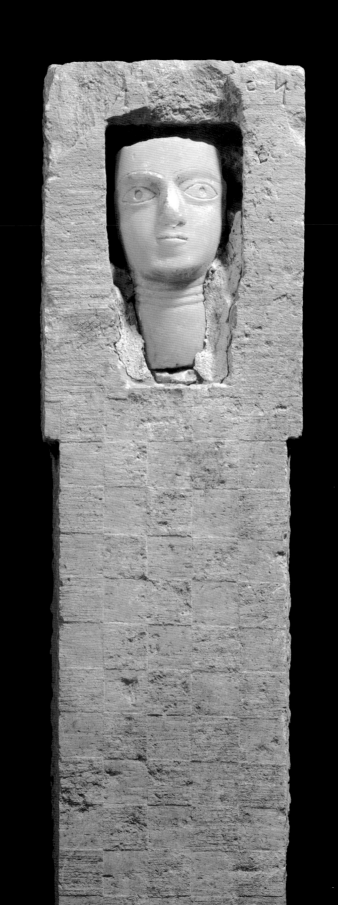

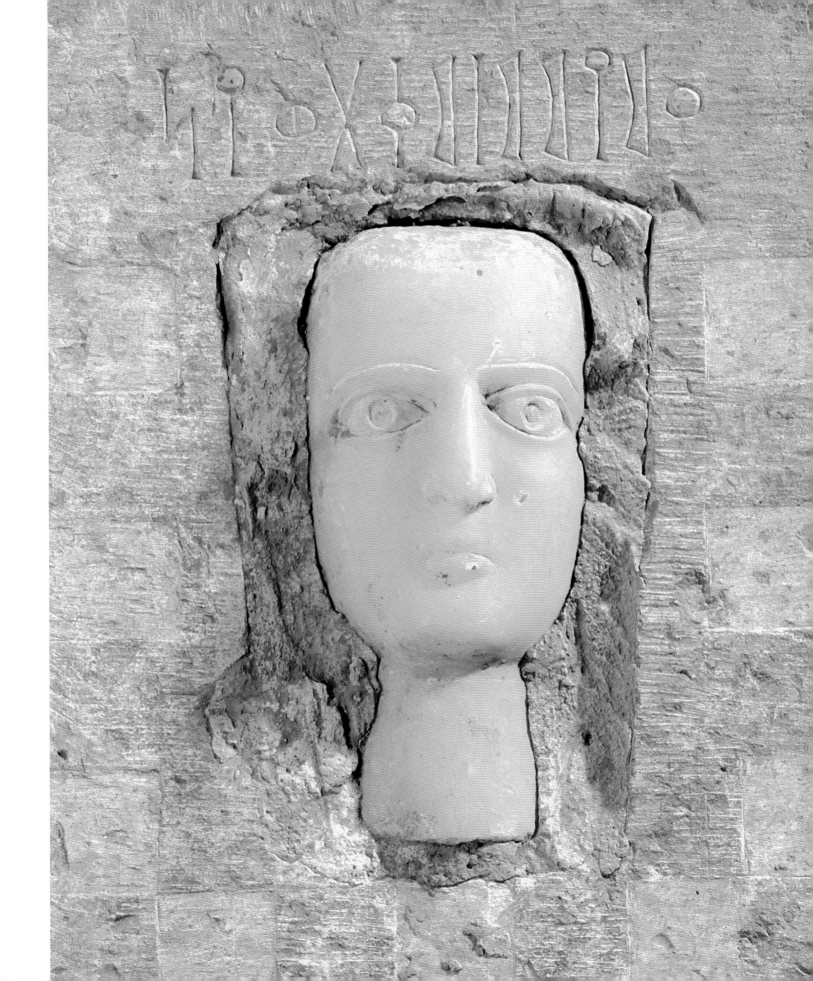

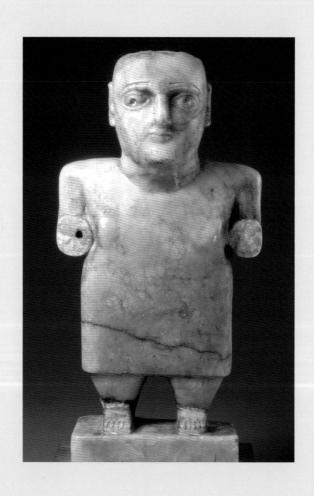

23  STANDING MALE FIGURE  Provenance uncertain, possibly 3rd–1st century BCE  Alabaster; H 37  W 18.5  D 7.50 cm  The British Museum, ANE 1907–1-12,5=102461

24  STANDING FEMALE FIGURE  Provenance uncertain, 1st–2nd century CE  Alabaster; H 74.5  W 33  TH 24 cm  The British Museum, ANE 1965–10–11,1=134693

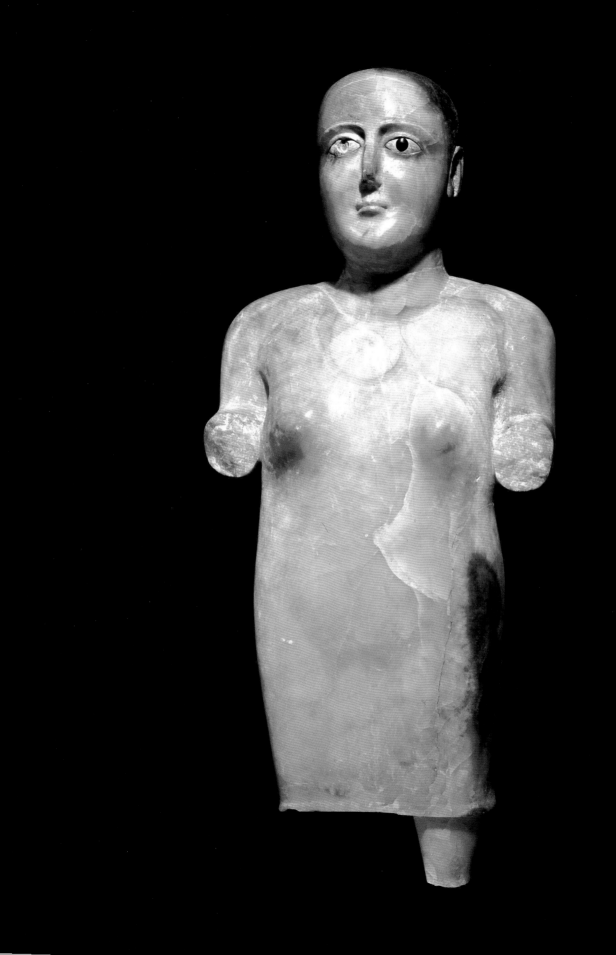

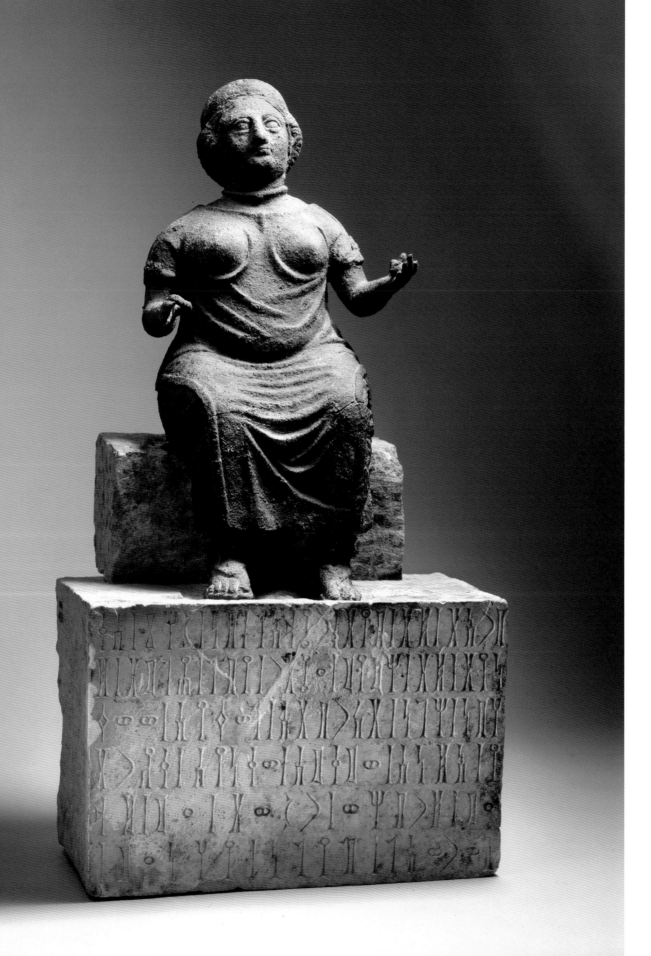

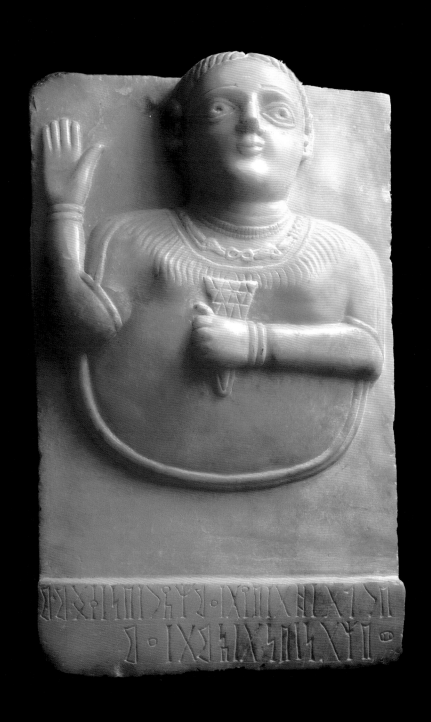

25 STATUE OF LADY BARAT  Tamna, circa 2nd century BCE  Bronze; H 52 cm  National Museum, Aden, NAM 56

26 STELA OF FEMALE FIGURE  al-Jubah, 1st century BCE  Alabaster; H 53 W 34 TH 5.5 cm  National Museum, Sanaa, YM 71

27 ARROWHEAD WITH DEDICATORY INSCRIPTION   The Jawf, possibly 1st century CE   Bronze; H 12  W 2.8 cm   National Museum, Sanaa, YM 3828

28 INSCRIBED HAND DEDICATED TO THE GOD TALAB   Provenance uncertain, 2nd–3rd century CE   Bronze; L 18.5  W 11  TH 3.6 cm

The British Museum, ANE 1983-6-26,2=139443

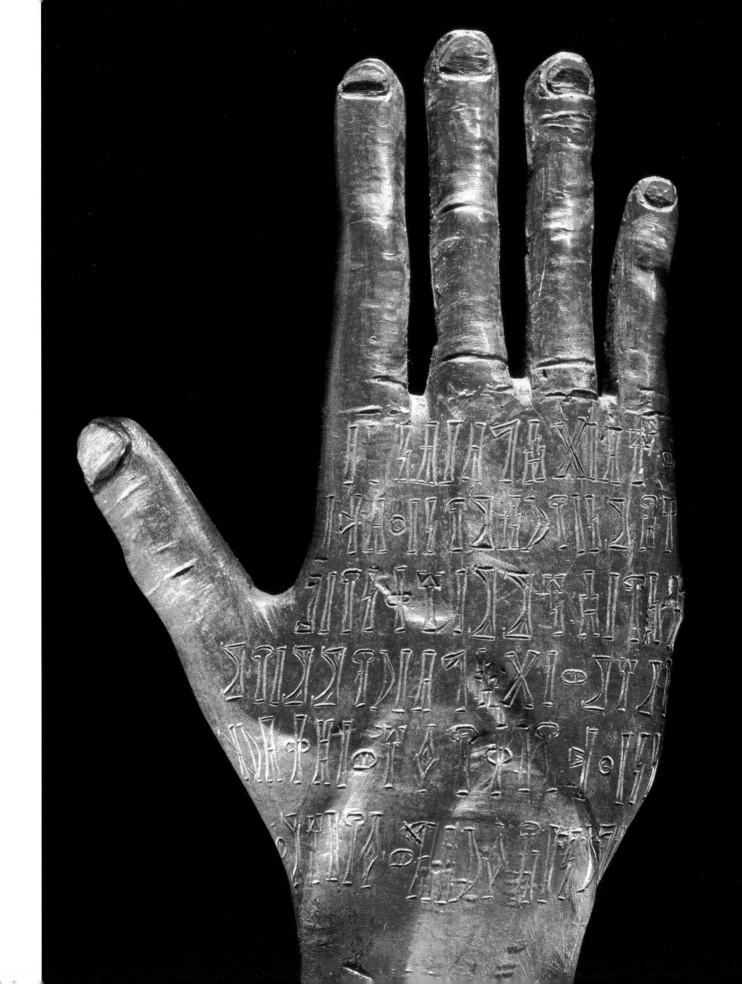

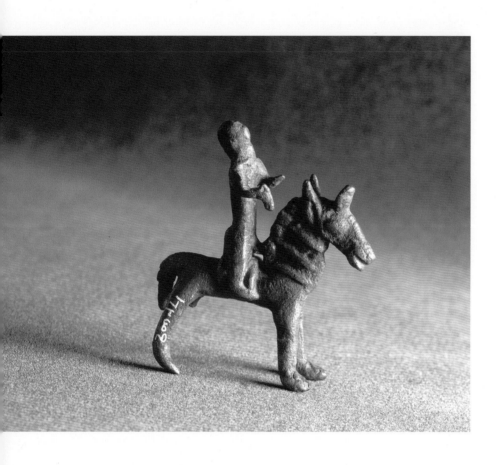

29  HORSE AND RIDER  Marib, 1st–3rd century CE  Bronze; H 7  L 6 cm  Military Museum, Sanaa, MiM 163

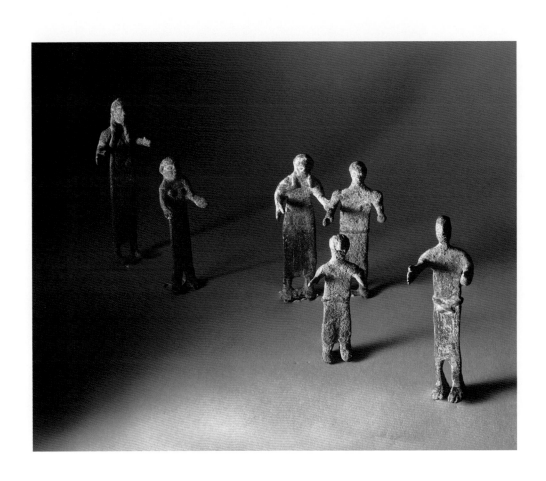

30 DEDICATORY STATUETTES  Wadi Marka, date uncertain  Bronze; H max 8.2  W max 2.6 cm  Ataq Museum, ATM 330–5

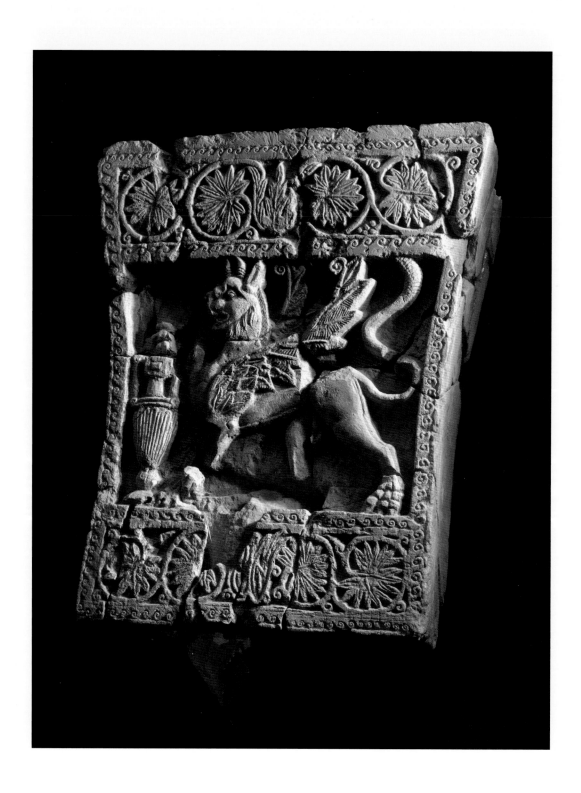

31 DECORATED PILLAR CAPITAL   Shabwa, mid-3rd century CE   Limestone; H 46  W 49 cm   National Museum, Aden, NAM 1218

32 (DETAIL) STELA DEPICTING IBEX HUNT   The Jawf, 1st–3rd century CE   Limestone; H 33  W 32  TH 9 cm   National Museum, Sanaa, YM 1131

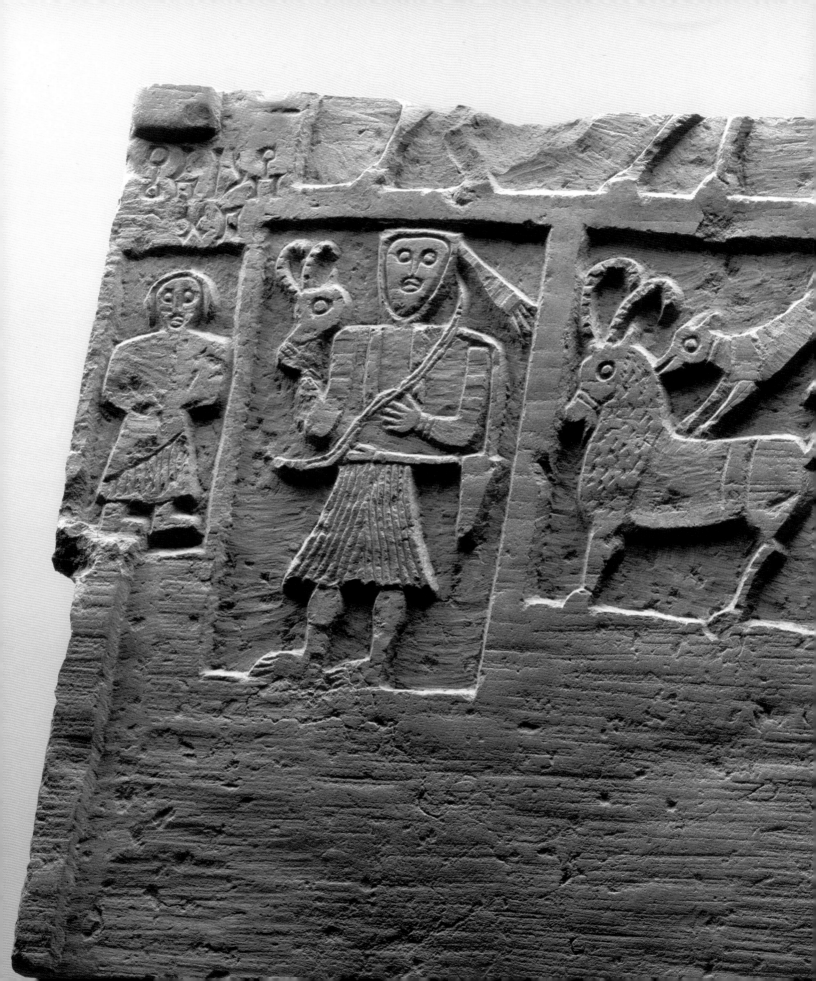

33 (DETAIL) CORNICE DECORATED WITH VINE SCROLL   Marib, 2nd century CE   Alabaster; H 22.5  W 130  TH 7 cm   The British Museum, ANE 1966-12-13,1=134886

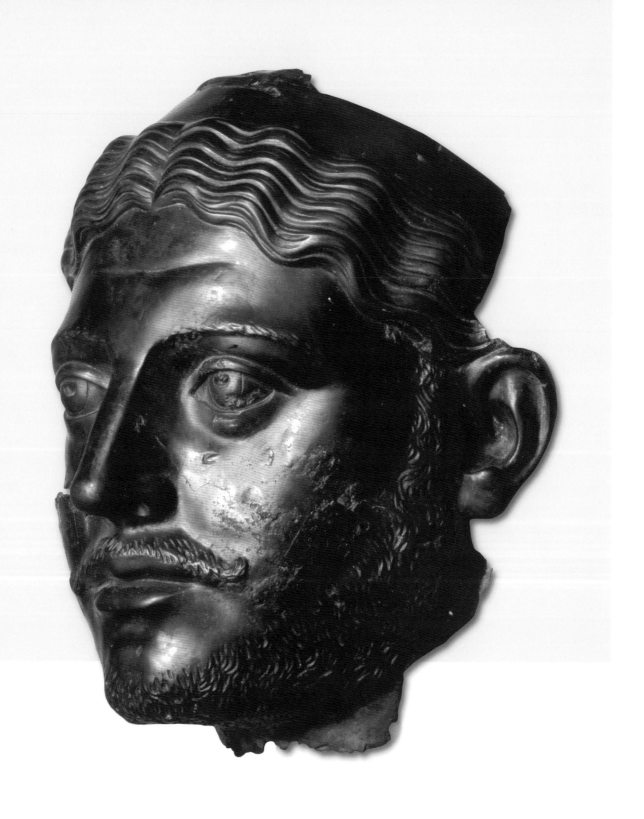

34 FRAGMENTS OF STATUES OF TWO KINGS OF HIMYAR   An-Nakhlat al-Hamra, 2nd–4th century CE
Bronze; H head 30  L arm 60  L leg 86 cm   National Museum, Sanaa, YM 197, 210, 217

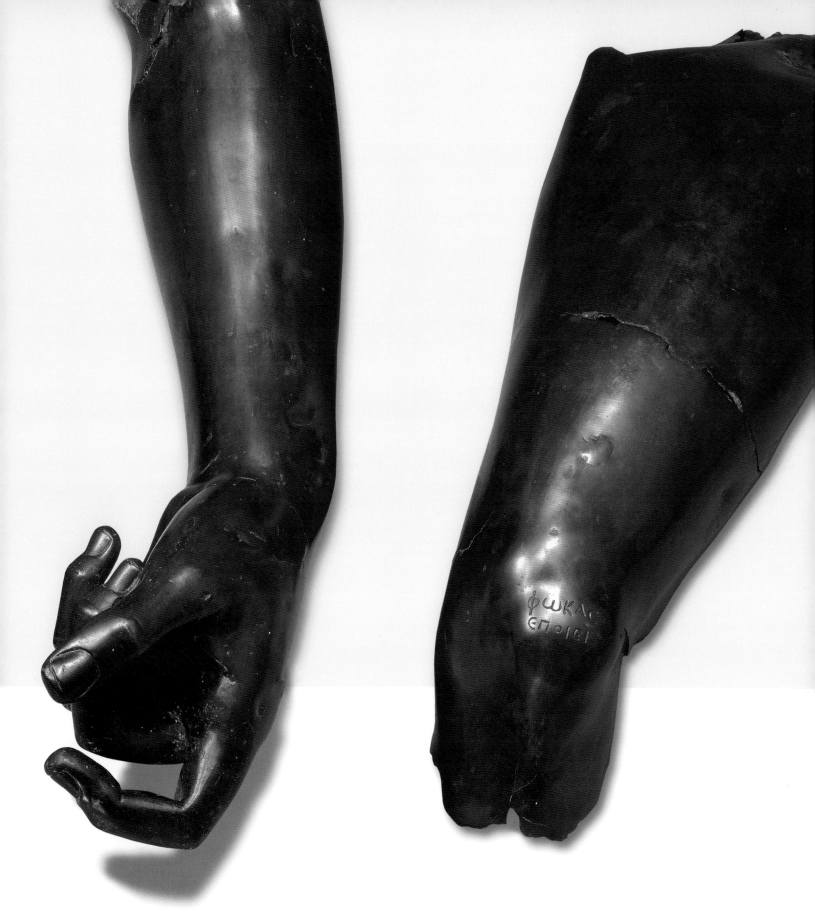

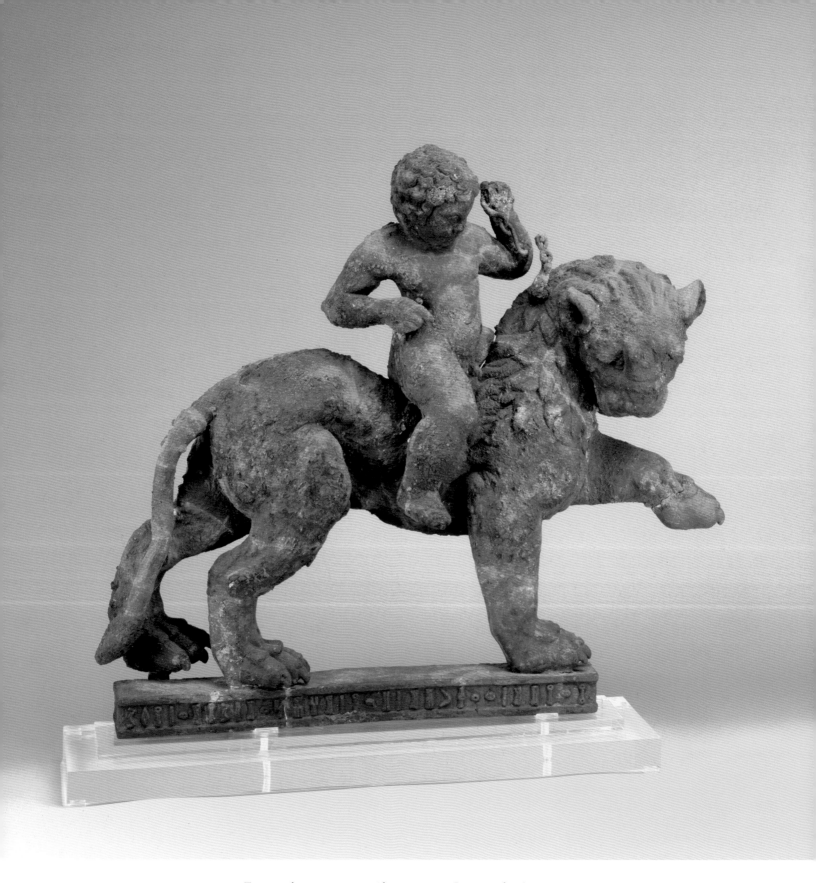

35  PAIR OF LIONS WITH RIDERS  Tamna, early 1st century BCE–mid-1st century CE  Bronze; each H 61  L 52.5 cm

The American Foundation for the Study of Man, TS 152A-B

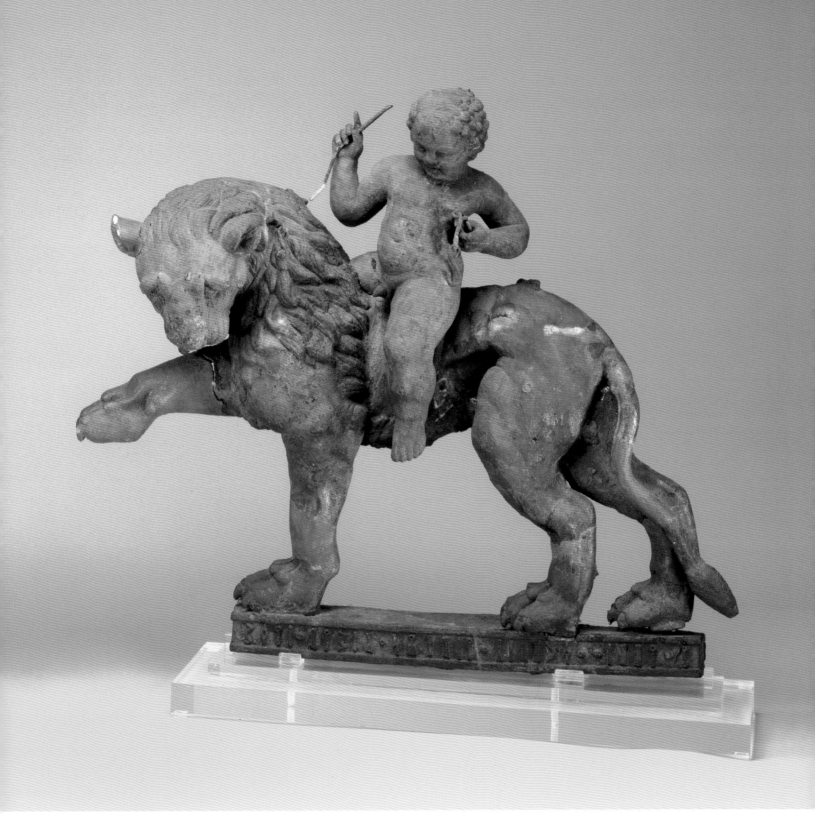

36 HEAD OF A MAN   Ghayman, possibly 2nd century CE   Bronze; H 20.8  W 17.5  D 18.5 cm
The British Museum, ANE 1937–6–16,1=127409=1.26

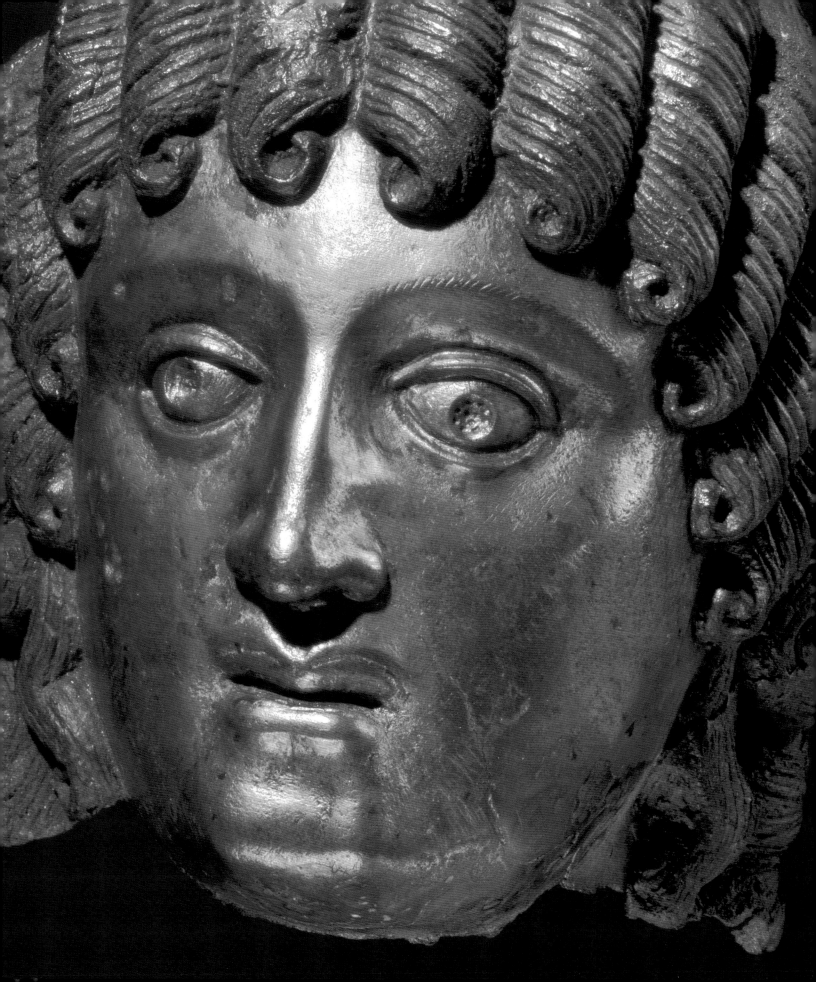

37   REARING HORSE WITH HIMYARITIC INSCRIPTIONS

Ghayman, 2nd–3rd century CE   Bronze; H 102  L 106 cm   Dumbarton Oaks, BZ 1938.12

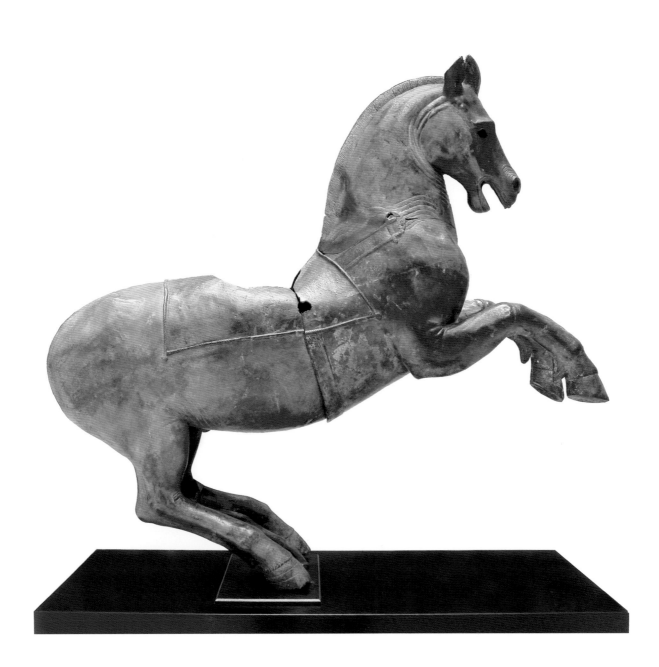

# CHRONOLOGY

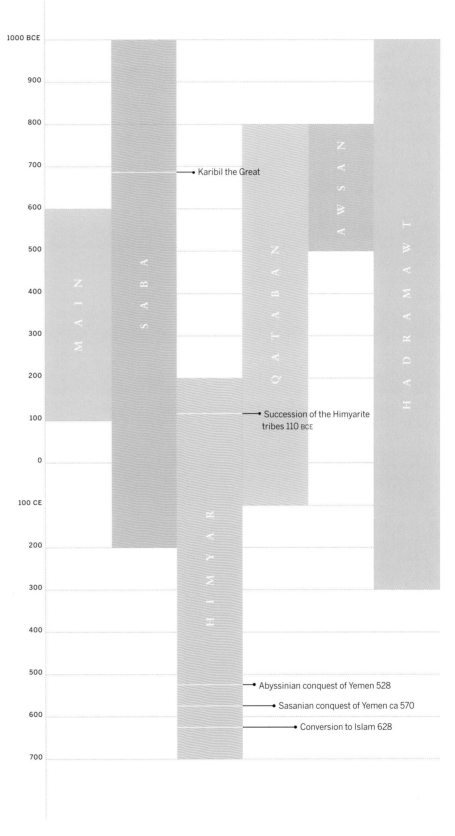

| | | | | | |
|---|---|---|---|---|---|
| 1000 BCE | | | | | |
| 900 | | | | | |
| 800 | | | | AWSAN | |
| 700 | | • Karibil the Great | | | |
| 600 | | | | | |
| 500 | MAIN | SABA | QATABAN | | HADRAMAWT |
| 400 | | | | | |
| 300 | | | | | |
| 200 | | | | | |
| 100 | | • Succession of the Himyarite tribes 110 BCE | | | |
| 0 | | | | | |
| 100 CE | | | | | |
| 200 | | | HIMYAR | | |
| 300 | | | | | |
| 400 | | | | | |
| 500 | | | | | |
| | | • Abyssinian conquest of Yemen 528 | | | |
| 600 | | • Sasanian conquest of Yemen ca 570 | | | |
| | | • Conversion to Islam 628 | | | |
| 700 | | | | | |

# BIBLIOGRAPHY OF WORKS CITED

## ABBREVIATIONS

**GI** "SAMMLUNG EDUARD GLASER." ÖSTERREICHISCHE AKADEMIE DER WISSENSCHAFTEN, PHILOSOPHISCH-HISTORISCH KLASSE, 1913–81

**MB** REGISTRATION SIGLUM OF INSCRIPTIONS DISCOVERED BY THE AFSM EXCAVATIONS AT THE AWAM TEMPLE (MAHRAM BILQIS), L998-2004

**RES** *RÉPERTOIRE D'ÉPIGRAPHIE SÉMITIQUE.* 8 VOLS. PARIS: ACADÉMIE DES INSCRIPTIONS ET BELLES-LETTRES, 1900–68

## PRIMARY SOURCES

Diodorus Siculus. *History.* 12 vols. Ed. and trans. by C. H. Oldfather et al. Loeb Classical Library. Cambridge, Mass.: Harvard University Press, 1933–67.

Dioscorides, Pedanius. *De materia medica: Being an Herbal with Many Other Medicinal Materials. A New Indexed Version in Modern English.* Ed. and trans. by T. A. Osbaldeston and R. P. A. Wood. Johannesburg: IBIDIS, 2000.

al-Hamdani, Hasan ibn Ahmad. *Kitab al-Iklil,* vol. 8. Ed. and trans. by N. A. Faris and entitled *The Antiquities of South Arabia.* Princeton: Princeton University Press, 1938.

Herodotus. *History.* 4 vols. Ed and trans. by A. D. Godley. Loeb Classical Library. Cambridge, Mass.: Harvard University Press, 1920–25.

*Periplus Maris Erythrae.* Ed and trans. by Lionel Casson. Princeton: Princeton University Press, 1989.

Pliny. *Natural History.* 10 vols. Ed. and trans. by H. Rackham. Loeb Classical Library. Cambridge, Mass.: Harvard University Press, 1938–63.

Strabo. *The Geography.* 8 vols. Ed. and trans. by H. L. Jones and J. R. Sitlington Sterrett. Loeb Classical Library. Cambridge, Mass.: Harvard University Press, 1917–32.

Theophrastus. *Enquiry into Plants.* 2 vols. Ed. and trans. by A. Hort. Loeb Classical Library. Cambridge, Mass.: Harvard University Press, 1961.

## SECONDARY SOURCES

Abdullah, Y. M. 1988. "Die Sonnengesang von Saba. Ein Stück religioser Literatur aus dem antiken Jemen." In *Im Land der Königin von Saba. Kunstschätze aus dem antiken Jemen,* ed. W. Daum, W. W, Müller, N. Nebes, and W. Raunig, 185–92. Munich: Staatliches Museen für Völkerkunde/IP.

Albright, F. P. 1982. *The American Archaeological Expedition in Dhofar, Oman, 1950–1953.* Publications of the American Foundation for the Study of Man, vol. 6. Washington, D.C.: American Foundation for the Study of Man.

Arnaud, T. J. 1845. "Relation d'un voyage à Mareb (Saba) dans l'Arabie méridional, entrepris en 1843 par M. Arnaud." *Journal asiatique* 5: 211–45, 309–45.

Basalama, M. 1998. "Die Mumien von Shibām al-Ghirās." In *Jemen. Kunst und Archäologie im Land der Königin von Saba',* ed. W. Seipel, 252–53. Vienna: Kunsthistorisches Museum.

Beaucamp, J., F. Briquel-Chatonnet, and C. Robin. 1999–2000. "La persécution des chrétiens de Nagrān et la chronologie himyarite." *ARAM* 11–12: 15–83.

Beeston, A. F. L. 1959. *Qahtan: Studies in Old South Arabian Epigraphy,* Fasc. I: *The Mercantile Code of Qataban.* London: Luzac.

Beeston, A. F. L. 1970. "Functional Significance of the Old South Arabian Town." *Proceedings of the Seminar for Arabian Studies* 1: 26–8.

Beeston, A. F. L. 1979. "South Arabian Alphabet Letter Order." *Raydan* 2: 87–8.

Beeston, A. F. L. 1984. "Further Remarks on the Zayd-'il Sarcophagus Text." *Proceedings of the Seminar for Arabian Studies* 14: 100–2.

Beeston, A. F. L. 1987. "Apologia for 'Sayhadic.'" *Proceedings of the Seminar for Arabian Studies* 17: 13–14.

Beeston, A. F. L. 1989. "Mahmoud Ali Ghul and the Sabaean Cursive Script." In *Arabian Studies in Honour of M. Ghul,* ed. M. Ibrahim, 15–19. Wiesbaden: Harrassowitz.

Beeston, A. F. L. 1995. "Saba." *The Encyclopedia of Islam,* new ed., vol. 8, 663–65. Leiden: E. J. Brill.

Blakely, J. A., J. A. Sauer, and M. R. Toplyn. 1983. *Site Reconnaissance in North Yemen, 1983.* The Wadi al-Jubah Archaeological Project, vol. 2. Washington, D.C.: American Foundation for the Study of Man.

Bordreuil, P., and D. Pardee. 1995. "Un abécédaire de type sud-sémitique découvert en 1988 dans les fouilles archéologiques françaises de Ras Shamra-Ougarit." *Comptes-rendus de l'Académie des Inscriptions et Belles-Lettres,* 855–60.

Bowen, R. LeB., and F. P. Albright. 1958. *Archaeological Discoveries in South Arabia.* Publications of the American Foundation for the Study of Man, 2. Baltimore: Johns Hopkins Press.

Bradbury, L. 1996. "Kpn-Boats, Punt Trade and a Lost Emporium." *Journal of the American Research Center in Egypt* 33: 37–60.

Breton, J.-F. 1999. *Arabia Felix from the Time of the Queen of Sheba: Eighth Century* BC *to First Century* AD. Trans. from the French by Albert LaFarge. Notre Dame, Ind.: University of Notre Dame Press.

Breton, J.-F., and M. A. Bafaqih. 1993. *Trésors du Wādī Dura' (République du Yémen). Fouilles franco-yéménites de la nécropole de Jahar am-Dhabiyya.* Institut français d'archéologie du Proche-Orient, Bibliothèque archéologique et historique, vol. 141. Paris: Librairie orientaliste Paul Geuthner.

Briend, J. 1996. "Sheba. I. Dans la Bible." In *Supplément au Dictionnaire de la Bible,* fasc. 70, cols. 1043–46. Paris: Letouzey and Ané.

Bron, F. 1991. "Les noms propres sudarabiques du type 'yf' l + nom divin." *Études sud-arabes. Receuil offert à J. Ryckmans,* 85–91. Publications de l'Institut Orientaliste de Louvain 39. Louvain: Institut Orientaliste.

Bron, F. 1994. "Remarques sur l'onomastique sudarabique archaïque." In *Arabia Felix, Festschrift Walter W. Müller zum 60. Geburtstag,* ed. N. Nebes, 62–66. Wiesbaden: Harrassowitz.

Calvet, Y., and C. Robin, et al. 1997. *Arabie heureuse, Arabie déserte. Les antiquités arabiques du Musée du Louvre.* Paris: Musée du Louvre.

Caton-Thompson, G. 1944. *The Tombs and Moon Temple at Hureidha (Hadhramawt).* London: Society of Antiquaries.

Cleveland, R. I. 1965. *An Ancient South Arabian Necropolis: Objects from the Second Campaign (1951) in the Timna Cemetery.* Publications of the American Foundation for the Study of Man, vol. 4. Baltimore: Johns Hopkins University Press.

Crone, P. 1987. *Meccan Trade and the Rise of Islam.* Princeton: Princeton University Press.

Cuvigny, H. 1997. "L'Arabie heureuse des classiques: naissance d'un mythe." In *Yémen: Au pays de la reine de Saba',* ed. C. Robin and B. Vogt, 67–69. Paris: Flammarion.

Dostal, W. 1990. *Eduard Glaser—Forschungen im Yemen. Eine quellenkritische Untersuchung in ethnologischer Sicht.* Österreichische Akademie der Wissenschaften, Philosophisch-historisch Klasse, Sitzungsberichte, Bd. 545 (Veröffentlichungen der arabischen Kommission, no. 4). Vienna: Verlag der Österreichischen Akademie der Wissenschaften.

Dostal, W. 1993. *Ethnographica Jemenica. Auszüge aus den Tagebüchern Eduard Glasers mit einem Kommentar versehen.* Österreichische Akademie der Wissenhaften, Philosophisch-historisch Klasse, Sitzungsberichte, Bd. 593. Vienna: Verlag der Österreichischen Akademie der Wissenschaften.

Frantsouzoff, S. A. 1999. "Hadramitic Documents Written on Palm-leaf Stalks." *Proceedings of the Seminar for Arabian Studies* 29: 55–65.

Galter, H. D. 1993. " '. . . an der Grenze der Länder im Westen,' Saba in den assyrischen Königsinschriften." In *Studies in Oriental Culture and History, Festschrift für Walter Dostal,* ed. A. Gingrich, S. Haas, G. Paleczek, and T. Fillitz, 29–40. Frankfurt am Main: Peter Lang.

Gerlach, I. 2001. "Edifices funéraires au royaume de Saba." *Dossiers d'Archéologie* 263 (May): 50–53.

Gerlach, I., and H. Hitgen. 2000. "Eine Totenstadt am Rande der Wuste: Der Friedhof des sabaischen Awam-Heiligtums in Marib/Jemen." *Archäologische Entdeckungen: die Forschungen des Deutschen Archäologischen Instituts im 20. Jahrhundert,* ed. Deutsches Archäologisches Instituts, 207–12, Mainz: von Zabern; Antike Welt Sonderband 2.

Gesenius, W. 1841. "Himjaritischer Sprache und Schrift, und Entziggerung der letzteren." *Allgemeine Literatur-Zeitung* no. 123–6: col. 369–99; and Ergänzungsblatt no. 64: col. 511–12, July.

Glanzman, W. D. 1999. "Clarifying the Record: The Bayt Awwam Revisited." *Proceedings of the Seminar for Arabian Studies* 29: 73–88.

Glanzman, W. D. 2002. "Some Notions of the Space at the Mahram Bilqis in Marib." *Proceedings of the Seminar for Arabian Studies* 32: 187–201.

Glanzman, W. D., and A. O. Ghaleb. 1984. *Site Reconnaissance in the Yemen Arab Republic, 1984: Stratigraphic Probe at Hajar ar-Rayhani.* The Wadi al-Jubah Archaeological Project, vol. 3. Washington, D.C.: American Foundation for the Study of Man.

Glaser, E. 1913. *Reise nach Marib.* Vienna: A. Holder.

Goitein, S. D., ed. 1941. *Travels in Yemen. An Account of Joseph Halévy's Journey to Najran in the Year 1870, Written in San'ani Arabic by his Guide Hayyim Habshush,* edited with a detailed summary in English and a glossary of vernacular words. Jerusalem: Hebrew University Press.

Grolier, M. J., R. Brinkmann, J. A. Blakely, and W. C. Overstreet. 1987. *Environmental Research in Support of Archaeological Investigations in the Yemen Arab Republic, 1982–1987.* The Wadi al-Jubah Archaeological Project, vol. 5. Washington, D.C.: American Foundation for the Study of Man.

Groom, N. 1981. *Frankincense and Myrrh: A Study of the Arabian Incense Trade.* London: Longman/Beirut: Librarie du Liban.

Groom, N. 1995. "The 'Periplus,' Pliny and Arabia." *Arabian Archaeology and Epigraphy* 6: 180–95.

Groom, N. 1997. *The New Perfume Handbook.* London: Chapter & Hall/ Blackie Academic & Professional.

Halévy, J. 1872. "Rapport sur une mission archéologique dans le Yémen." *Journal asiatique,* Sixième série, 19 (January–June): 5–98, 129–266, 489–547.

Halévy, J. 1873. "Voyage au Nedjran." *Bulletin de la Societé de Geographie,* Sixième série, 6 (July–December): 5–31, 249–73, 581–606, map following text.

Halévy, J. 1877. "Voyage au Nedjran." *Bulletin de la Societé de Géographie,* Sixième série, 13 (January–June): 466–79.

Haran, M. 1960. "The Uses of Incense in the Ancient Israelite Ritual." *Vetus Testamentum* 10: 113–29.

Hitgen, H. 1998. "The 1997 Excavations of the German Institute of Archaeology at the Cemetery of Awam in Marib." *Proceedings of the Seminar for Arabian Studies* 28: 117–24.

Hitgen, H. 1999. "Jabal al-'Awd: Ein Fundplatz der Spätzeit im Hochland des Jemen." In *Im Land der Königin von Saba. Kunstschätze aus dem antiken Jemen,* ed. W. Daum, W. W. Müller, N. Nebes, and W. Raunig, 247–53. Munich: Staatliches Museen für Völkerkunde/IP.

Honeyman, A. M. 1952. "The Letter-order of the Semitic Alphabets in Africa and the Near East." *Africa* 22: 136-47.

Irvine, A. K., and A. F. L. Beeston. 1988. "New Evidence on the Qatabanian Letter-Order." *Proceedings of the Seminar for Arabian Studies* 18: 35–38.

Jamme, A. 1962. *Sabaean Inscriptions from Mahram Bilqīs (Mārib).* Publications of the American Foundation for the Study of Man, vol. 3. Baltimore: Johns Hopkins Press.

Kitchen, K. A. 2000. *Documentation for Ancient Arabia.* Part II: *Chronological Framework and Historical Sources.* The World of Ancient Arabia Series. Liverpool: Liverpool University Press.

Liverani, M. 1992. "Early Caravan Trade between South Arabia and Mesopotamia." *Yemen. Studi archeologici, storici e filolgici sull'Arabia meridionale* 1: 111–15, Rome: IsMEO.

Lundin, A. G. 1987. "L'abécédaire de beth Shemesh." *Le Muséon* 100: 243–50.

Maigret, A. de. 1996. "New Evidence from the Yemenite 'Turret Graves' for the Problem of the Emergence of the South Arabian States." In *The Indian Ocean in Antiquity,* ed. J. E. Reade, 321–37. London: Kegan Paul.

Maigret, A. de. 2002. *Arabia Felix. An Exploration of the Archaeological History of Yemen.* Trans. from the Italian by Rebecca Thompson. London: Stacey International.

Maraqten, M. 2002. "Newly Discovered Sabaic Inscriptions from Mahram Bilqīs near Marib."

*Proceedings of the Seminar for Arabian Studies* 32: 209–16.

Maraqten, M. 2004. "The Processional Road between Old Marib and the Awam Temple in the Light of a Recently Discovered Inscription from Mahram Bilqis." *Proceedings of the Seminar for Arabian Studies* 34: 157–63.

Maraqten, M., and Y. M. Abdullah. 2002. "A Recently Discovered Inscribed Plaque from Mahram Bilqis near Marib, Yemen." *Journal of Near Eastern Studies* 61: 49–53.

Moorman, B. J., W. D. Glanzman, J.-M. Maillol, and A. L. Lyttle. 2001. "Imaging Beneath the Surface at Mahram Bilqis." *Proceedings of the Seminar for Arabian Studies* 31: 179–87.

Müller, W. W. 1978. "Weihrauch." In *Real-Encyclopädie der klassiches Altertumswissenschaft (Pauly-Wissowa)*, suppl. 15, cols. 701–77. Munich: A. Druckenmüller.

Müller, W. W. 1991. "Mārib." *The Encyclopedia of Islam*, new ed., vol. 6, 559–67. Leiden: E. J. Brill.

Overstreet, W. C., M. J. Grolier, and M. R. Toplyn. 1985. *Geological and Archaeological Reconnaissance in the Yemen Arab Republic*. The Wadi al-Jubah Archaeological Project, vol. 4. Washington, D.C.: American Foundation for the Study of Man.

Phillips, W. 1955. *Qataban and Sheba. Exploring Ancient Kingdoms on the Biblical Spice Routes of Arabia*. London: Victor Gollancz.

Phillips, W. 1966. *Unknown Oman*. London: Longmans.

Phillips, W. 1967. *Oman: A History*. London: Longmans.

Piotrovsky, M. B. 1988. "The Fate of Castle Ghumdān." In *Ancient and Medieval Monuments of Civilization of Southern Arabia*, 28–38. Moscow: Nauka.

Pirenne, J. 1958. *A la découverte de l'Arabie. Cinq siècles de sciences et d'aventure (l'aventure du passé)*. Paris: Le Livre Contemporain.

Rathjens, C., and H. von Wissmann. 1932. *Vorislamischer Altertümer*. Hamburg: Walter de Gruyter.

Robin, C. 1992. *Inventaire des inscriptions sudarabiques, vol. 1: 'Inabba', Haram, al-Kāfir, Kamna et al-Harāshif Inabba'*. Paris: de Boccard/Rome: Herder.

Robin, C., and F. Bron. 1974. "Nouvelles données sur l'ordre des letters de l'alphabet sud-arabique." *Semitica* 24: 77–82.

Robin, C., and B. Vogt, eds. 1997. *Yémen. Au pays de la reine de Saba*. Paris: Flammarion.

Rödiger, E.R. 1841. *Versuch über die himjaritischen Schriftmonumente*. Halle: Verlagder Buchhandlung des Waisenhauses.

Roux, J. C. 1992. "La tombe-caverne 1 de Shabwa." In *Rapports préliminaires, Fouilles de Shabwa* 2, ed. J.-F. Breton, 331–65. Institut français d'archéologie du Proche-Orient, no 19. Paris: Librairie orientaliste Paul Geuthner.

Ryckmans, J. 1953. "Inscriptions sud-arabes (Dixième série)." *Le Muséon* 66: 267–317.

Ryckmans, J. 1984. "Alphabets, Scripts and Languages in Pre-Islamic Arabian Epigraphical Evidence." In *Studies in the History of Arabia*, vol. 2: *Pre-Islamic Arabia*, 73–86. Riyadh.

Ryckmans, J. 1985. "L'ordre alphabétique sud-sémitique et ses origins." In *Mélanges linguistiques offerts à Maxime Rodinson*, ed. C. Robin, 343–59. Paris: Paul Geuthner.

Ryckmans, J. 2001. "Origin and Evolution of South Arabian Minuscule Writing on Wood." *Arabian Archaeology and Epigraphy* 12: 223–35.

Ryckmans, J., W. W. Müller, and Y. M. Abdullah. 1994. *Textes du Yémen antique: inscrits sur bois (with an English Summary)*, with foreword by J.-F. Breton. Publications de l'Institut orientaliste de Louvain, vol. 43. Louvain: Université catholique de Louvain, Institut orientaliste.

Sayed, A. M. A. H. 1984. "Reconsideration of the Minaean Inscription of Zayd'il bin Zayd." *Proceedings of the Seminar for Arabian Studies* 14: 93–99.

Schippmann, K. 2001. *Ancient South Arabia. From the Queen of Sheba to the Advent of Islam*. Trans. from the German by Allison Brown. Princeton: Markus Wiener.

Sedov, A. V. 1997. "Sea-trade of the Hadramawt Kingdom from the 1st to the 6th Centuries A.D." In *Profumi d'Arabia. Atti del convegno*, ed. A. Avanzini, 365–83. Rome: 'L'Erma' di Bretschneider.

Sedov, A. V. 2001. "Qani', port antique du Hadramout." *Dossiers d'Archéologie* 263 (May): 32–35.

Sedov, A. V., and P. A. Griaznevich, eds. 1996. *Raybun Settlement (1983–1987 Excavations)* (Russian text). Moscow: Izdatel'skaia firma "Vostochnaia lit-ra" RAN.

Seipel, W., ed. 1998. *Jemen. Kunst und Archäologie im Land der Königin von Saba*. Vienna: Kunsthistorisches Museum.

Sima, A. 1999. *Die Lihyanischen Inschriften von al-ᶜUdhayb'*. Rahden: Marie Leidorf.

Simpson, S. J., ed. 2002. *Queen of Sheba: Treasures from Ancient Yemen*. London: British Museum Press.

Thulin, M., and P. Claeson. 1991. "The Botanical Origin of Scented Myrrh (Bissabol or Habbak Hadi)." *Economic Botany* 45 no. 4: 487–94.

Toplyn, M. R. 1984. *Site Reconnaissance in North Yemen, 1982*. The Wadi al-Jubah Archaeological Project, vol. 1. Washington, D.C.: American Foundation for the Study of Man.

Van Beek, G. W. 1969. *Hajar Bin Humeid: Investigations at a Pre-Islamic Site in South Arabia*. Publications of the American Foundation for the Study of Man, vol. 5. Baltimore: Johns Hopkins Press.

Vogt, B., and I. Gerlach. 2002. "Bericht über die Notgrabungen im Friedhof von Sha'ub (Sana'a)." *Archäologische Berichte aus dem Yemen* 9: 185–204.

Vogt, B., A. de Maigret, and J.-C. Roux. 1998. "Die Grabsitten zu Zeiten der südarabischen Hochkultur." In *Jemen. Kunst und Archäologie im Land der Königin von Saba'*, ed. W. Seipel, 232–45. Vienna: Kunsthistorisches Museum.

Wellsted, J. R. 1838. *Travels in Arabia*. London: J. Murray.

Young, G. K. 2001. *Rome's Eastern Trade: International Commerce and Imperial Policy, 31 BC–AD 305*. London: Routledge.

Moscha 107, 110
Mouza 109–10, 113
*mukarrib* 5, 10, 11, 18, 23, 93, 98
mummification 83, 92
Myos Hormos 111
myrrh 10, 17, 105–113

**N**
Nabataeans 11, 37
Najran (Najrān) 12, 37, 41, 57, 58, 108
Nakrah (Nakraḥ) 55, 98
Narmada River 110
Nashan 28, 32, 55, 98
Nashq 98
Nile River 105, 111
*ntyw* (*'ntyw*) 105, 111

**O**
offering tables 86, 99
Okelis 110, 112
*olibanum see* frankincense
Oman 27, 29, 31, 62, 110
oracle 56–57
ostraca 87, 95
ostrich 99

**P**
palaces 14, 15, 37–38
Palestine 5, 6, 31
pepper 110
perfumes 17, 107, 108, 111, 112
*Periplus* 106, 110, 112
Persia 105, 110. *See also* Sasanian empire
Petra 10, 108, 109
pharmaceuticals 17, 107, 108
Phillips, Wendell 13, 22, 61–63, 65, 66, 69, 70
pilgrimage 10, 56–57, 69, 73, 81
Pirenne, Jacqueline 3, 99
plaster 46–47, 64, 77, 86, 121. *See also* qadhat
Pliny 21, 22, 55, 57, 106, 107, 108, 111, 112, 113
precious/semiprecious stones 17, 18, 108
prisoners 107
proto-Sinaitic 17
Ptolemies 111
Ptolemy 109
Punt 105, 111

**Q**
*qadhat* 46, 77, 121, 122
Qani (Qāni') 11, 82, 84, 107, 108, 110, 113
Qarnaw 98
Qataban (Qatabān) 15, 16, 18, 21–24, 28, 29, 61, 63, 97, 98, 99, 106, 108, 112
Qatabanian dialect/language 15, 23, 24, 28, 29, 54
queen of Sheba (Saba) 18–19, 53, 61, 98, 106
Quran (Qur'ān) 9, 14, 18, 53, 56

**R**
radiocarbon dating 4, 63, 66, 116
Ramlat as-Sabatayn (Sab'atayn) 5, 9, 27, 108
Rathjens, Carl 12
Raybun (Raybūn) 5–6, 33, 83
Red Sea 22, 23, 109–11
Rhapta 109
rhinoceros horn 109
Riyam 54, 57
Rödiger, E.R. 31
Rome 11, 108, 109, 111
royal titles 10, 11, 21, 23, 24
Russian Archaeological Mission 5

**S**
Saba 6, 9–19, 23–24, 28, 35, 36, 53, 54, 63, 72, 84, 87, 91, 97, 98, 106
Sabaean dialect/language 5, 10, 15, 16, 27–30, 62
saffron 109
Salala 107
Sanaa (Ṣana'ā') 12, 13, 14, 82, 83
Sappho 105
Sasanian empire 16, 58
Sayhadic 27
Scythia 110
Semitic 27, 28
Sennacherib 37
serpent 99
sesame 111
Shabwa 6, 29, 38, 57, 83, 86, 107, 108
Shar Awtar (Sha'r Awtar) 23
Shaub (Sha'ub) 85, 92
shell 86, 110
Shib al-Aql (Shi'b al-'Aql) 5
Shibam al-Ghiras (Shibām al-Ghirās) 83
shipping 1, 108–111
Shuka (Shuka') 81, 86
silver 87, 108, 110
Sin 55
Sirwah (Ṣirwāh) 12, 13, 18, 34–41, 55, 95
slaves 109, 110
Solomon 18, 53, 106
Somalia/Somaliland 105, 107, 108, 109, 110, 111
Soqotra 27, 107, 109, 110
Sosippi 109
sphinx 45, 94
spices 110
spikenard 112
Stark, Freya 13
storax 110, 113
Strabo 22, 108
Sudan 87, 107
Sukhu 17
Sumhuram 62
Syria 11, 113

**T**
Taizz 109
Tamna (Tamna') 22, 24, 29, 38, 61, 83, 97, 106, 108
Tamna, cemetery (Hayd ibn Aqil) 22, 81, 83, 85, 86, 97
Tayma (Tayma') 17
Thebes 105
Theophrastus 106, 112
Tihama 37
tombs 46–47, 81–88; offerings in, 48–49, 82–88, 93–95. *See also* cemeteries
tortoiseshell 10, 109
trade 10, 17, 22, 37, 41, 105–13

**U**
Uganda 105
Ugaritic 17, 28, 31
Uthman ('Uthmān), caliph 14

**W**
Wadi (Wādī) Bana 23, 43
Wadi Bayhan (Wādī Bayḥān) 3, 22, 23, 24, 27, 29, 31, 61, 106, 115
Wadi (Wādī) Dhana 9, 14, 27, 62, 115, 119
Wadi Doan (Wādī Doān) 5
Wadi Dura (Wādī Ḍura') 84–85, 87
Wadi Hadramawt (Wādī Ḥaḍramawt) 5, 115
Wadi Harib (Wādī Ḥarīb) 22, 23, 24, 27, 29
Wadi (Wādī) Jawf 27, 115
Wadi (Wādī) al-Jubah 4, 63
Wadi (Wādī) Madhab 29
Wadi (Wādī) Markha 115, 116
Wadi Siham (Wādī Sihām) 6
Wadi (Wādī al-Sudd) 119
Warawil (Waraw'īl) 21
weapons 47, 87
Wellsted, Lieutenant J. R. 31
Wissman, Hermann von 3, 12

**Y**
Yadail (Yada''il) 23
Yadail Darih (Yada''il Darih) 36, 91
Yala (Yalā) 4–6
Yathiamar Bayan (Yāthi'ī'amar Bayān), son of Sumhualay (Sumhū'alāy) 5

**Z**
Zafar (Ẓafār) 12, 23, 29, 43, 58. *See also* dhu-Raydan

CREDITS

We owe special thanks to the Deutsches Archäologisches Institut, Iris Gerlach, Philippe Maillard, and Pascal and Maria Maréchaux for their kindness and generosity in making photographs available for reproduction.

© Berlin, DAI, Orient-Abteilung, Dr. Iris Gerlach. Pages 18, 35 (top), 36, 37 (top), 38 (top, bottom), 39 (top), 40 (top, bottom), 78, 116 (bottom), 119.

© Berlin, DAI, Orient-Abteilung, Dr. Holger Hitgen. Pages 43 (top), 75.

© Berlin, DAI, Orient-Abteilung, Dr. Johannes Kramer. Pages 43 (bottom), 44 (left), 45 (left, right), 46 (top, center, bottom), 47 (top, bottom), 77, 85 (left, right), 92 (top, bottom), 93, 94 (top, bottom), 95.

© Berlin, DAI, Orient-Abteilung, Dr. Burkhard Vogt. Page 76 (top, bottom).

© Berlin/Bochum, DAI/Deutsches Bergbau-Museum, Jürgen Heckes. Pages 41 (top, bottom), 107.

© Berlin/Bochum, DAI/Deutsches Bergbau-Museum, Jürgen Heckes/Anja Fengler. Pages 35 (bottom), 37 (bottom), 39 (bottom), 91 (top, bottom), 120 (top).

© Berlin/Bonn, DAI/KAVA/Dr. Burkhard Vogt. Page 122 (bottom).

© Berlin/Bonn, DAI/KAVA/Werner Herberg. Pages 120 (bottom), 121 (top, center, bottom).

© Bonn, Dr. Burkhard Vogt. Pages 81 (top), 82 (bottom).

© Falls Church, Virginia, American Foundation for the Study of Man. Pages 3, 4, 5, 24, 57(bottom), 61, 62 (top, bottom), 63 (top, bottom), 64, 65, 66, 69 (top, bottom), 71, 72, 86, 88, 97 (top), 98 (left, center, right), 110, 111, 112. Color plates 5, 6, 10, 12, 13, 16, 20, 35.

© London, British Museum. Pages 27 (bottom), 31, 57 (top), 87, 105. Color plates 3, 11, 23, 24, 28, 33, 36.

© London, Dr. St John Simpson. Page 27 (top).

© Paris, Institut du Monde Arabe. Page 116 (top).

© Paris, Pascal and Maria Maréchaux. Pages i, iv, v, viii, ix, xviii, ixx, xx, xxi, 48, 49, 50, 51, 100, 101, 102, 103, 106, 204.

© Paris, Philippe Maillard. Pages 6 (top, bottom), 9, 10, 15, 16, 17, 21, 22, 23, 28, 29 (bottom), 30 (top and bottom), 32, 33, 54, 55 (top, bottom), 56, 58, 83, 97 (bottom), 99 (left, right), 108, 109. Color plates 1, 2, 4, 7, 8, 9, 14, 15, 17, 18, 19, 25, 26, 27, 29, 30, 31, 32, 34.

© Sanaa, National Museum. S. al-Zubir. Page 82 (top).

© Vienna, Kunsthistorisches Museum. Pages 14, 44 (center, right), 84 (left, right). Color plates 21, 22.

© Washington, D.C., Dumbarton Oaks, Byzantine Collection. Color plate 37.

© Washington, D.C., National Air and Space Museum, Smithsonian Institution. Pages xvi, xvii.

Compilation copyright © 2005 Smithsonian Institution
Text and translations copyright © 2005 Smithsonian Institution, excepting essays noted below. All rights reserved.

"Languages and Writing," "Saba and the Sabaeans," "Trade, Incense, and Perfume," "Religion," and "Death and Funerary Practices" are reprinted with permission from Queen of Sheba: Treasures from Ancient Yemen, edited by St John Simpson (London: British Museum Press, 2002).

"The Dawn of History in Yemen's Interior," "The Hegemony of Qataban," "Images: Gods, Humans, and Animals," and "The Beginnings of Irrigation" are reprinted in translations from the French with permission from the Institut du Monde Arabe from Yémen: Au pays de la reine de Saba, edited by Christian Robin and Burkhard Vogt (Paris: Flammarion, 1997).

"New Research at the Sabaean City and Oasis of Sirwah," "An Early Himyarite Mountain Settlement on Jabal al-Awd," "Conservation of the Almaqah Temple of Baran," and "The Cemetery of the Awam Temple," are reprinted with permission from the authors and the Deutsches Archäologisches Institut, Orient-Abteilung, Aussenstelle Sanaa, from Twenty-five Years Excavations and Research in Yemen, 1978–2003, Hefte zur Kulturgeschichte des Jemen, Band 1 (Deutsches Archäologisches Institut, 2003). Titles have been slightly revised for this printing. "The Great Marib Dam: New Research by the German Archaeological Institute in 2002" is reprinted from the same source with permission from the author and the Deutsches Archäologisches Institut, Kommission für Allgemeine und Vergleichende Archäologie (KAVA), Bonn.

Published by the Freer Gallery of Art and Arthur M. Sackler Gallery on the occasion of an exhibition held at the Arthur M. Sackler Gallery, Smithsonian Institution, Washington, D.C., June 25–September 11, 2005.

ISBN 0-934686-00-9

Library of Congress Cataloging-in-Publication Data

Caravan kingdoms : Yemen and the ancient
incense trade / Edited by Ann C. Gunter.
     p. cm.
Includes bibliographical references and index.
ISBN 0-934686-00-9
1. Yemen–Antiquities–Exhibitions.
2. Incense industry–Yemen–History–Exhibitions.
3. Excavations (Archaeology)–Yemen–Exhibitions.
I. Gunter, Ann Clyburn, 1951-
II. Arthur M. Sackler Gallery (Smithsonian Institution)

DS247.Y43C37 2005
939'.49'0074753--dc22
     2005010448

The paper used in this publication meets the minimum requirements of the American National Standard for Information Services—Permanence of Paper for Printed Library Materials, ANSI Z39.48-1992.

Project Coordinator  Kelly Swain
Designer  Kelly Doe
Production Manager  Rachel Faulise
Photography Studio Head  John Tsantes
Copyeditors  Nancy Eickel and Jane Sunderland

Printed in Singapore

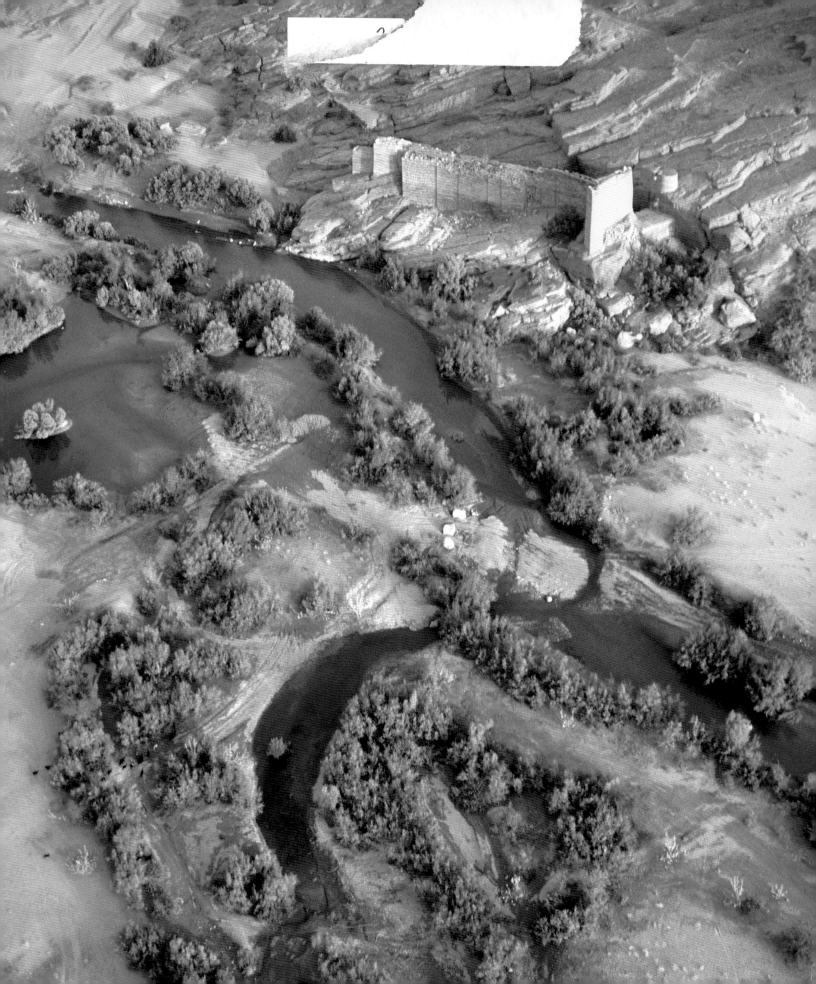